T0272561

THE FLY TYER'S ART

Also by Tony Lolli

Go-To Flies: 101 Patterns the Pros Use When All Else Fails (2004)
Amazing Fishing Facts and Trivia (2012)
Fly Patterns by Fishing Guides: 200 Patterns that Really Work (2013)
The Art of the Fishing Fly (2018)

THE FLY TYER'S ART

THIRTY-THREE WORLD-FAMOUS TYERS TIE THEIR REALISTIC FLIES

TONY LOLLI

PHOTOGRAPHS BY ALEX WILD

FOREWORD BY TOM ROSENBAUER

Skyhorse Publishing

Copyright © 2021 by Tony Lolli

Photographs copyright © Alex Wild

All rights reserved. No part of this book may be reproduced in any manner without the express written consent of the publisher, except in the case of brief excerpts in critical reviews or articles. All inquiries should be addressed to Skyhorse Publishing, 307 West 36th Street, 11th Floor, New York, NY 10018.

Skyhorse Publishing books may be purchased in bulk at special discounts for sales promotion, corporate gifts, fund-raising, or educational purposes. Special editions can also be created to specifications. For details, contact the Special Sales Department, Skyhorse Publishing, 307 West 36th Street, 11th Floor, New York, NY 10018 or info@skyhorsepublishing.com.

Skyhorse® and Skyhorse Publishing® are registered trademarks of Skyhorse Publishing, Inc.®, a Delaware corporation.

Visit our website at www.skyhorsepublishing.com.

10 9 8 7 6 5 4 3 2 1

Library of Congress Cataloging-in-Publication Data is available on file.

Cover design by Kai Texel
Cover photo credit: Alex Wild

ISBN: 978-1-5107-5857-5
Ebook ISBN: 978-1-5107-6750-8

Printed in China

CONTENTS

FOREWORD

In the 1930s, John Maynard Keynes predicted that, a hundred years in the future, workers would have too much free time on their hands, and that they would need to work no more than fifteen hours per week. I don't think we're going to get there, but advancements in productivity and automation did give us more free time. It also led us to the concept of hobbies, and a renewed interest in objects made by hand in previous eras, which took on the name "folk art." Fly tying has often been called an art, but the creation and recreation of objects in a consistent manner can hardly be treated as art. Folk art, perhaps, or maybe just a craft. Tying flies prior to the decrease in working hours was typically practiced by wealthy dabblers who had time on their hands, or by commercial tyers who made these fishing lures for a living. By the mid- to late-twentieth century, people from all walks of life were tying flies for the pragmatic reason of filling their fly boxes. But, equally important, for constructing objects with their hands that could be then used to catch fish. To me, tying flies is an integral part of my fishing, and if I stopped tying flies I would get much less pleasure in my fishing.

The attempt to make ultrarealistic flies is nothing new. In the nineteenth century, experimenters used materials like fish scales and eel skin and celluloid to make flies more lifelike. The problem with these materials was that they were too stiff and heavy; the resulting flies had no semblance of life and movement, and the fish did not approve. When I was a kid I haunted a local spring-fed pond that was full of small, skinny largemouth bass. I pretended they were trout and they even looked and behaved like trout in that clear water. I remember being excited about a new fly-rod lure I had bought at the hardware store—a grasshopper made of plastic that looked real enough to spring from a blade of grass. But the bass would have no part of it. When I cast it, the bass would sidle up to the fly, stare at it, and then slink away, unconvinced. When I replaced it with a hopper pattern made from feathers and deer hair, the bass would jump on it.

The problem with ultrarealistic flies is that we're trying to convince a fish that our offering is a living, moving creature. Stiff plastics and other materials don't have the whirling movement of hackle around a dry fly that simulates the movement of an insect's twitching legs and fluttering wings. Rigid plastics don't replicate the constant undulations of a mayfly nymph's gills, but ostrich herl and pheasant tail fibers do. I'm not sure what materials are used to construct Fred Hannie's Flier, but I'm willing to bet that a wad of marabou feathers or a hunk of bucktail (or bunches of trimmed synthetic fibers as in Anastasios Papadopoulos's Sea Bream fly) will construct a far more effective fly. But Hannie's fly is absolutely gorgeous—and could almost be called a work of art.

We have so many more interesting materials at our disposal these days that fly tyers can create near-perfect replicas of fish, insects, and crustaceans as *we* see them.

We can also develop flies that look realistic and exhibit the flowing movement of a natural bait. We have better threads, better hooks, access to a wide variety of natural feathers and hairs, but also thousands of different synthetic materials, from thin, flowing nylon and polyester fibers, to tiny strands of mylar, to molded tiny plastic eyes that rival anything a taxidermist would use on a miniature scale. And, with the transfer of knowledge through books and videos, we've just gotten better at building on the concepts used by other fly tyers.

I like to classify the exquisite miniature creatures presented in this book as realistic flies and ultrarealistic flies. Realistic flies that utilize materials to both simulate natural creatures to our eyes and provide enough lifelike movement to the fish are effective fish-catchers. I've used the patterns developed by Oliver Edwards, shown here, for years and have caught many fine trout using them. He blends a realistic profile with mobile materials like ostrich herl and partridge fibers to give the fish what they expect to see. Similarly, other featured tyers like Ola Andersson, James Lund, and Lars Persson develop flies with mobile materials that are slightly impressionistic but realistic enough to fool trout. I have not used their patterns but plan to in the future because I know they'll work. On the other hand, Peter Wigdell's Rubbadubb mayfly imitation, Bill Blackstone's beetle, crayfish, and damselfly imitation or something like Bram van Houten's damselflies are not, in my mind, for fishing and I suspect they were not intended to be fished. However, I can admire them and would frame them in a shadowbox because they are flawless and detailed. I know my fly-tying skills are not up to their level, nor would I have the patience to spend the hours that must have been required to make them.

Fly tying is an endlessly fascinating craft, folk art, or whatever term you choose. I can't wait to see what the future brings. But, for the moment, I'll delight in the photos of these examples shown here and will spend hours trying to determine exactly how they were made.

—TOM ROSENBAUER
PAWLET, VERMONT
2021

PREFACE

As much as I'd like you to believe this book is the result of several years of experience tying realistic flies, those who know me would roll their eyes and say, "pull up your boots, it's getting deep." My skill at prevarication not only precedes me, it follows me. The truth may not set me free, but it will certainly lengthen my leash.

A few years ago, I was talking with my longtime friend Jim Krul, former Executive Director of the Catskill Fly Fishing Center and Museum. In between lie-swapping one-upmanship, I mentioned my idea for a new book. The topic shall remain nameless, because I still think it's a good idea. Jim's advice was he'd rather read about how to watch paint dry. Instead, he proposed a book on realistic fly tying, because, for the most part, previous books were step-by-step volumes featuring only the author's own flies.

A short time later, I needed a photographer whose skill would meet the approval of my editor. Jim suggested I try "one of those bug guys," as Jim put it. He recommended I look into Alex Wild's work—another perfect suggestion.

I suspect I'm on the hook for a fifth of some fancy scotch but, it's well worth it.

So, here it is, Jim. Now that it's done, I think I'll go fishing.

—Tony Lolli
Grantsville, Md
2021

INTRODUCTION

These fish feed on a fly peculiar to the country, which hovers on the river . . .
They (the Macedonians) fasten red wool round a hook, and fix on to the wool
two feathers which grow under a cock's wattles, and which in color are like
wax . . .

—Claudius Aelian (175 CE–235 CE)

Despite its antiquity, the majority of contemporary fly tyers, as well as those in the intervening years, resonate to Roman philosopher Aelian's 1,800-year-old written description of Macedonian fly tying. It is the earliest written record describing how to tie a fly. It expresses the Macedonians' intentions to create imitations of natural insects with which to fool fish. It was no accident that the Macedonian combination of materials and colors proved effective for capturing "the fish with speckled skins." Only trial and error, over many years, could have yielded so successful a fly pattern that it was valued, above all others, for its performance on the Astræus River in today's Northern Greece. While not what we would think of today as realistic, it certainly served its purpose 1,800 years ago, and reflects the essential raison d'être for fly tying ever since.

Subsequent imitative efforts improved with the advent of new techniques and access to innovative materials that paved the way for the art of current-day realistic fly tying. Clearly, this desire for realistic imitations is not a recent phenomenon. In fact, this has been the goal of fly tyers for millennia and was only limited by the materials available through the ages. As such, contemporary fly tyers take their place in the long line of feather-benders extending back into the mist of untold eras. Who, among the Macedonians, could have anticipated the incredible level of detail displayed by the tyers featured in this book?

Despite the absence of other fly-tying writings dated between Aelian's description around 200 CE and German Wolfram von Eschenbach's work in 1200 CE, it seems reasonable that artificial flies probably have been in use in Europe since ancient times. While fly tying probably occurred in several locations, there is no evidence to suggest it had gone extinct, only to be rediscovered at some later time; progress in the art of fly dressing would have been much slower were there not an evolving basis to draw upon. This should not come as a surprise to anyone who is aware of the propensity of contemporary fly tyers to treat their "killer" patterns as secrets, if not proprietary. With a modicum of research, it becomes clear that there is nothing new under the sun and even the most tightly kept secret pattern has already been discovered by another fly tyer.

Realism is a relative and completely subjective term. Between Aelian's time and the twentieth century, anglers focused their efforts on the task of efficiently fooling fish. The more artificials looked like fish prey, the better was a fisher's success. At some point, tyers began to craft more authenticity into their patterns. Some took realism to the max while others used "relative" realism to improve their working flies. There is no fine line between realistic fishing flies and realistic flies as an art form. In fact, some tyers describe their creations as serving both functions. Several of the realistic fly tyers featured later in this book mention the dual purposes in their patterns. For them, the goal is a matter of producing an exact duplication of what the fish are expecting to see while feeding. Imagine the surprise of observers who learn some of these tyers actually fish with their creations.

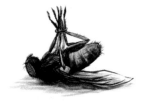

The purpose of this book is twofold: to trace the evolution of realistic fly tying, and to feature the creations of the world's most-skilled practitioners of this art form. Some of these contemporary artisans concentrate on imitations of aquatic insects most likely seen by fish. Their focus is on mayflies, caddisflies and stoneflies. For others, the sky is the limit and they tie replicas of anything, including praying mantis, crabs, bees, hornets, ants, spiders, and fish.

A well-tied fly. *Matt Lolli*

Theirs is a small but expanding cadre of enthusiastic tyers whose work will astonish even those who have never tied a fly. The realism of their fly patterns, whether as an art form destined for framed presentation, or a working fly intended for the end of a fly leader, will amaze.

PART 1
A SHORT DIVERSION

Before a discussion of the foundation of realistic flies, a short diversion into development of the fly fisher's quartet is in order—hooks, lines, rods, and reels—because the improvement of these objects allowed tyers to advance their art of realistic fly tying. Without these improvements, realistic fly tying could not have happened.

HOOKS

The hook, as we know it, was preceded by the invention of the *gorge*, from the French for *throat*. It is a long, thin device, carved from wood, bone, or stone, sharpened at both ends and fastened, off-center, with a length of cord. The availability of an unlimited supply of these materials made the gorge a common tool. Different lengths were designed for different sizes of fish. Once baited and swallowed by a fish, it became stuck in the fish's throat, allowing the angler to pull in the line and capture the fish. One of the earliest types of gorge was discovered in France and is believed to be 7,000 years old. But the gorge has not yet disappeared. Some modern-day survival manuals describe the gorge as a way to fish without proper hooks. Apparently, a tool with a 7,000-year history is not to be disregarded.

The oldest-known fishhook-shaped device is between 22,000 and 23,000 years old. It was found in a seaside cave on Okinawa Island and made from a shell cut into a circular hook shape. As was the case with the gorge, seashells were abundant and free for the taking. Whether it was used with a hand line or rod is unknown. In seafaring communities, it may have been trolled behind a boat or dugout canoe. Although fragile, this device

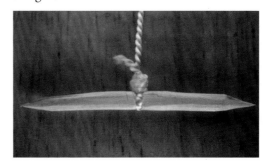

Anglers fashioned inexpensive and easy-to-make wooden gorges in sizes to suit the targeted fish.

was common across many seaside villages. Because of the abundance of hook-making material, their relative fragility was not a major concern.

The First Egyptian Dynasty (3000 BCE) had access to the first bent, barbless, metallic hooks. This period is also known as the Bronze Age (3000 BCE–1200 BCE)

during which smaller hooks began to appear. Around 1200 BCE, as metal-lurgy improved, barbed hooks showed up in Ancient Egypt. And because of their efficiency, anglers used them for thousands of years, although nothing about how to make hooks emerged in print for some time.

A Treatyse of Fishing with an Angle (1496) by Dame Juliana Berners appears to have the first mention of steel hooks, including detailed instructions about making "spade-ended" hooks (angles) from a length of a square needle:

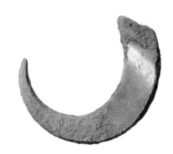

Hooks fashioned from shells resemble more modern hooks. It's believed the angler used a net to secure the fish.

> You shall understand that the subtlest and hardest art in making your tackle is to make your hooks, for the making of which you must have suitable files, thin and sharp and beaten small, a semi-clamp of iron, a bender, a pair of long and sharp tongs, a hard knife, a somewhat thick an anvil and a little hammer. For small fish, make your hooks from the smallest steel needles of square section that you can find, in this way: Put the needle in a red charcoal fire until it is as red as the fire. Then take it out and let it cool, and it will be well enough tempered to be filed. Then raise the barb with your knife, and sharpen the point. Then temper the work again, or it will break in the bending. Then bend it, as in the bend shown in the illustration.

Given the lengthy process described by Berners, one can assume hooks were of great value to those who made their own. The effectiveness of these handmade hooks seems obvious when considering that anglers could have used the simple gorge rather than go through the process described by Berners. Commercially made hooks would not appear for nearly 150 years. There may have been cottage industries providing hooks, but their prices must have been dear, given all the skills required in this handmade process.

Only those serious about fishing would go through the trouble of making hooks as described by Berners.

Although metallic hooks have been around since the Bronze Age, commercial hooks appeared only when steel became commonly available. In 1650, Englishman Charles Kirby started a decades-long trade of quality hooks, and his unusual Kirby bend and offset hook point is still in use today. By 1730, Redditch, England, became the center of hook making in Britain for Kirby's firm as well as many other hook manufacturers.

Today, there are hundreds of commercial hook makers from around the world. In spite of this, a few skilled artisans continue to offer handmade hooks mostly for full-dress salmon fly tyers. Their niche is the recreation of salmon hooks so rare as to be virtually unavailable.

A modern Kirby hook.

LINES

Ancient Egyptian textiles included fibers from palm trees, grass, seeds, sheep's wool, and goat hair. Once textile workers removed fibers from flax, they could spin and weave linen on a loom. Given the availability of these strands, it seems reasonable to assume fishing lines were made of these fibers. However, no written record confirms this conjecture.

Dame Juliana Berners was, once again, the first to write about line making and coloring. She also included an illustration of a tool for forming lines (shown below). Her directives were,

. . . you must learn to make your lines of hair this way. First, you must take, from the tail of a white horse the longest and best hairs you can find; and the longer and rounder it is, the better it is. Divide it into six bunches, and you shall colour every part by itself in a different colour—as yellow, green, brown, tawny, russet, and dusky colours.

Her formulas for dyeing involved ale, alum, dyer's weed and minerals. Once again, in the absence of tackle shops, one either undertook the effort or relied on thievery to provide serviceable lines.

If one has a line, one should know about knots. Berners left nothing to chance and included an illustration for trying the water knot, writing,

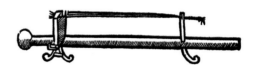

Lines were so difficult to acquire that making one was the only way to go. Berners suggested use of this tool to make a good-quality line.

> Thus you will make your lines fair and fine and also completely secure for any type of fish. And because you should know both the water knot and the duchess knot, behold them here in pictures—tie them in the likeness of the drawing.

Unfortunately for us, the drawings did not survive. A later diagram of a water knot, from the early nineteenth century is shown at right.

Anglers favored braided horsetail hair for both lines and leaders on into the 1700s. Being rot-proof, horsetail hair leaders were valuable, and fathers would pass them on to their sons. The braiding, or twisting process enabled the making of lines equal in length to the rods. With a twelve-foot rod and a line of equal length tied to the tip of the rod (à la tenkara fishing), a fisher could cast his fly twenty-four feet, more than enough distance to fly fish successfully, even by today's standards.

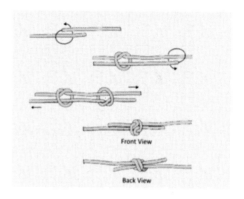

This knot went by many names including the water knot and the angler's knot, from *Kent Coast Sea Fishing Compendium*.

In the early 1800s, line makers began mixing silk with horsehair to strengthen them. By mid-century, line makers had woven hollow-core, oil-soaked silk lines. Such lines needed to be dried after each use to prevent rotting, and this style remained in use for a hundred years. Woven strands of silk gut took over as the leader material of choice. Unfortunately, silk became brittle when dry, so anglers kept their leaders between two layers of damp wool to prevent them from drying out. Preferred leader material changed in 1938 when the DuPont company introduced nylon.

RODS

At some point a light bulb went off in someone's head, and they realized a rod could deliver the fly farther than a hand line. Best of all, rods grew wild everywhere. Every kind of native wood was used in many areas surrounding the Mediterranean Sea and everywhere else angling was practiced. Wood was the most easily available material for crafting a rod. Anglers used whatever was handy. Local wood, however, was too heavy and discarded when lighter woods such as lancewood, greenheart, hazel, willow, and hickory became available.

About 300 CE, jointed rods showed up in Roman times. Apparently, carrying a long rod was too cumbersome and the solution was to create a joint. Early joints were nothing more than flat-tapered intermediate ends of the rod, lashed together at streamside to make a longer tool. Having gone through the trouble of

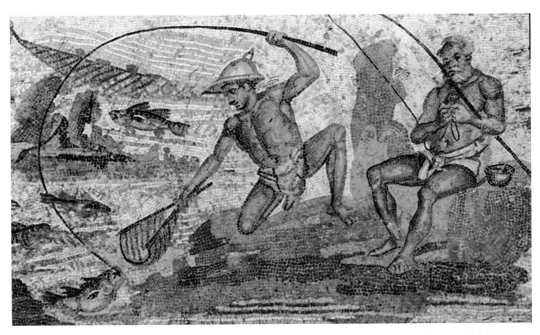

The Romans captured everyday life in their mosaics. Here, the Libyan way of fishing is depicted.

neatly tapering the rod ends, it's unlikely these jointed rods were relegated to the riverside when the fishing was completed. These jointed rods were apparently intended to be stout enough to last.

In *A Treatise of Fishing with an Angle* (1496) Dame Juliana Berners instructed the reader how to make a rod, writing, "And how you should make your rod skillfully, I shall teach you." What followed was her instruction on how to select, cut, dry and shape a rod that looked like a walking staff. She ended her instruction with, "And so you will make yourself a rod so secret that you can walk with it, and no one will know what you are doing." Apparently, then, as now, fly fishers were careful to keep their secret spots close to the vest lest they be followed to their favorite fishing location.

A hundred and fifty years or so later, in the mid–1600s, as fishing became sufficiently popular to create a demand, Scots introduced the commercial production of fishing tackle. As was the case many years before, these rods were formed by shaving tree branches and were tipped with a line of equal length.

The short rod of about three feet, shown in use by Middle Easterners, was in use for a thousand years.

Not only did Berners's rod work well, it also concealed the fact that its bearer was going fishing, something contemporary fly fishers can appreciate.

Two hundred years later, a new material took over and persisted well into the nineteenth century. In the mid–1850s, Samuel Phillippe from Easton, Pennsylvania, created a fly rod made of six bamboo strips. The attraction of bamboo was its lighter weight and ability to recover after being bent during the casting motion.

The cross section of a
split-bamboo rod.

**Samuel Phillippe, father of the
bamboo rod.**

Others experimented with cane rods of four or eight segments, but the six-segment rod proved to be the most efficient design, and continues to be handcrafted today.

Soon, bamboo rods were being made on both sides of the Atlantic and they remained the material of choice far into the twentieth century. Steel rods held sway for a short time, but disappeared when synthetic materials took over due to lower cost and ease of manufacture.

Today, bamboo, or cane rods, are held in high esteem by many anglers. The romance of a well-crafted rod is alive and well in countries around the world. The skills required to fashion a cane rod are practiced by contemporary cane rod makers. Clubs, similar to guilds or unions, exist around the world to preserve and promote the skills of cane rod making.

REELS

The earliest written record of the fishing reel comes from a fourth-century Chinese work, *Lives of Famous Immortals*. However, the earliest *illustration* of a fishing reel comes from a Chinese painting called "Angler on a Wintry Lake" (1195 CE). It shows a man sitting on a small boat while casting his fishing line. His reel is well depicted. Anglers realized the importance of a reel because an angler could lengthen his line to meet varying exigencies.

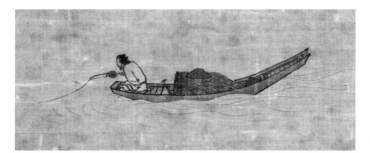

**"Angler on a Wintry Lake," circa 1195 CE, was the first-
known image of a fisherman using a reel.**

Dame Juliana Berners's *A Treatise of Fishing with an Angle* (1496), among the first fly-fishing texts, had no mention of a reel. The line was simply tied to the tip of the rod as shown in her drawing of a fly fisher, below.

A total of only five fishing reel images were seen before 1651. That year, Thomas Barker wrote *The Art of Angling*, in which he mentioned, but did not illustrate, a winde (reel):

> The manner of his Trouting was, with a Hazel Rod of twelve foot long, with a Ring of Wyre in the top of his Rod, for his line to runne thorow: within two foot of the bottome of the Rod there was a hole made, for to put in a winde, to turn with a barrell, to gather up his Line, and loose at his pleasure; this was his manner of Trouting.

These earliest reels were made of wood, again, because it was easily available. Because a wooden reel was easily shaped into the necessary form, anglers could make their own. And being easily made, there was no need to visit a reel-making specialist. Early reels were not much more than a device for holding extra line when the extra length of line was not needed. Soon, the use of a reel increased because anglers discovered they could make longer casts by pulling extra line off the reel and shooting it during the cast. No longer were they limited to the combined length of their rod and same-length line. By pulling more line off their winches, and holding it in reserve, they could use the casting motion of the rod to throw the reserve line out beyond the length of the rod.

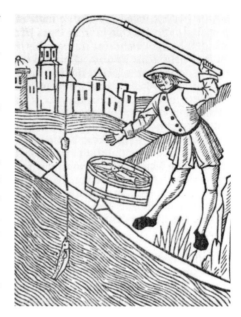

This woodcut shows use of a rod with the line tied to the top of the rod. The angler appears also to be using a float, or strike indicator, in today's jargon.

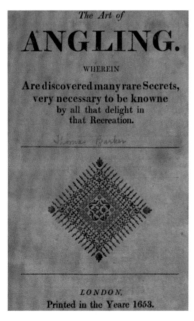

Title page from the 1653 edition of Barker's *The Art of Angling*.

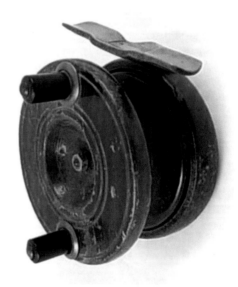

A wooden reel with brass fittings probably more advanced than the one described in Barker's *The Art of Angling*.

Narrow brass reels, called "winches" were being produced by the late eighteenth century. To meet the increased demand, clock makers and jewelers made and sold winches, since they already had the requisite metalworking tools and skills to perform the necessary operations involved in reel making.

Charles F. Orvis designed, patented, and distributed a ventilated fly reel in 1874. Interestingly, he and his brother, Franklin, started out as hoteliers in the Manchester, Vermont, area. Charles built his own rods for himself and friends. With the hotel tourist trade came an opportunity to sell rods to visitors. So successful was this trade that Charles opened a shop next to his brother's hotel. Word of mouth increased demand to such an extent that, in 1861, Charles began selling his rods by mail in what can be described as the first commercial catalog in the United States.

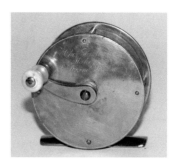

Early brass reels had solid spools and side plates, making them heavy.

Having presented a quick sketch of how the tools of the trade developed over the years, it's time to return to the focus of this book: the evolution of realistic fly tying.

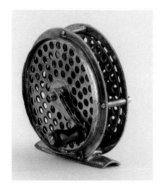

Charles F. Orvis's original 1874 reel, with ventilated spool and side plate, set the benchmark for modern reels. Charles held the first patent for a fly reel, number 150,883.

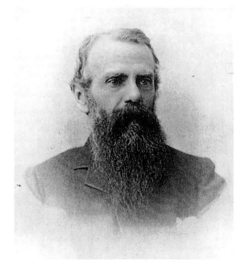

Charles F. Orvis. A man of high expectations, Charles was unsatisfied with the lack of consistent material lists for fashioning popular fly patterns. His only daughter, Mary Orvis Marbury, made her daddy happy when she published *Favorite Flies and Their Histories* (1892), the reference standard for flies in that era.

PART 2
A BRIEF HISTORICAL OVERVIEW OF FLY FISHING AND TYING

It is the constant—or inconstant—change, the infinite variety in fly fishing that binds us fast. It is impossible to grow weary of a sport that is never the same on any two days of the year.

—Theodore Gordon

But for fly fishing, there would be no need for fly tying, and vice versa. Each relies on the other. As Aristotle said, "The whole is greater than the sum of its parts." While we can be fairly sure he was not referring to fly fishing, even though Egyptian fly fishing and fly tying preceded Aristotle by at least 1,800 years, the concept of synergy applies. So, where does the record of fly fishing begin?

It shouldn't come as a surprise that fly fishing has been around for a long time. After all, what method could be simpler? Other means, like spin fishing and bait casting, require mechanical equipment not available until very recently. But, when all you have is a rod, a line, and a hook, fly fishing seems to fit the bill, as it has for millennia.

ANCIENT EGYPT

William Radcliff, in his *Fishing from the Earliest Times* (1921), credits P.E. Newberry with the discovery of this depiction from the Beni Hasan era, circa 2000 BCE. The two central Egyptian figures in the panel appear to be fishing with a hand line and fishing with a rod and line. The lower drawing shows a seated figure, perhaps a nobleperson, also engaged in fishing with a rod, line, and what appears to be a fly, circa 1400 BCE.

An unanswered question remains; why fish in this manner when baskets and nets, also shown in the drawing, could surely be more efficient? A possible explanation comes from the success of the Egyptian culture. Ponds were formed alongside the Nile River so that when the river flooded, fish would find shelter in the ponds and be trapped there when the river receded. This provided for the easy capture of fresh fish for many months.

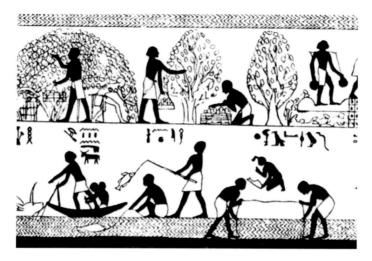

The lower level of this Beni Hasan era (2,000 BCE) engraving shows one fisher with a hand line, a second with a rod and line, and others with a net.

While the first engraving appears to show workers fishing, this seated figure (circa 1,400 BCE) has the appearance of a nobleperson fishing with a fly.

Due to the advent of farming, aquaculture, and agriculture, free time was created for all classes of Egyptians. This was reflected in many forms of recreation. Fishing with a spear was a form of survival while fishing with a rod and line defined an angler. Fishing was but one of many sports and games in Egyptian life. It's not unreasonable to conclude fishing with a rod and line was fun: something contemporary fly fishers will attest to.

THE ROMAN ERA

Claudius Aelian's sixteen-volume *De Natura Animalium* (On the Characteristics of Animals) also includes a portrayal of how the Macedonians fished. The entire quotation seldom appears in print but is included here to set Aelian's description of fly tying in its larger context: fly fishing.

I have heard of a Macedonian way of catching fish, and it is this: between Bercea and Thessalonica runs a river called the Astræus, and in it there are fish with speckled skins; what the natives of the country

call them you had better ask the Macedonians. These fish feed on a fly peculiar to the country, which hovers on the river. It is not like flies found elsewhere, nor does it resemble a wasp in appearance, nor in shape would one justly describe it as a midge or a bee, yet it has something of each of these. In boldness it is like a fly, in size you might call it a midge, it imitates the color of a wasp, and it hums like a bee. The natives generally call it the Hippouros.

These flies seek their food over the river, but do not escape the observation of the fish swimming below. When then the fish observes a fly on the surface, it swims quietly up, afraid to stir the water above, lest it should scare away its prey; then coming up by its shadow, it opens its mouth gently and gulps down the fly, like a wolf carrying off a sheep from the fold or an eagle a goose from the farmyard; having done this it goes below the rippling water.

Now though the fishermen know of this, they do not use these (natural) flies at all for bait for fish; for if a man's hand touch them, they lose their natural colour, their wings wither, and they become unfit food for the fish. For this reason they have nothing to do with them, hating them for their bad character; but they have planned a snare for the fish, and get the better of them by their fisherman's craft.

They fasten red (crimson red) wool round a hook, and fix on to the wool two feathers which grow under a cock's wattles, and which in colour are like wax. Their rod is six feet long, and their line is the same length. Then they throw their snare, and the fish, attracted and maddened by the colour, comes straight at it, thinking from the pretty sight to get a dainty mouthful; when, however, it opens its jaws, it is caught by the hook and enjoys a bitter repast, a captive.

This quote appears in *Fishing from the Earliest Times* by William Radcliffe (1921) and he in turn credits the translation of Aelian's work to Mr. O. Lambert in his *Angling Literature in England* (1881). Although not a complete explanation of the fly's construction, in the larger context it is clear the Macedonians' intent was to create a credible imitation. The reason, of course, was to catch more fish. The Macedonians understood the fish "preferred" a lure tied with red wool and wax-colored feathers for those times when the hatch was on.

This notion of "matching the hatch" is familiar to present-day fly fishers and has been adopted by countless contemporary fly-tying writers. Indeed, every fly fisher worth his or her salt takes time to look for which insect is on the water before selecting a dry fly lest s/he waste the limited time during which the fish will be rising to the natural insect. Although we do not know what insect the Macedonians were imitating—some suspect it was a horsefly, a drone, or dragonfly—it matters not. The Macedonians' experience and observations were enough to guarantee this imitation's success.

THE DARK AGES

In early thirteenth-century Germany, documents (but not yet books) described how to dress *vederangle* or "feathered hooks" (Wolfram von Eschenbach, 1210). A rational guess is that trout and grayling flies came to England with the Normans between the twelfth and fifteenth centuries. The 1066 Norman Conquest resulted in more than political and

Although Aelian was Roman, he preferred to write in Greek. This title page is from a much later reprint of his work.

social changes. It seems probable to have also paved the way for the British fly-fishing tradition. And, this tradition, in turn, influenced fly fishing around the world (Gordon M. Wickstrom, *The History of Fishing for Trout with Artificial Flies in Britain and America: A Chronology of Five Hundred Years, 1496 to 2000.*)

THE RENAISSANCE

An interesting unearthing in the history of fly tying in print relates to the 2016 discovery of a book published between Aelian's (200 CE) and the oft-cited *Treatyse of Fishing with an Angle* (1496) by Dame Juliana Berners. The *Haslinger Breviary* by Leonardus Haslinger, now in Yale University's collection of rare books, dates to between 1452 and 1462. This time estimate places its publication at more than 1,300 years *after* Aelian's work and thirty years *before* Berners's. This also suggests there was sufficient interest in fly fishing to make the

Discovered in 2016, *The Haslinger Breviary* was written thirty years before Dame Juliana Berners's *Treatyse of Fishing with an Angle* and lends credence to the possibility that Berners's tome borrowed from an earlier work. That both writers should claim to be of the clergy seems too much a coincidence.

compilation worthwhile. Haslinger was a priest near the River Traun, a pre-alpine tributary of the Danube still known for its trout and grayling. It is likely the *Breviary* reflects his firsthand experiences on the Traun. How else could he have written so much detail about the skills required for fly fishing?

Of particular interest in this Austrian tome are his instructions advising "how one should bind hooks." Haslinger's twenty patterns constitute the earliest-recognized compilation of fly patterns. Haslinger presented them in order by month of their use but noted only "feather," "silk," and "other" materials in his description for creating each of his twenty patterns. This approach appears to be the first hatch chart for helping anglers know what hatches to expect through the year. For example, the first October pattern recommends a "pale 'mousey colored' feather," "white and red silk," and "gold breast" feather. Not much by way of instruction, but apparently, sufficient for those who could read at that time.

It is unreasonable to think the absence of subsequent transcriptions between 200 CE and 1210 CE meant fly fishing was suspended. No doubt, the art of fly tying advanced even though there is, thus far, no known written account.

The next appearance of fly-tying writing was Dame Juliana Berners's *Treatyse of Fishing with an Angle* (1496). Her work is perhaps among the most-recognized, if unread, title by contemporary fly fishers. There

**By following Haslinger's "hatch chart," an angler
could know what insects might be seen during each
month through the fishing season.**

is some controversy about whether it was written by a woman and whether or not it was borrowed from an earlier (Haslinger?) text. Regardless, *Treatyse of Fishing with an Angle* has always been of special importance to fly fishers as an early account of the art even if has not been read by many contemporary fly fishers.

It was definitely written by someone intimate with fishing as evidenced by the descriptions of how sections of a rod were joined and spliced with metal ferrules, how horsehair lines should be dyed according to the color of the water, and techniques for catching several fish species. Without a doubt, this was a person with considerable experience. Was she a nun? Was she a woman? Was this all a marketing ploy to sell more books? Who knows? But, there can be no doubt as to the expertise reflected in Berners's writing.

Berners offers a narrative describing twelve flies, presented according to the month of their use, just as Haslinger did. Coincidence? She writes, "The Flies: These are the twelve flies with which you shall angle for the trout and grayling and dub them like you will now here me tell . . . In the beginning of May, a good fly, the body of reddened wool and lapped about with black silk, the wings, of the drake and red capon's hackle."

Nothing here can be considered realistic, but instead, effective. It's interesting to note that her use of the word "dub," familiar to all fly tyers, from Old English, means to dress or adorn.

1653

Perhaps the most-recognized angling title is Izaak Walton's *The Compleat Angler* (1653). More than simply a practical fishing guidebook, it was also a guide for enjoying the outdoors and its abundance. This orientation is similar to today's description of fly fishing as "the contemplative sport," one in which the larger experience of nature is important.

Among his quotes on the larger experience were the following:

> Rivers and the inhabitants of the watery element are made for wise men to contemplate, and for fools to pass by without consideration.
>
> You will find angling to be like the virtue of humility, which has a calmness of spirit and a world of other blessings attending upon it.
>
> We may say of angling as Dr. Boteler said of strawberries: "Doubtless God could have made a better berry, but doubtless God never did;" and so, if I might be judge, God never did make a more calm, quiet, innocent recreation than angling.

Walton made his start as a metal manufacturer but soon left that business to concentrate on fishing and literature. For the next forty years he lived the life of a fishing bum in Hampshire and fished the area's celebrated chalk streams.

Walton's advice for fly tying:

> First for a *May-flie*, you may make his body with greenish coloured crewel, or willow colour; darkning it in most places, with waxed silk, or rib'd with a black hare, or some of them rib'd with silver thred; and such wings for the colour as you see the flie to have at that season; nay at that very day on the water.

Walton's original title page from the 1653 first edition.

An engraving from Walton's *The Compleat Angler*.

Here, Walton's intent seems to be similar to that explained in Aelian's description; the fly should mimic the color of the natural insects seen on the water "that very day." His writing comes a little closer to realistic tying, but still not too close.

1662

Sooner or later someone would contest the wisdom of earlier writers. *The Experienced Angler or Angling Improved* by Colonel Robert Venables challenged some tenets of earlier authors when he wrote, "But I must here beg leave to dissent from the opinion of such who assign a certain fly to each month, whereas I am certain . . . therefore all I can say as to time is, that your own observation must be your best instructor." In other words, although you may have flies dressed in accordance with what the "experts" suggest, your observations will determine which fly should be used. Presumably, the closer your imitation is to the natural, the better your results. Perhaps this was a rogue idea at a time when the experts were declaring which fly for which month. But, as is the case today, observation will lead one to the most effective pattern.

Chapter 3, "Of the Artifical Fly," gives extensive instruction on tying flies. Regarding the task of naming or illustrating flies, he writes

> Therefore, except some one that hath skill, would paint them, I can neither well give their names nor describe them, without too much trouble and prolixity . . . let him make one as like it as possibly he can, in colour, shape, proportion; and for his better imitation let him lay the natural fly before him. All this premised and considered, let him go on to make his fly, which according to my own practice I thus advise.

His comment regarding the importance of someone with skill who could illustrate the flies foretold the contributions of writers who would follow many years later and implied the importance of such illustration, as well. His advice regarding "colour, shape, proportion" while closer to realistic tying than was Walton's, was still not as close as what we find in contemporary flies.

Many anglers found Venables's advice practical, and his book went through many reprints.

1776

Richard Brookes, an English physician, wrote about surgery, medicine, geography, and natural history. His work *The Art of Angling in Two Parts* (1776) was among the first to give extensive attention to fly tying and materials, devoting twenty-six pages to these topics (pages 54–80).

Brookes wanted anglers to take advantage of his experience and wrote, "In making artificial dub-flies, chiefly observe and imitate the belly of the fly; for that the fish most take notice of, as being most in their sight . . ." His admonition, like that of Venables more than a hundred years before, was to observe and then imitate. His advice that the belly of the natural insect determined what color to use for the dubbing makes sense, considering the belly is what the fish sees when a dry fly floats overhead. Brookes was

the first to mention this, although it seems likely someone, sooner or later, would have figured it out. We're better fly fishers for his suggestion.

Brooks advised attention to materials:

> Seal's fur is to be had at the Trunk-makers; get this also dyed of the Colors of Crows and Calves Hair, in all the different shades, from the light to the darkest brown . . . A piece of old Turkey carpet will furnish excellent Dubbing . . . Get also Furs of the following Animals, vis. The Squirrel . . . Fox-Cub, Otter-Cub . . . All these, and almost every other Kind of Fur, are easily got at the Furriers.

The only source Brookes missed was roadkill. However, the lack of motorcars probably accounts for the absence of this source.

Birds also received attention, as they were important for his patterns. Among the species Brookes suggested for feathers were: wild mallard, partridge, cock pheasant, blackbird, starling, jay, coot, plover, peacock, ostrich, and many others. Certainly, those tyers who followed his advice would be well prepared to imitate any natural they might observe. Nothing, however, is mentioned regarding a fisher's wife's reaction to having so many dead birds at hand.

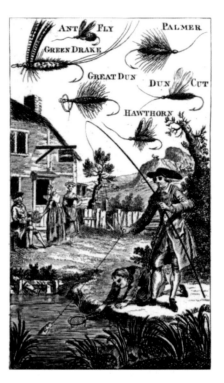

A Brookes engraving depicting angling and several types of flies.

1792

Charles Bowlker's *The Art of Angling* (1792) offered the following advice in his Preface: "Never regard what bunglers and slovens tell you, but believe that neatness in your tackle, and a nice and curious hand in all your work are absolutely necessary." Bunglers and slovens? This sounds like the advice of someone who had been disappointed by the guidance of self-proclaimed experts. Advice, as essential today, as it was in 1792. Apparently, there was an abundance of "bunglers and slovens" afoot in the land in the 1790s, and Bowlker must have been aware of their poor advice. Far be it for me to suggest "bunglers and slovens" still roam the world of fly tying, however, online videos often suggest this may, in fact, be the case.

Bowlker gave a list of twenty-one recommended flies, by the season of their appearance, and includes his detailed instruction for "The Manner of Making the Artificial Fly."

Bowlker wrote, for example, "then taking as much feather as is necessary for the wings, lay it as even as you can upon the upper side of the shank, with the butt end of the feather downwards, toward the bend of the hook, and tie it fast three or four times with the silk, and fasten it; then, with a needle or pin, divide the wings as equal as you can . . ." This approach of detailed instruction would be copied

The title page from the 1854 edition.

120 ART OF ANGLING.

MARCH BROWN.—No. 3.

About the middle of March this very excellent fly makes its appearance, and continues till the end of April. The wings are upright, and made of a feather from a pheasant's wing, or a dark mottled feather from the tail of a partridge; the body of fur from a hare's ear, mixed with squirrel's fur, and ribbed up with yellow silk, or hare's fur, mixed with a little yellow worsted; a partridge's or grizzled cock's hackle for legs; and two fibres of the feather which compose the wings to form the tail; the hook No. 7 or 8. This fly may be used with great success in warm gloomy days, from eleven o'clock till three; and when the Brown fly is on the water the fish will refuse all other kinds. There cannot be too much said in commendation of this fly, both for its duration, and the extraordinary sport it affords the angler. A reduced fly, of the same form and materials, will be found very killing in the month of August.

Bowlker's recipe for his March Brown.

RED FLY.

THIS Fly comes down about the middle of February, and continues till the latter end of March. He is made artificially of a dark drake's feather, the body of the red part of of a squirrel's fur, with the red hackle of a cock wrapt twice or thrice under the butt of the wing; has four wings, and generally flutters on the surface of the water, which tempts the fish, and makes them take him the more eagerly. The size of the hook, No. 6.

Bowlker's instructions for a Red Fly.

by many writers in the future as a means to create flies imitative of natural insects. Closer to realistic fly tying but still not there.

THE NINETEENTH CENTURY

This century saw a proliferation of instructional fly-fishing and fly-tying books. Among the notable publications was Alfred Ronalds's *The Fly-Fisher's Entomology* (1836).

DIRECTIONS FOR MAKING, TYING, OR DRESSING THE ARTIFICIAL FLY.

After having enumerated the materials for making the artificial fly, we will proceed to give directions for its formation. Whether a common hackle or winged fly is to be manufactured, it is invariably necessary to have the whole of the materials in readiness previous to commencing operations; viz. the hackles stripped of the soft fibres which grow near the quill; the gut carefully selected and examined; the dubbing mixed to the exact colour of the body of the natural fly; the silk, of the same colour as the body, well waxed; and the hooks properly selected in point of size.

Bowlker's advice for fly tying.

THE

FLY-FISHER'S ENTOMOLOGY

WITH COLOURED REPRESENTATIONS OF
THE NATURAL AND ARTIFICIAL INSECT, AND A FEW
OBSERVATIONS AND INSTRUCTIONS ON

TROUT AND GRAYLING FISHING

BY ALFRED RONALDS

With Twenty Coloured Plates

NINTH EDITION

Title page from the ninth edition.

TROUT

GRAYLING

A sumptuous color plate from *The Fly-Fisher's Entomology*.

Ronalds was the first to provide detailed instruction *and* drawings of both the natural insect as well as their respective imitation. In doing so, he fulfilled Colonel Robert Venables's 1662 lament for illustration in fly tying. This approach made a giant step toward the goal of realistic fly tying, albeit in tying fishing flies rather than the art form as shown in this book.

Ronalds did not intend to be seen as an expert. In his preface he wrote,

> The Author of this little work entreats that it may considered and judged of as the labour, or rather the amusement, of an amateur; whose chief object has been to facilitate to the Tyro in the art, the making and choice of artificial flies, on a plan of elucidation derived from personal experience.

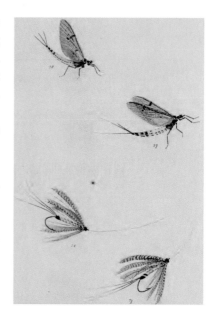

Ronalds's illustration depicting natural insects and their imitations.

Perhaps a too-modest statement given the major leap Ronalds provided in the instruction of fly-tying skills:

> Many books, after trying to tell us how to make a fly, very justly add, that the art cannot be communicated by writing, the practice must be seen. We shall follow the fasion by way of furnishing a few hints for those who are unable to meet with a friend to direct them.

Ronalds went on to write,

> Having himself sorely felt the inadequacy of mere verbal instructions to enable him to imitate the natural fly correctly, or even approximately, and the little utility of graphical illustrations unaccompanied by the prinicpal requisite, vis. colour, he has been induced to paint both the natural and artificial

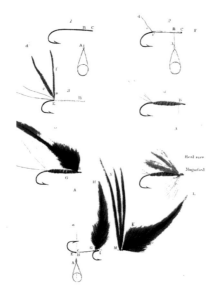

Illustration of using tools and feathers from *The Fly-Fisher's Entomology*.

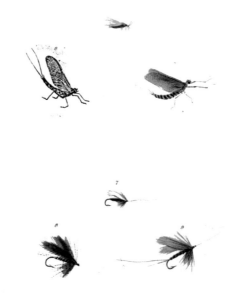

Ronalds's natural flies and imitations.

fly from nature, to etch them with his own hand, and to colour, or superintend to colouring of each particular impression.

As can be seen from these selected examples, early writers of fly-tying instruction chose to give freely their acquired knowledge of skills necessary for the craft. This willingness to promote the art of fly tying is as true now as it was in the past. Attend any fly-tying show and you will find contemporary realistic fly tyers feely giving advice to everyone who asks for direction.

Those well versed in the history of fly tying may shake their heads at the paucity of nineteenth-century reference works cited here. However, including all references is not the focus of this book. Rather, our intent is to connect the dots between practices described 1,800 years ago by Aelian and those of contemporary realistic fly tyers.

Part 3
Louis John Rhead
(1857–1926)

Fly making gives us a new sense, almost. We are constantly on the lookout, and view everything with added interest. Possibly we may turn it into a bug of some kind.

—Theodore Gordon

Louis John Rhead was born in England in 1857 and studied art the National Art Training School in London and in Paris. He emigrated to the United States at the age of twenty-four. He deserves special attention for his important contributions to realistic fly tying. Most people know Rhead as the preeminent American book illustrator. Between 1902 and 1926, his work brought to life the stories told in *Treasure Island*, *Robin Hood*, *Swiss Family Robinson*, *Robinson Crusoe*, *The Deerslayer*, *Kidnapped*, *Arabian Nights*, *Heidi*, and many others.

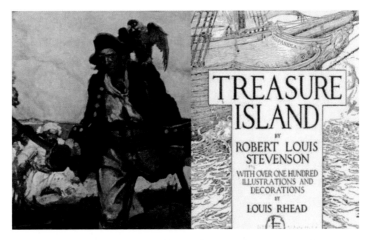

Rhead's illustration for Robert Louis Stevenson's
Treasure Island.

He was also a fly fisher, having "caught the bug," according to Rhead, in the late 1890s. By the early 1900s his interest turned to angling art, and he wrote several books and many magazine articles.

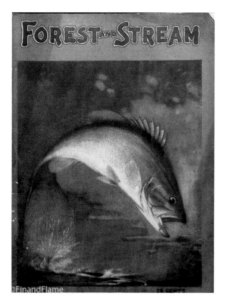

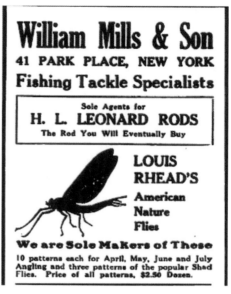

One of many covers Rhead painted
for *Forest and Stream* magazine.

1920 Mills & Son catalog for
Rhead's flies.

Rhead was also a tackle dealer and sold his own line of flies. Many were sold through the Mills & Son catalog as well as in **Forest and Stream** magazine ads.

Later in his career, Rhead also sold lures through
Forest and Stream magazine.

Rhead is best remembered by fly fishers for his *American Trout-Stream Insects: A Guide to Angling Flies and Other Aquatic Insects Alluring to Trout* (1916), one of the earliest and most comprehensive studies of stream entomology ever published. Finally, fly fishers had an entomological reference book unlike anything that came before. Not until color photography could another book come close to presenting the detail of both natural and imitative flies.

In it, Rhead wrote, "In this volume I propose to describe and picture in colors a selected number of the most abundant and most common insects that trout feed upon in a typical American stream, and to show,

side by side with these correct artificial imitation flies tied by my own hands, in the order that anglers may better understand how to choose their own flies and thus be enabled to lure fish with greater success and pleasure than heretofore."

To say he accomplished this intent would be an understatement. Whereas Ronalds was an amateur illustrator, Rhead was a professional. His work raised the bar for all fly-tying literature that would follow. By writing, "tied by my own hands" Rhead gave encouragement to all tyers that they, too, could accomplish Rhead's level of realism in fly tying.

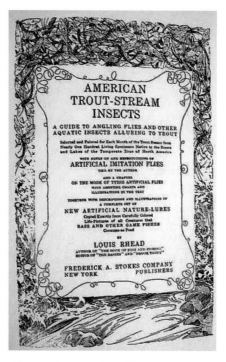

The predecessor for all contemporary fly-tying books.

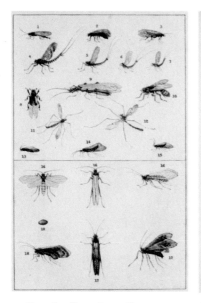

For the first time, fly tyers could see color pictures of natural insects.

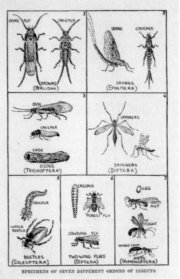

Rhead organized insect types in this illustration.

Rhead was committed to teaching neophyte tyers. He wrote, "Only the most salient points, condensed and briefly told, will be required for the beginner to get an insight of the art; the method is best learned by practice and experience." He goes on to write about the importance of "neatness, solidity, strength, and artistic finish by the use of the tying silk and in the winding up or finishing knot." His style of encouragement, as well as his skill at illustration, was intended to convey all he had learned to the reader and to demystify the little-known art of fly tying. Rhead had suggestions for materials and their collection:

There are two ways to gather a collection of feathers, viz: to buy them, and to beg them. . . . You can buttonhole every poultry-man, hunter, furrier, and taxidermist of your acquaintance for assistance; and in that way you are more likely to get choice varieties and colors not available in the market at any price.

Still no reference to roadkill. But, I digress.

Regarding learning the required process, Rhead suggested, "The amateur must first understand that in the making of artificial flies the method of procedure varies considerably with each individual. Most of the

Rhead's artful depiction of the craft.

amateurs claim their method is the only right one." Even though Rhead was writing the most detailed book on the subject, he was committed to having new tyers learn by doing and to develop their own techniques. This notion of unique technique development will be seen in the work of the international realistic fly tyers featured later in this book.

His instructions as to technique were detailed and complete, right down to the tyer's recommended manicure:

> The thumb and forefinger nails of both hands should be long enough to pick up readily small single hooks, then bristles, and delicate wisks used for tails. You will save a good deal of trouble by discarding the use of tweezers every time you pick up objects. . . . The silk must always be wound and pulled as tight as you dare without having a break.

Rhead's instructions for tying specific patterns were detailed and left nothing to the tyer's imagination. His was a complete tutorial, well thought out and executed with proficiency never before seen. It could only be bettered when photography became commonly used in the printing of fly-tying books.

EXPERT DRY FLY-CASTING ON THE STREAM
(Pencil Portrait of Mr. George La Branche)

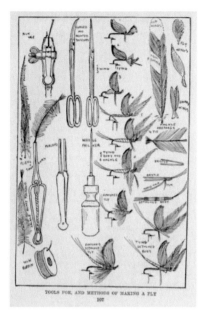

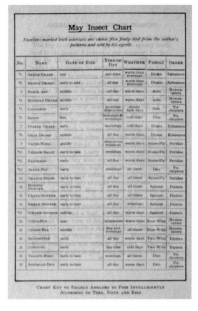

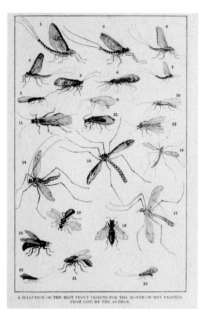

Rhead's May hatch list.

Color plate of naturals expected
in May.

This groundbreaking publication marked the first time fly tyers could observe accurate color drawings of important aquatic insects with which to guide their fly tying. Rhead further assisted his readers by giving lengthy instructions and illustrations of the imitations he recommended. *American Trout-Stream Insects* was the prototype for all fly-tying pattern books that would follow.

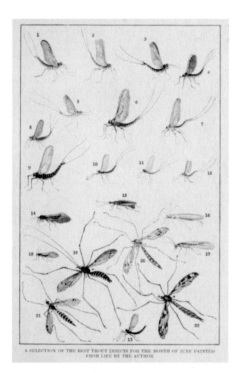

Rhead's June hatch list.

Color plate of June streamside insects.

Why would Rhead give so much attention to natural insects when so many other fishing flies already existed? He explained it this way,

> It is incomprehensible British and American fly-makers in recent years have gone out of their way to tie "fancy" flies when the natural insects are so beautiful in form and color; so varied, so graceful, that if they are copied true, fancy flies are exceedingly commonplace when they are put side by side.

Imagine how pleased he would have been had he been able to see the work of today's realistic fly tyers.

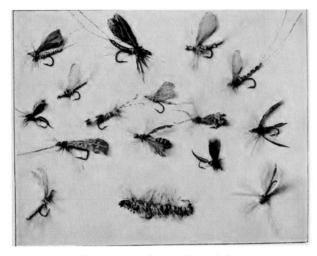

Illustration of Rhead's tied flies.

Rhead's **New York Times** obituary on 29th July, 1926 read:

LOUIS RHEAD, ARTIST AND ANGLER, DEAD. Exhausted Recently by Long Struggle in Capturing a Thirty-Pound Turtle.

About two weeks ago Mr. Rhead set out to catch a turtle weighing thirty pounds which had been devastating trout ponds on his place, Seven Oaks. After the turtle was hooked, it put up a fight for more than half an hour. Although Mr. Rhead was successful in the end, he became exhausted. A short time later he suffered from his first attack of heart disease. Yesterday's was his second.

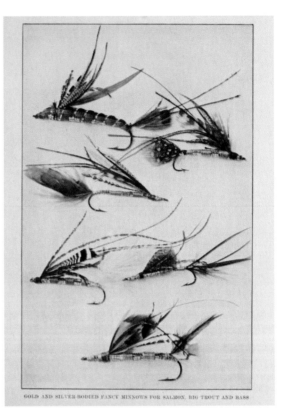

GOLD AND SILVER-BODIED FANCY MINNOWS FOR SALMON, BIG TROUT AND BASS

Rhead's work was not limited to insects. He also tied flies for salmon and bass.

Rhead in his studio, circa 1920.

PART 4
PIONEERS OF CONTEMPORARY REALISTIC FLY TYING

Thus far we've seen most of the chronological history of realism in the fly tyer's art. The final stage is to close the distance between Louis Rhead (1920s) and the tyers featured in part 5. Fortunately, we have the recollections of two contemporary pioneers to fill this time line. One, Oliver Edwards, reflects on the experience of tyers from the United Kingdom. The other, Bill Blackstone, tells us about the early work of American realistic tyers.

OLIVER EDWARDS

Fly Tiers of the UK have never gone down the road of realistic fly tying, nor are they ever likely to. I'm talking about fly tying as seen from the vise of New Jersey's Bill Logan. That is to say, tying insects with incredible detail: mouthparts on stone fly nymphs, for instance.

But, we have two exceptions. First is Paul Whillock's book, *Flies as Art*. What a book! Never mind the flies, his illustrative artwork is quite incredible! Bill Logan beware. Even if you never tie a fishing fly, anyone, simply anyone, ought to have this book. It makes the illustrations in my book, *Masterclass*, look like children's scribbling.

The other is Paul Little. Paul specializes in fully dressed salmon flies. His mentor is the American salmon fly dresser Marvin Nolte of Wyoming. Paul would never admit this but for a good while now his fully dressed salmon flies have been no different from those of his American master. Paul Little is in my opinion a true artist with silk, fur, and feather.

I have been accused of tying "realistics," which is nothing short of laughable. At best, my creations are what Dave Whitlock would call "super impressionistic."

Here in the UK, the emphasis has been catching fish to eat. And from a fly-fishing point of view, the UK can best be described as trout fishing on the southern chalk streams. The rest of the UK (rain-fed freestoners) where, to a large extent, the many authors either offered little wordage or their patterns were just completely ignored.

For instance, an early Wharfedale river keeper and Beck River watcher, William Lister, had a comprehensive list of lethal patterns for the trout and grayling of

Wharfedale. This diary is dated 1712 yet inside it clearly states his book (diary) 1724. But remember, he was little more than a farm laborer and little better than illiterate.

Lister was but one of several "Dales" fly tyers who brought forward trout and grayling flies for the growing number of fly fishers with a family to feed. But remember, at that time *all* rivers ran free of organochloride pesticide residue, so fish were very safe to eat.

Following Lister were several other river keepers and beck watchers who also added their two penn'orth. We even have a John Thomas Chippendale, a near relative of the world famous "Dales" cabinetmaker, with his own fly collection.

The freestone rivers of the Yorkshire "Dales" were perfect for these soft-hackled spiders, and many are still in use today, still bearing their quaint names. We are very proud of our river trout fishing history.

A note to all who may have a yearning for fishing history: A very fine book appeared in 2015, *The North Country Fly* by Robert L. Smith. It is an inch-thick tome of great interest and essential reading for fly fishers of any persuasion (Coch-Y-Bonddu Books).

The chalk streams were made famous by Frederic M. Halford and his followers, who allegedly put fly fishing on the map. Halford, it seems, was on to something new and different and was quickly taken up by the aristocratic toffs. He quickly saw the niche writing for his now famous and expensive books. Halford was a wealthy London solicitor, so could easily afford the coach ride from London to Hampshire.

However, the dry flies were, by today's standards, rubbish. They were top-heavy, bad floaters, and far, far from realistic. But remember, these flies were absolute groundbreakers.

BILL BLACKSTONE

As fly tying became the "thing to do" in the 1950s, I began to see patterns that were becoming popular that were headed in the direction of realism.

The first patterns I saw were by Bill Blades. A friend shared them with me, and I was awestruck. Here was a guy tying flies more realistic than I had ever seen. My concern was not to copy Blades, but I continued to work on my own with available material.

I met Paul Jorgensen early in the 1970s. Paul was writing books and showing the world some new methods and materials. On his talk circuit, he visited with me in California. I kept him up almost all night showing him my work and discussing my choice of synthetic materials and how they filled my needs. It was through his interest and kindness that I kept pursuing realism. He later corresponded with several requests for materials and techniques which indicated I had at least "arrived"!

Along the way, I was asked to participate in *Art of the Trout Fly* by Judith Dunham (1988). This was a chance to join other realistic tyers and show my progress such as Bob Mead and his praying mantis and John Betts and his realistic bugs. This publication was loaded with the finest tyers of the day. Though miles apart, I began to communicate with some. Bob Mead was instantly helpful and encouraging, which spurred me to continue pressing the envelope. I cannot thank them enough for their help and interest: This is so important to anyone who is experimenting or pioneering.

As I look at fly-tying patterns today, I would like to think I had a small influence on the use of materials other than feathers and fur. It was through the encouragement of other tyers working at realism that I feel that I am one of them. These pioneers are responsible for the advancement of the craft and the materials used to create it.

PART 5
TODAY'S REALISTIC FLY TYERS

I look into . . . my fly box, and think about all the elements I should consider in choosing the perfect fly: water temperature, what stage of development the bugs are in, what the fish are eating right now. Then I remember what a guide told me: "Ninety percent of what a trout eats is brown and fuzzy and about five-eighths of an inch long."

—Allison Moir, *Love the Man, Love the Fly Rod*

Allison Moir's comment notwithstanding, today's realistic fly tyers are concerned with exact specifications of shape, size, color, and anatomical details. "Close enough" is not in their lexicon. They dream of entomology textbooks, digital calipers, and the latest wonder fibers from many sources. What follows is proof of their devotedness to this art form, whether "show" flies or fishing flies. While only a few can fully understand what it takes to carry off these attempts, the rest of us can marvel at their successes.

As will be seen, there is no distinct boundary between fishing flies, realistic fishing flies and realistic art flies. The only person who can define the intended function is the creator of each of the following patterns. Some realistic tyers fish with their creations because it brings them joy. Others house their creations in shadow boxes or presentation glass domes so that other people can enjoy them. Still others prefer the whimsy of unexpected creations. Thanks to the contributions of the men and women featured here, we can enjoy the first collection of the work of more than thirty realistic tyers from around the world.

Many techniques and materials are shared by every type of tying. These common materials and techniques can be thought of as a collective starting point. Here, the commonalities end and individual differences emerge as the creative skills of each tyer produces a unique pattern never before seen.

As you view the individual images of realistic flies, you'll notice a materials list for each pattern. The materials lists are included as a substitute for step-by-step instructions. To include tying instructions for patterns that may require one hundred hours is beyond the scope of this book. Those wishing to learn realistic tying skills should contact these tyers for possible learning opportunities.

A few of these crafters limit their creations to natural fibers. Others will use

whatever synthetic best meets their artistic needs. The widely held belief is that synthetic, or man-made, fibers began sometime between World War I and World War II. The truth is much more interesting. A Swiss-born chemist named Audemars was granted the first patent for "artificial silk" in the 1800s. His fabric was made from the bark of mulberry trees. There might be a question as to the "synthetic" nature of this fiber due to its plant-based origin. But, the product required human intervention to change the nature of tree bark into something silklike.

Around this same time, Sir Joseph Swan created rayon using a process similar to Audemars. In 1894, French engineer Hilaire de Chardonnet, a French engineer, built the first plant producing artificial silk. In 1935 DuPont Chemicals invented nylon. Ever since shortly before World War II, and continuing into the present day, thousands of additional synthetic materials became available to the general public, as well as to realistic fly tyers. The following images demonstrate how well these materials have been employed to create this incredible art form.

OLA ANDERSSON, SWEDEN

I live in a small village north of Falun, Sweden, population eleven. It's me, my family of three and a few others. That's it. It's peaceful, for sure!

For as long as I can remember, fishing has been a big part of my life. I got started because my friend, Klas, was into it. It became natural for me to tag along. The importance of fishing in my life just kept growing, and by my mid-teens I took up fly fishing and fly tying. Of course, I sucked at both at the start but kept at it (and by now I'm pretty good at it).

What really kick-started my tying was the birth of my son. Okay, not the birth part, because it was terrifying but the paternity leave was the ticket. If you don't know, a small child sleeps a few hours every day and what else is there to do but tie a fly, or twenty, while he's asleep? And so, I got a two-hour tying break every day for nine months. That, and Oliver Edwards (YouTube) really kicked me into gear. Oliver is, by the way, my number one inspiration. His realistic patterns really opened my eyes to tying possibilities.

When I tie flies, I don't look at existing patterns. I look first at the specific insect and then tie a bug that resembles it. Not necessarily an exact copy but a bug that can be passed off as the real deal. I fish these insect copies on a short-line upstream nymph rig. You can call it Czechnymph or Euronymph or whatever you like. I sure don't know what name to use, but fish seem to dig them.

In this kind of fishing, realistic patterns show their greatness. Fishing realistics in fast-moving water is very effective, because fish don't get a long look at their food. They must quickly decide if it's food or not or at least look like something that might be edible or tasty. If you offer a bug that's got the main features of a real bug, the fish are feeding on at the time, they will have a taste.

I see the future for my realistic fly tying going in two directions. The first is that I need to work on my focus. I tend to not try enough. This might sound weird, but rarely do I have a plan for what I tie, and almost never do I give it my best. I may have some kind of ADHD; ideas just pop into my head but the concentration and stamina to complete them is a bit off. The second direction is to work on realistic fishable stones, BWOs and Ephemera nymphs to use on my Euro rig. I think I've got the caddis world covered, but stones and mayflies still need some work.

Blackhead Pupa—Ola Andersson

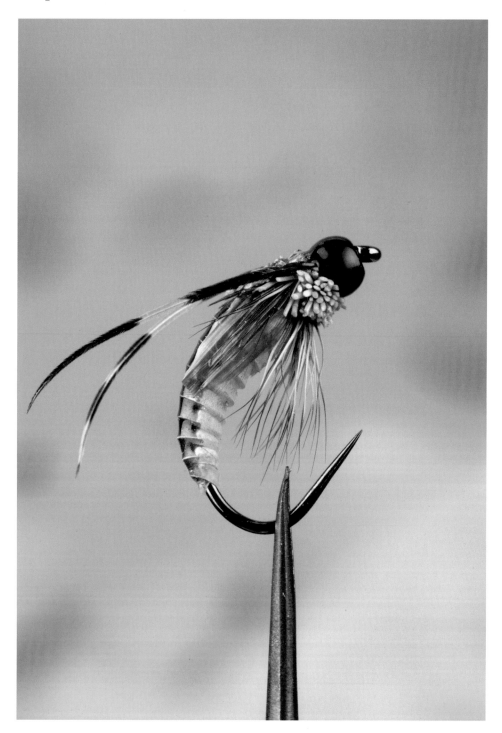

Hook: Hanak Competition 310, size 12, **Thread:** FTS, 12/0, **Body:** Natural latex, **Thorax:** Deer hair, **Wing Abutment:** Swiss straw, **Bead:** Hanak Competition Classic, fluoro black, **Antennae:** Golden pheasant tail fibers.

Natural Pupa—Ola Andersson

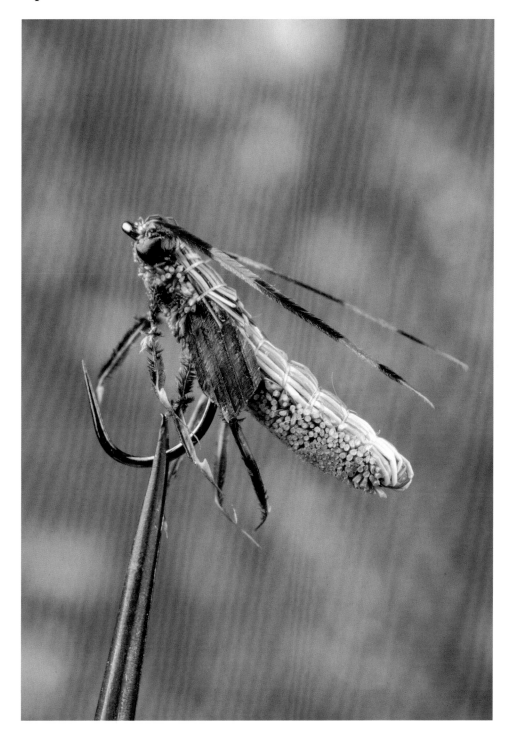

Hook: Hanak Competition 390, size 14, **Thread:** Semperfli Nano Silk, 18/0, **Body (Extended):** Moose mane and deer hair, **Thorax:** Roe deer, **Wing Abutment:** Turkey, **Eyes:** FTS Melteyes, black, **Antennae:** Golden pheasant tail fibers, **Legs:** Golden pheasant tail fibers.

Pepper Caddis—Ola Andersson

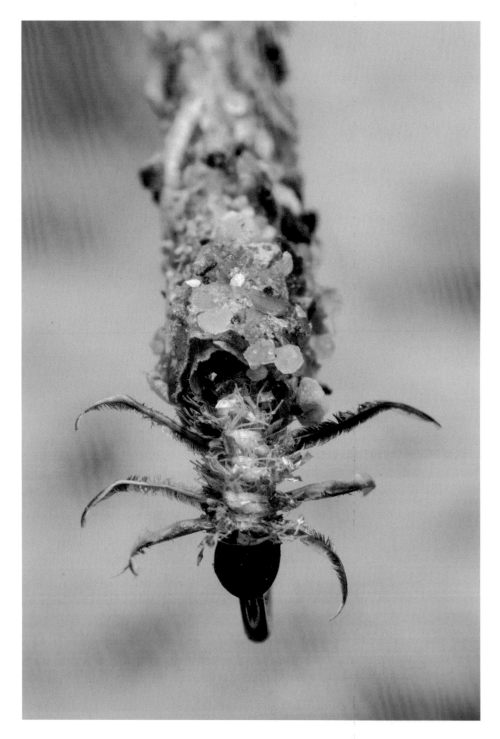

Hook: Hanak Competition 970, size 10, **Thread:** FTS, size 12/0, **Case:** Gulff Flexman UV resin with pepper and spice as building material, **Body:** Hends Micro chenille, **Legs:** Golden pheasant tail fibers, **Head:** Gulff Black Magic UV resin.

Latex Larva—Ola Andersson

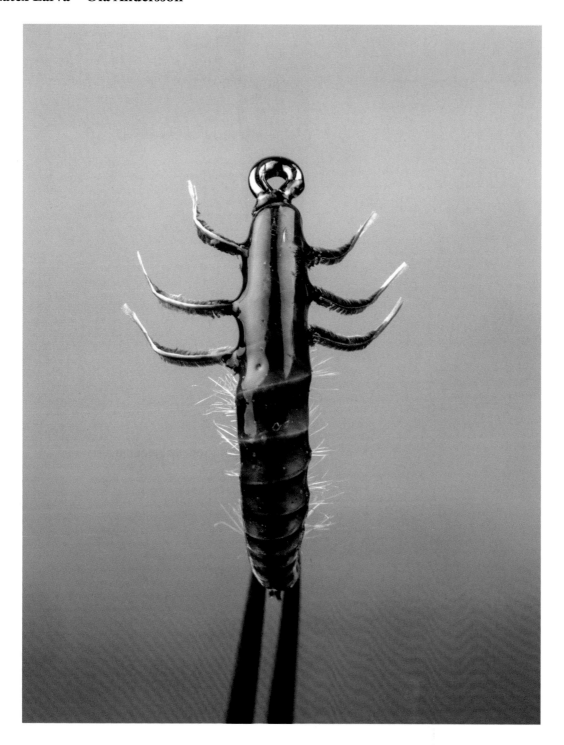

Hook: Hanak Competition 310, size 12, **Thread:** Semperfli Nano Silk, 18/0, **Body:** Natural latex, top colored with Gulff Black Magic UV resin, **Gills:** Ostrich, **Legs:** Golden pheasant tail fibers.

Rope Cased Caddis—Ola Andersson

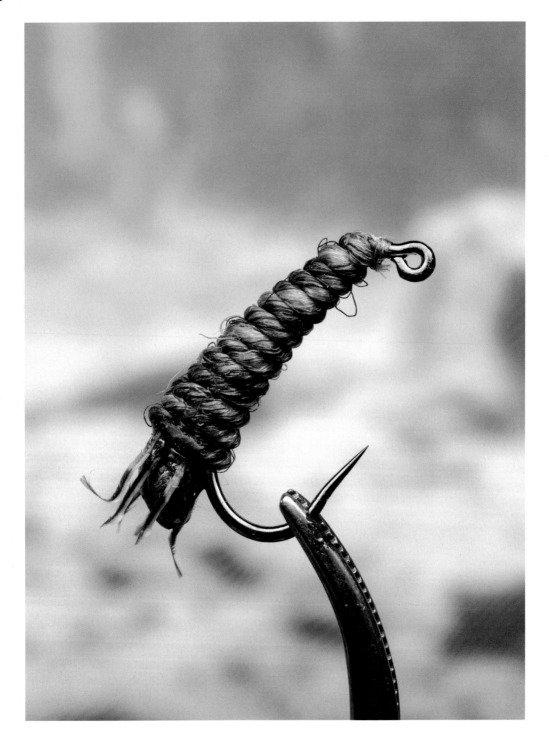

Hook: Hanak Competition 470, size 10, **Thread:** FTS, size 12/0, **Bead:** Hanak Competition Body+, 3.7 mm
Case: Antron yarn twisted hard and wrapped backward, **Legs:** Golden pheasant tail fibers.

Stone Fly—Ola Andersson

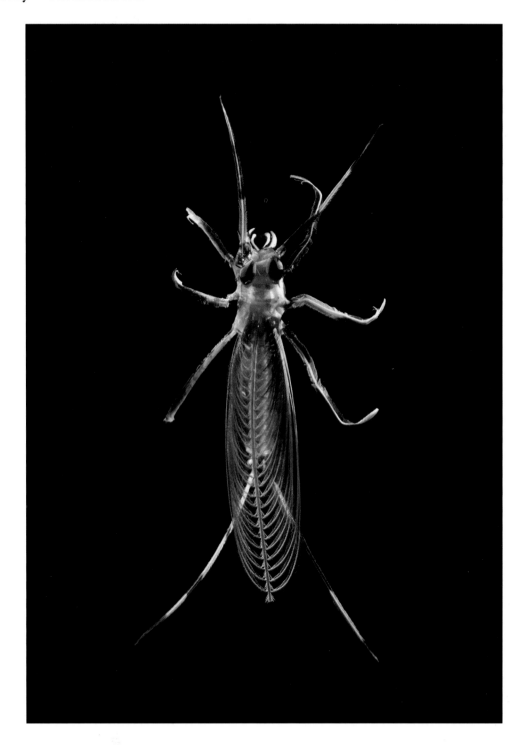

Hook: Hanak Competition 280, size 10, **Thread:** FTS, size 12/0, **Tail:** Golden pheasant tail fibers, **Body:** Latex, **Thorax:** Gulff Nymph Brown UV resin, **Wing:** Hackle with fibers stroked forward, **Legs:** Golden pheasant tail fibers, **Eyes:** Gulff Black Magic UV resin.

Latex Mayfly—Ola Andersson

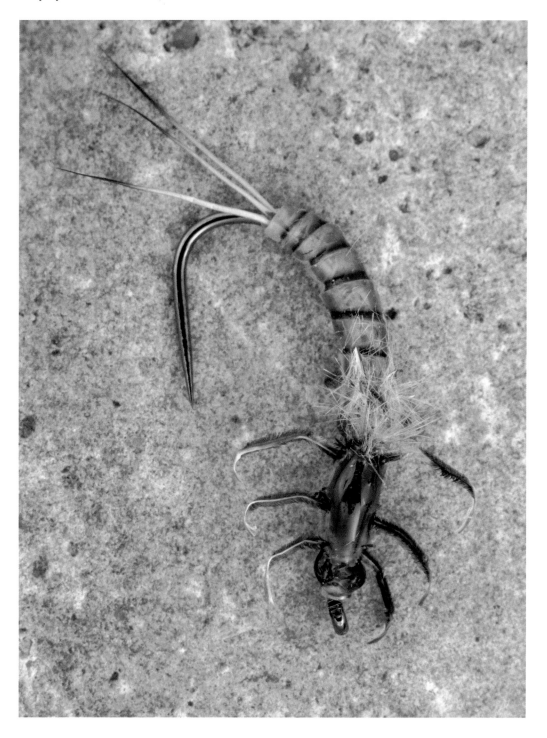

Hook: Hanak Competition 360, size 10, **Thread:** FTS, size 12/0, **Tail:** Moose mane, **Body/Thorax:** Latex painted with Gulff Black Magic and Nymph Brown UV resin, **Gills:** Ostrich, **Legs:** Golden pheasant tail fibers, **Eyes:** Gulff Black Magic UV resin.

Latex Stone—Ola Andersson

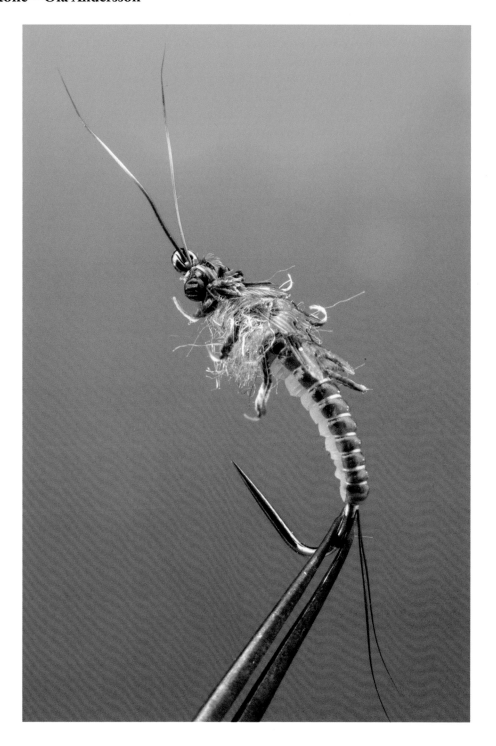

Hook: Hanak Competition 360, size 8, **Thread:** FTS, size 12/0, **Body:** Latex and Sybai Body Stretch, **Thorax:** Synthetic dubbing, **Wing Abutment:** Hackle with Gulff Nymph Brown UV resin, **Legs:** Golden pheasant tail fibers, **Antennae/Tail:** Moose mane, **Eyes:** FTS Melteyes.

LEE BARBEE, ELIZABETHTON, TENNESSEE

I became involved with fly fishing and fly tying through Project Healing Waters Fly Fishing. PHWFF gave me a newfound passion while I was still in the U.S. Army. I was medically retired, and love to help others with fly tying and fly fishing. I have been tying flies for about four and a half years. I tie at The Fly Fishing Show in different locations, the Sowbug Roundup, and the International Sportsmen's Expo.

I got into realistic tying by looking up to those who inspired and helped mentor me. People such as Bob Mead, Bill Blackstone, Bruce Corwin, Peder Wigdell, and Karen Royer inspired me to try realistic flies. I now pursue getting more flawless and realistic fishing flies out of my fly tying.

Caddis Pupa—Lee Barbee

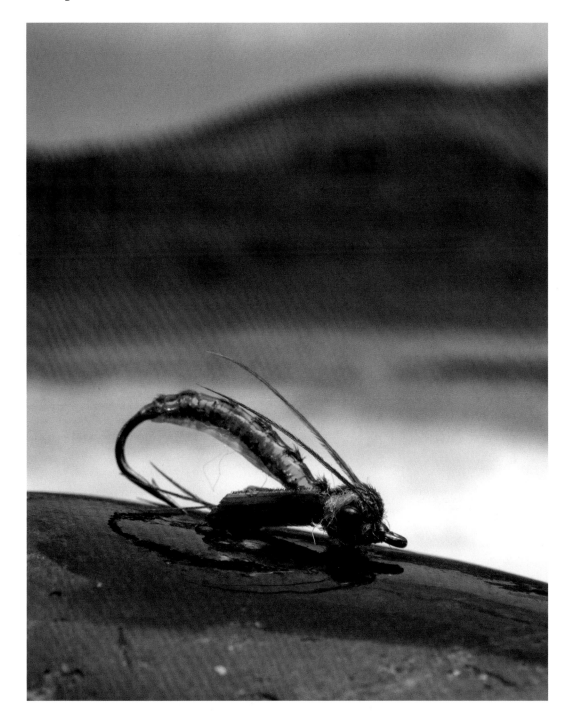

Hook: Partridge K12ST, bent near the eye, **Thread:** Semperfli Nano Silk, 18/0, **Eyes:** Burned monofilament with Solarez Bone Dry Black, **Underbody:** Semperfli Pearl tinsel, **Body:** Latex, colored with Solarez Fl. Green, **Dorsal line:** Semperfli Pheasant Tail, **Legs:** Semperfli Pheasant Tail Fibers, **Wings:** Cinnamon turkey flat fibers with Solarez Bone Dry, **Head:** Semperfli Olive dubbing, **Antennae:** Semperfli pheasant tail fibers.

Dun Mayfly—Lee Barbee

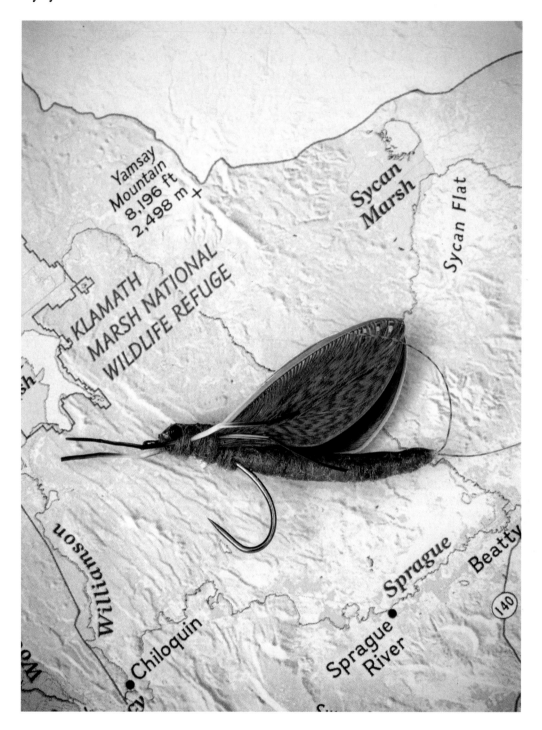

Hook: Partridge 15BNY, size 8, **Thread:** Semperfli Nano Silk, 18/0, **Eyes:** Burned monofilament, **Tail:** Dun mallard flank, **Extended Body:** Semperfli Adams Gray dubbing with silicone, **Thorax:** Semperfli Adams Gray dubbing, **Backing:** Solarez Thin and Solarez Chocolate brown, **Origami Wings:** Dun Mallard Flank, **Legs:** Nature's Spirit Peccary.

BILL BLACKSTONE, CALIFORNIA

My first experience with realistic tying occurred years ago while fishing. As I was tying a new fly on, a mayfly lit on my finger. My questions began when I noted the difference between my fly and the natural. My fly was not even close, yet it was catching fish. Later, at the vise, the idea of tying something new presented itself. I probably should have stopped right there. Up to that point every fly I tied had followed a strict set of guidelines. It was pure "rote" and no fun. This all changed the minute I struck out on my own, and the excitement has never been greater. Now my flies come with no instructions, just plenty of trial and error. The rewards are great, and living in a fishless area also gives me time to work, think, and try new patterns.

Bill Blackstone is a fly tyer who specializes in realistic flies. He lives in California and travels to other areas for shows where he displays his amazing creations. He is the sixteenth recipient of the International Federation of Fly Fishers' Buz Buszek Fly Tying Award, the most prestigious award in the world of fly tying. He is a member of the Sespe Fly Fishers, a group of dedicated fly fishers and fly tyers with a common interest in conservation, education, and fellowship. He is also a member of the Fly Fishers Club of Orange County.

(Author's Note: You will find Bill Blackstone mentioned by many featured tyers in this book. As a pioneer in realistic fly tying, his contributions encouraged many to participate in this art form. It is appropriate that Bill's work should appear here.)

Hopper—Bill Blackstone

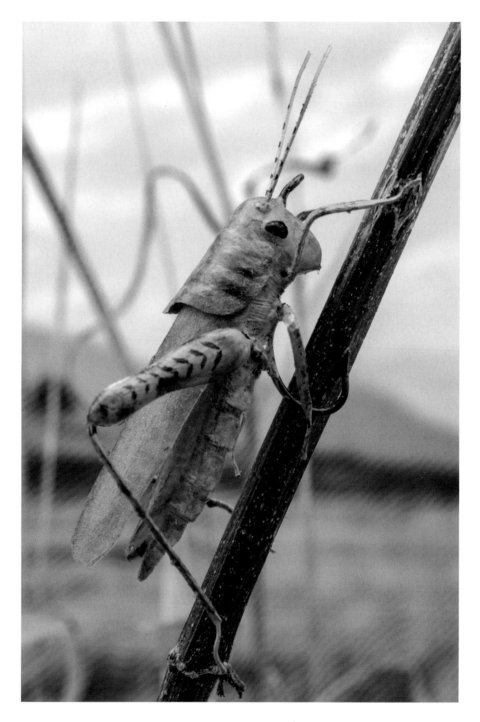

Hook: Mustad 9672, size 10, **Thread:** Danville 6/0 primrose, **Body and Head:** Carved basswood, **Legs:** Plastic grocery twist-ons, trimmed, **Kickers:** Plastic grocery twist-ons, trimmed with hot glue forming upper leg, **Wing:** Plastic sheeting, **Headcap:** Plastic sheeting, **Antennae:** 15-pound monofilament, tapered, **Finish:** Paint and stain.

Crab—Bill Blackstone

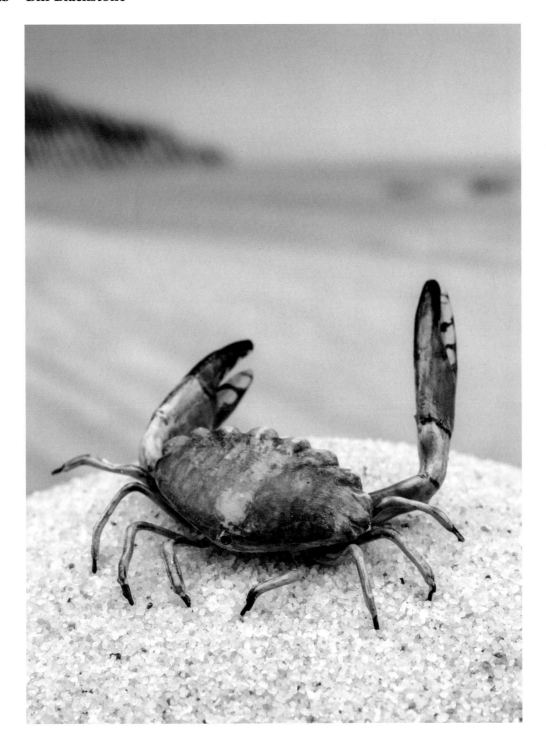

This is a tube fly. A leader is threaded through, and a hook is tied on.
Body: Shaped basswood, **Legs:** Plastic grocery twist-ons, **Claw legs:** Hot glue over wire base, **Claws:** Carved basswood epoxied to wire, **Finish:** Paint, stain, and lacquer combination.

Small Adult Stone Fly—Bill Blackstone

Hook: Mustad 79580, size 12, 4x long, **Thread:** Danville 6/0 primrose, **Tail:** 15-pound monofilament, tapered, **Body:** Tan Larva Lace foam, **Legs:** 9mm black strand from monofilament rope tweaked to shape, **Wing:** 9 mil plastic sheeting, etched, **Eyes:** Singed 20-pound monofilament, **Feelers:** 8-pound monofilament, tapered, **Pronatum Cap:** Trimmed artificial fingernail, **Finish:** Paint and lacquer combined with permanent marker.

Large Beetle—Bill Blackstone

Hook: Mustad 9762, size 10, **Thread:** Danville 6/0 primrose, **Body:** Rear body carved basswood with tag glues to basswood for mounting to hook, **Thorax and rear body cover:** Trimmed artificial fingernail pieces cut to shape, **Antennae:** 12-pound monofilament, tapered, **Legs:** Plastic grocery twist-ons trimmed to shape, **Finish:** Paint, stain, and lacquer combination.

Small Beetle—Bill Blackstone

Hook: Mustad 9672 size 12, **Thread:** Danville 6/0 primrose, **Body:** Molded hot glue placed on fabric base, trimmed warp threads used to tie on hook, **Legs:** 9mm black mono strand from rope tweaked into desired positions, **Thorax and Head:** Closed-cell foam strip, **Final finish:** Paint and lacquer antennae tapered #10 mono.

Blue Damselfly—Bill Blackstone

Hook: Mustad 9174 size 12 (short hook), **Thread:** Danville 6/0 white, **Rear body:** #15 linen line painted blue, **Thorax:** Poly yarn to match body color, **Legs:** 9mm black mono strand from mono rope tweaked to shape, **Wings:** 8mm acetate, etched and folded, **Eyes:** #20 mono singed, **Finish:** Paint and stain.

Crayfish—Bill Blackstone

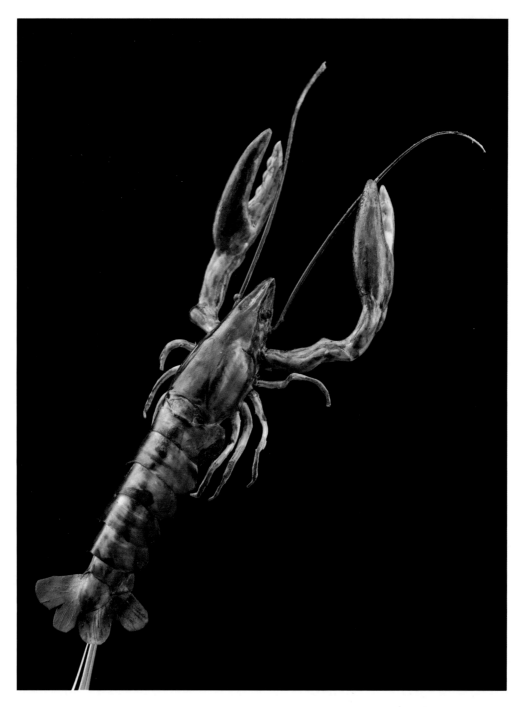

This is a tube fly. A leader is threaded through, and a hook is tied on.
Thread: Danville 6/0, Tube: Brass ⅛-inch, slightly bent, **Underbody:** Tan wool yarn covered with 4mil plastic, **Head:** Basswood, **Scales:** Semi-hard plastic cut into overlapping scale shapes, **Legs:** Plastic grocery twist-ons trimmed to shape, **Eyes:** Singed 80-pound monofilament, **Antennae:** 50-pound monofilament, tapered, **Claws:** Carved basswood, **Claw arms:** Hot glue over a wire base, **Finish:** Paint, stain, and lacquer.

Shrimp (saltwater)—Bill Blackstone

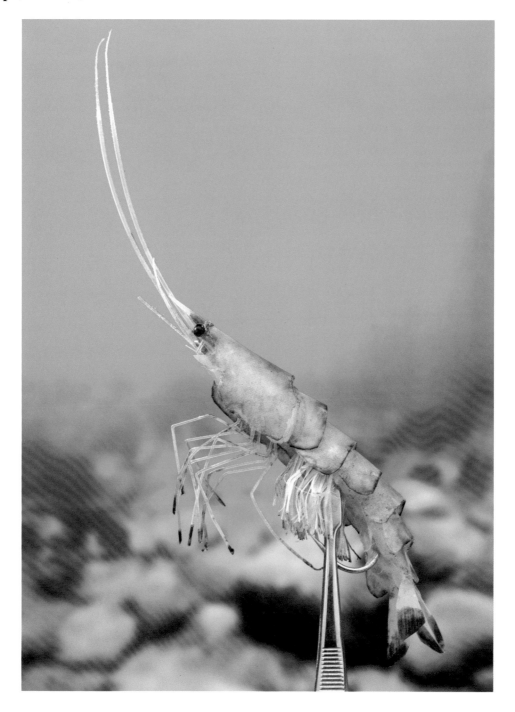

Hook: Mustad 66N, size 6, **Thread:** Danville 6/0, white, **Underbody:** ¼-inch silk grosgrain ribbon, **Rear legs:** Tiedown cord strands from Home Depot, **Front legs:** Eight pieces of 35-pound monofilament with tapered ends tied and looped over body, **Scales and tail:** Precut and pre-sized shapes starting at tail and ending in head cap with snout and beak, **Antennae:** 40-pound monofilament, tapered, **Eyes:** 80-pound monofilament, singed. Body is filled with clear silicone and wedged into a tapered jig until dry.

Black Stone Fly Nymph—Bill Blackstone

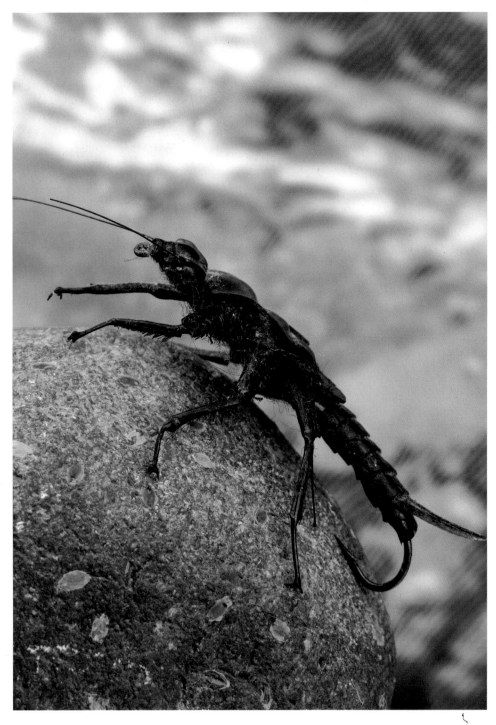

Hook: Mustad 3301-A, size 6. Hook has pre-shaped body of epoxy and precut form, **Tail:** Plastic tapered forms from artificial flower center, **Body:** 8mm black vinyl tape used in pipe industry, **Wing pads:** Same as body, **Legs:** Grocery twist-ons painted black and trimmed, **Leg hair:** Trimmed ostrich, **Eyes:** 30-pound monofilament, singed, **Head:** Same as body, **Antennae:** 15-pound monofilament, tapered, **Dubbing:** Black mohair.

Black Stone Fly Adult—Bill Blackstone

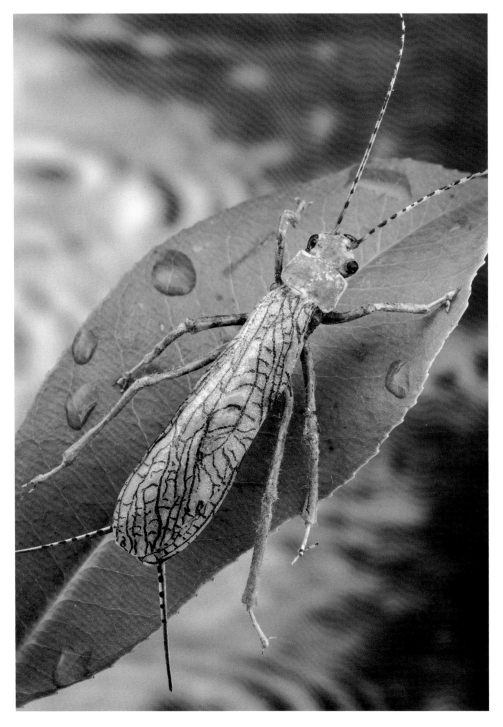

Hook: Mustad 79580, size 8, **Thread:** Danville 6/0 primrose yellow, **Tail:** 20-pound monofilament tapered, **Rear body:** Basswood, **Legs:** Grocery twist-ons trimmed to desired length, **Claw:** 6/0 black thread, **Thorax:** Dyed muskrat, **Head:** Closed-cell foam, **Wing:** Etched 15mil acetate, **Antennae:** 15-pound monofilament, tapered, **Forward body cover:** Artificial fingernail, **Finish:** Paint, stain, lacquer, permanent marker for details.

EUGENE BOROVIN, RUSSIA

I come from the city of Belorechensk, which is in the south of Russia. I have been fond of fishing for a long time. From an early age I have loved to "throw in the rod." I started fly fishing in 2016. I remember how, while away on a working trip, I accidentally stumbled upon a video about casting. Upon my arrival home I decided to get a starter kit. It all began with the most primitive Indian vise and an inexpensive rod.

I practiced every day, learning from various YouTube videos and, of course, before too long, progress was apparent. However, I did not stop there. I wanted to achieve more. So, I came to the creation of realistic flies, which I consider a special kind of art.

Caddis Pupa—Eugene Borovin

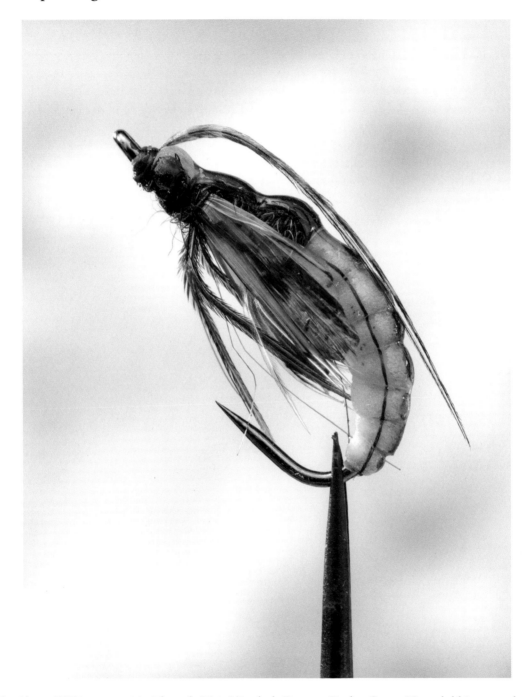

Hook: Ahrex FW521, size 10, **Thread:** Uni 8/0, dark Brown, **Body:** Green Hare dubbing as a base with Virtual Nymph Skin translucent 4.5 mm plus Veevus A11 16/0 (dark brown) thread for each side plus Veevus A02 16/0 (white) as a ribbing, **Thorax:** Kaufmann SLF dubbing, brown stone color, **Back:** Virtual Nymph Skin translucent 4.5 mm, **Legs: Short legs:** partridge fibers; **Long legs:** pheasant tail fibers, **Wing:** Swiss straw, **Eyes:** Burned line under UV resin Gulff Black Magic, **Horns:** Bronze mallard fibers, **Back:** Coated with Gulff UV resin, Amber, **Top of body:** Coated with Gulff Thinman UV resin and brown marker.

DIEGO BOSELLO, VICENZA, ITALY

Diego was born in 1962 in Rovigo, a small town in northeastern Italy. At the age of six, he started to be interested in fishing thanks to his uncle, who used to bring him fishing. Since then, Diego made fishing his biggest hobby. He used to go fishing as much as he could, discovering early his passion for fly fishing and exploring some of the most beautiful rivers in Italy and Europe.

It was 1985 when he first met his mentor Francesco Palu, who was one of the most important fly tyers and fly-fishing experts at that time. Diego was really impressed by him, so he started to develop this big passion and dedication for fly tying, starting to tie flies both for friends and for himself. Day by day, studying techniques and new approaches, always inspired by his mentor Palu, he improved his ability to reproduce flies. For more than thirty years, Diego has dedicated most of his free time to increasing his knowledge about fly tying and trying to develop his own personal technique.

He uses a variety of natural plumage and hair, giving them new colors and vitality, and creating something original and as realistic as possible, paying attention to the shape and the dimensions of the insects that he wants to reproduce. In particular, Diego focuses on the abdomen of the insects using peccary hair.

Since 2018, some of his creations, have been displayed at the Catskill Fly Fishing Center and Museum in Livingstone Manor, New York. Diego always creates his flies in the Italian Style, invented by his mentor Francesco Palu.

Rhithrogena—Diego Bosello

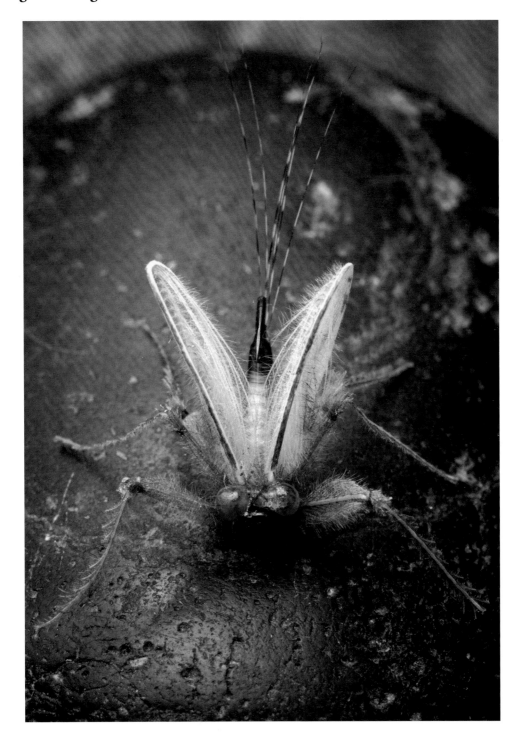

Hook: Knapek, size 14, **Thread:** Ultra, 70 d, **Body:** Peccary, **Tiny paws:** CDC, **Wings:** CDC, **Tails:** Coq de Leon.

Epeorus—Diego Bosello

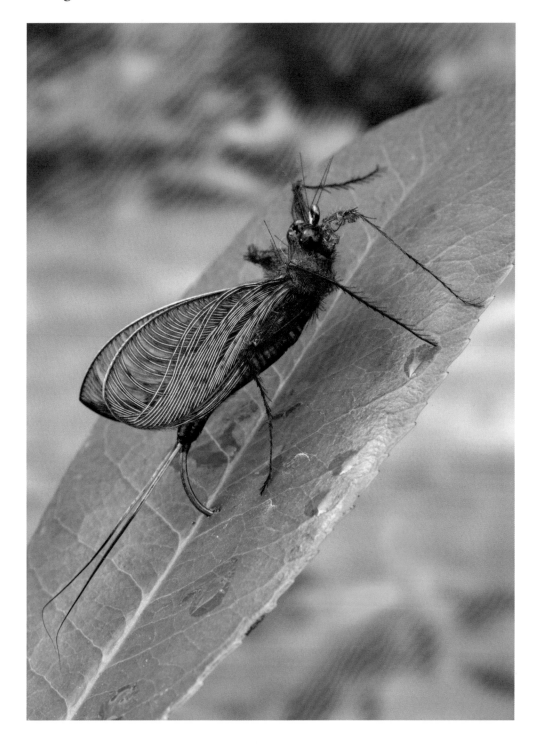

Hook: Mustad, size 10, **Thread:** Ultra, 70d, **Tail:** Peccary, **Body:** Peccary, **Tiny paws:** CDC, **Wings:** Coq de Leon.

Scutigera—Diego Bosello

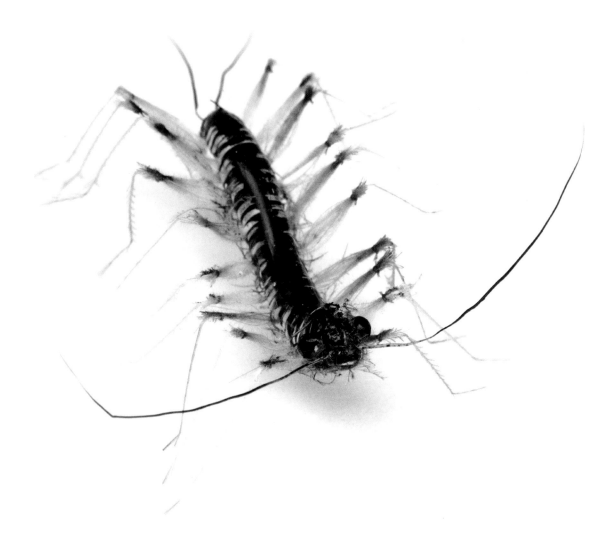

Hook: Mustad, size 10, **Thread:** Ultra, 70 d, **Tail:** Elk, **Body:** Peccary, **Tiny paws:** CDC.

Baetis—Diego Bosello

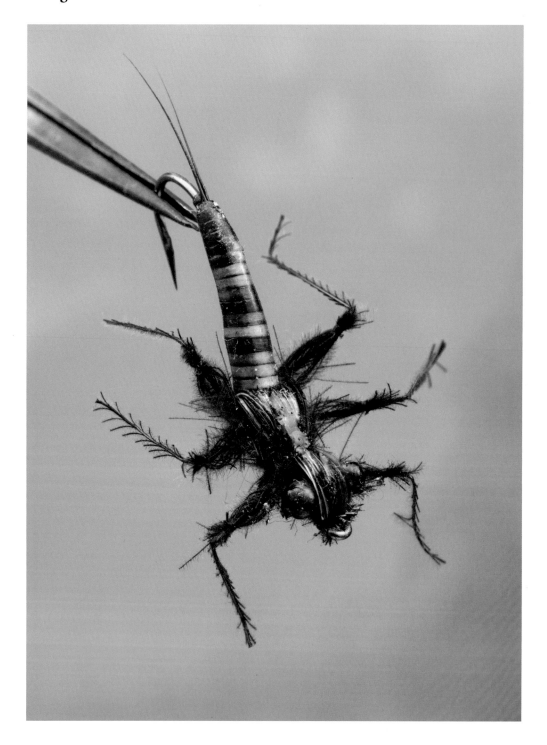

Hook: Mustad, size 10, **Thread:** Ultra, 70 d, **Tail:** Elk, **Body:** Peccary, **Tiny paws:** CDC, **Thorax:** CDC.

Zoropsis spinimana—**Diego Bosello**

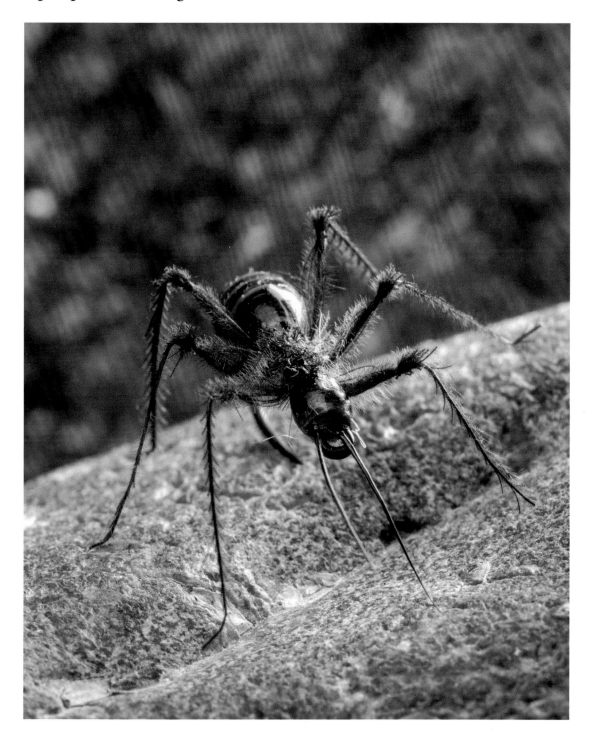

Hook: Knapek, size 8, **Thread:** Ultra, 70 d, **Body:** Peccary, **Tiny paws:** CDC, **Thorax:** CDC, **Antennae:** Elk hair.

Plecottero—Diego Bosello

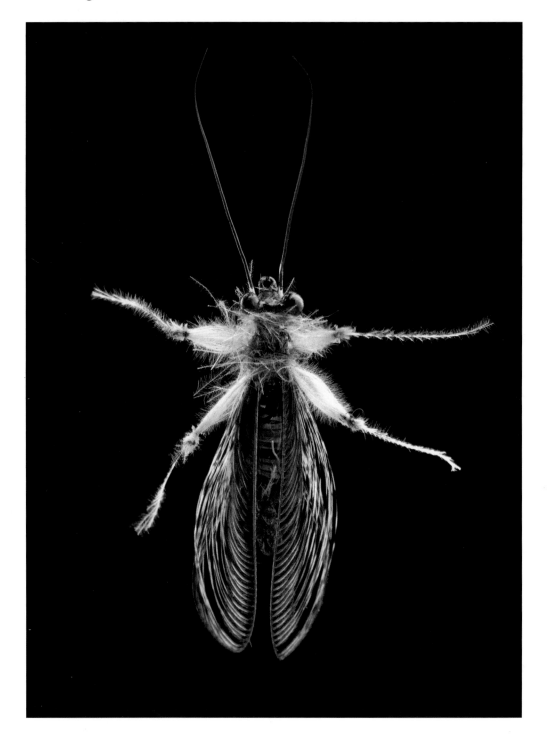

Hook: J. Parker, size 12, **Thread:** Ultra, 70 d, **Wings:** Coq de Leon, **Tiny paws:** CDC, **Thorax:** CDC, **Antennae:** Elk hair.

ED BURGHOLZER, MILFORD, PENNSYLVANIA

I started fly fishing and fly tying over fifty years ago. I fished in the Catskills, Poconos, and New Jersey streams. I've also fished many places out west and in northern states such as Alaska. Also, in saltwater in Belize, Yucatán, the Florida Keys, and the Bahamas. Also fished Rhode Island for strippers and albies. Being retired, I fish about 150 days per year. Besides fly fishing, I hunt upland game in Pennsylvania, New York, and New Jersey with Forrest, my bird dog. Other hobbies include primitive skills, bow making, arrow making, flintknapping, and brain tanning.

I got interested in realistic flies after seeing some Poul Jorgensen flies at the Catskill Fly Fishing Center and Museum. After seeing Poul tying in person, decided to try to tie something similar to his mayfly and stone fly nymphs. After several years I became the featured tyer at the Catskill Fly Fishing Center and Museum and began tying some of my own creations. I used materials never seen before in tying such as Tyvek paper that I cut and color with markers, as well as the inside bag in cereal boxes. I still use these materials today.

I tie and display my realistics at many shows, especially the International Fly-Tying Symposium, which I've done for twenty-nine years. My flies have appeared in *Fly Tyer Magazine* and *Fly Fish America*. The man who got me started tying realistically (Poul Jorgensen) put my mayfly on the cover of a book he did, *Dry-Fly Patterns for the New Millennium*. My flies are also in *Tying Heritage Featherwing Streamers* by Sharon Wright. These are not realistics. I have appeared on a local show *Out in the Open*, where I have done some tying.

Thirteen-Year Locust—Ed Burgholzer

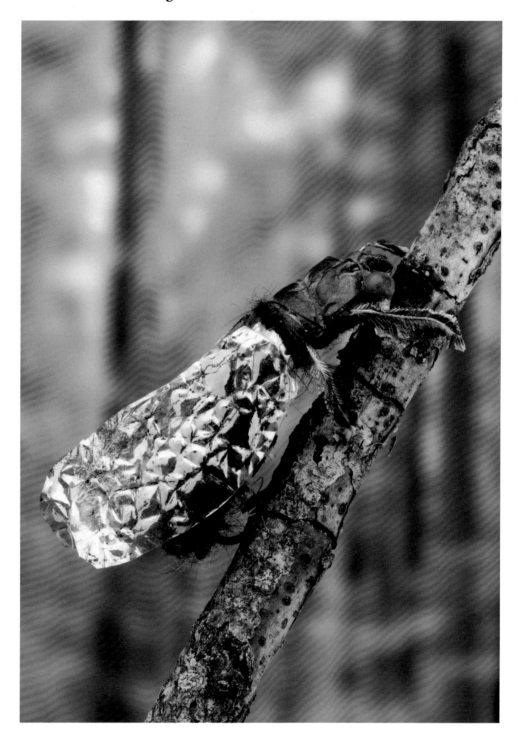

Hook: Mustad 35941, size 2, **Thread:** Danville black, 6/0, **Body:** Foam under black dubbing, **Wings:** Bill Skilton's wasp wing, **Wing case:** Tyvek paper, colored black, **Legs:** Clipped pheasant feather.

Mantis Shrimp—Ed Burgholzer

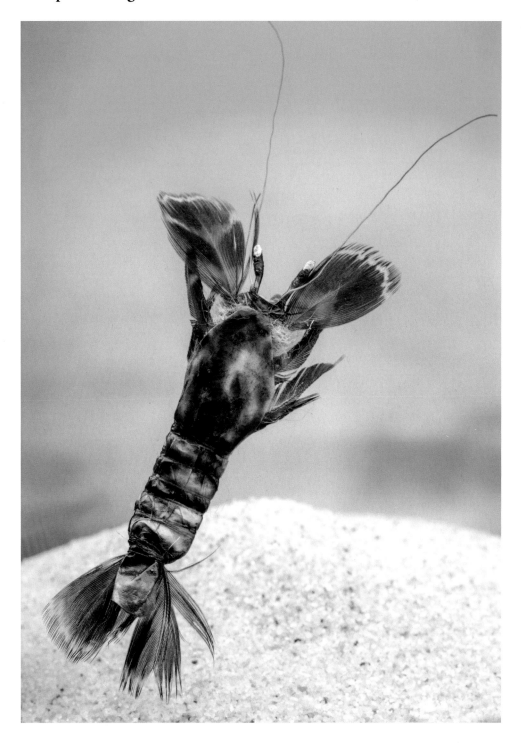

Hook: Eagle Claw saltwater, 3/0, **Thread:** Danville, tan 6/0, **Tail:** Chocolate pheasant breast, **Body:** Tyvek paper over tan dubbing, **Legs and claws:** Dark pheasant, **Feelers:** Rabbit whiskers.

Asian Longhorned Beetle—Ed Burgholzer

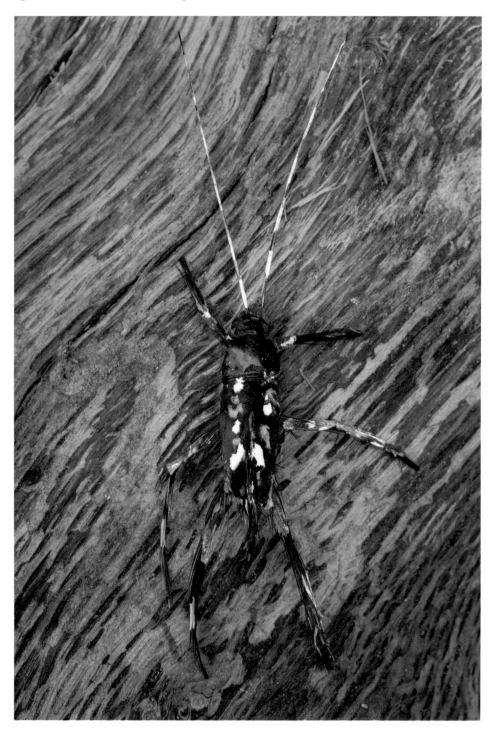

Hook: Mustad 38941, size 6, 4x long, **Thread:** Danville black 6/0, **Body:** Tyvek paper over black dubbing, **Legs:** Hen hackle, **Antennae:** Stripped hackle.

Crane Fly—Ed Burgholzer

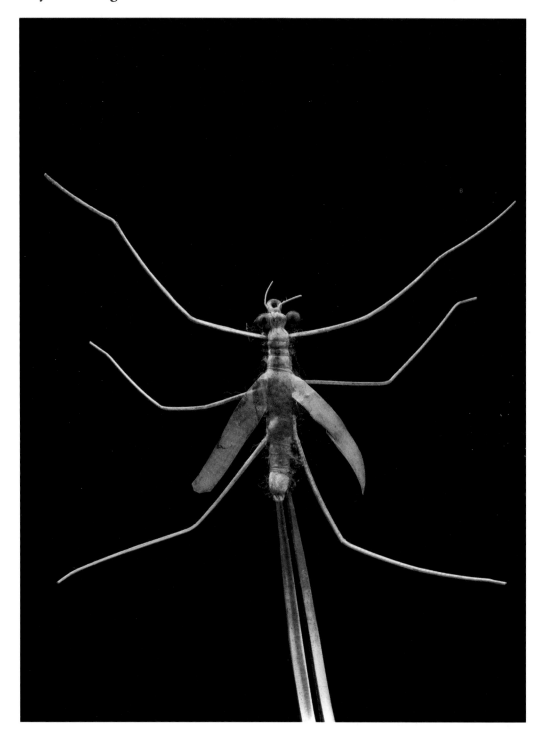

Hook: Mustad 79580, size 10, 4xlong, **Thread:** Danville tan, 6/0, **Body:** Tyvek paper over tan dubbing, **Wings:** Plastic inner bag from cereal box, colored with markers, **Legs:** Stripped hackle.

Hellgrammite—Ed Burgholzer

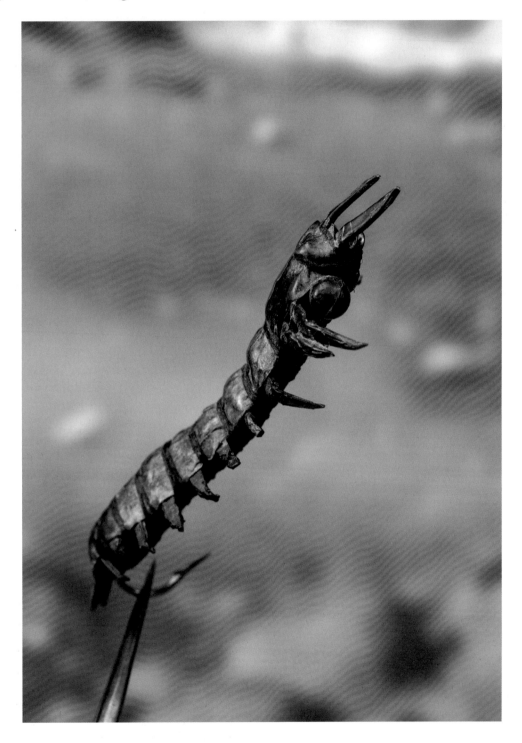

Hook: Mustad 38941, size 6, 4x long, **Thread:** Danville black 6/0, **Body:** Plastic body form, black dubbing, Tyvek paper colored black, **Legs:** Pheasant tail, **Head:** Tyvek paper, **Pincers:** Pheasant tail.

Dobsonfly—Ed Burgholzer

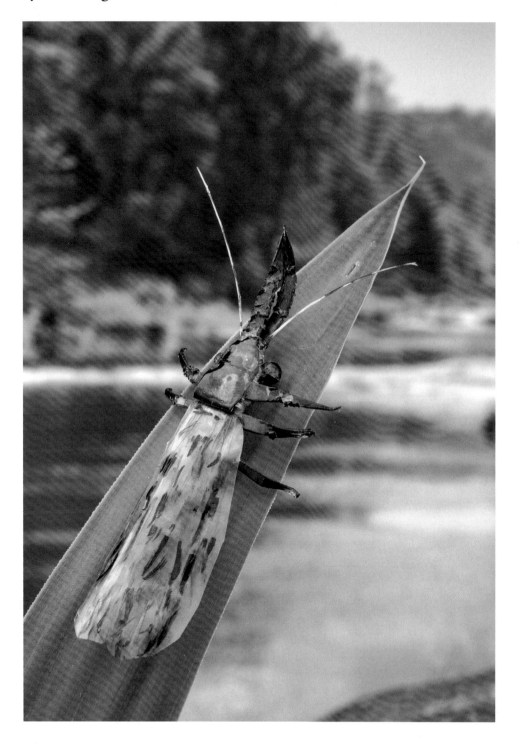

Hook: Mustad 48941, size 6, 4x long, **Thread:** Danville black 6/0, **Body:** Black and green dubbing, **Wings:** Plastic inner bag from cereal box tinted green, **Head:** Tyvek paper colored green and black, **Pincers:** Tyvek paper black, **Antennae:** Stripped hackle.

Mayfly, Emerging Adult Mayfly– Ed Burgholzer

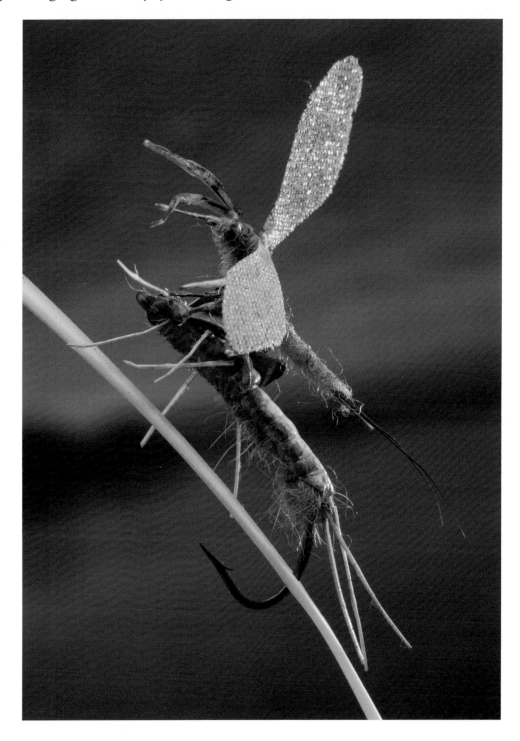

Hook: Mustad size 10, **Thread:** Danville tan 6/0, **Body:** Dubbed green over peccary hair, **Tails:** Peccary hair, **Legs:** Stripped hackle, **Wings:** Micro web, Emerged body, **Hook:** Mustad size 6, **Body:** Tyvek paper, **Wing case:** Tyvek paper, **Legs:** Stripped hackle, **Tail:** Stripped hackle.

Sulphur—Ed Burgholzer

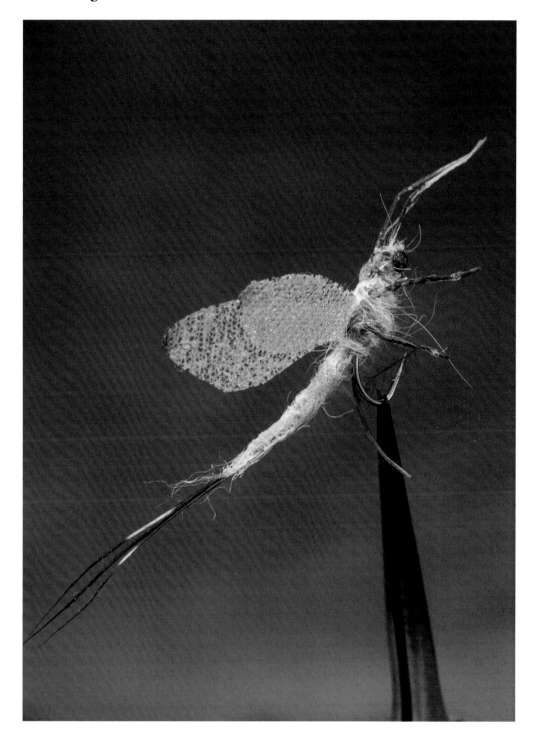

Hook: Mustad size 14, **Thread:** Danville tan 6/0, **Body:** Light yellow dubbing, **Tail:** Peccary hair, **Wings:** Micro web, **Legs:** Stripped hackle.

Spotted Beetle—Ed Burgholzer

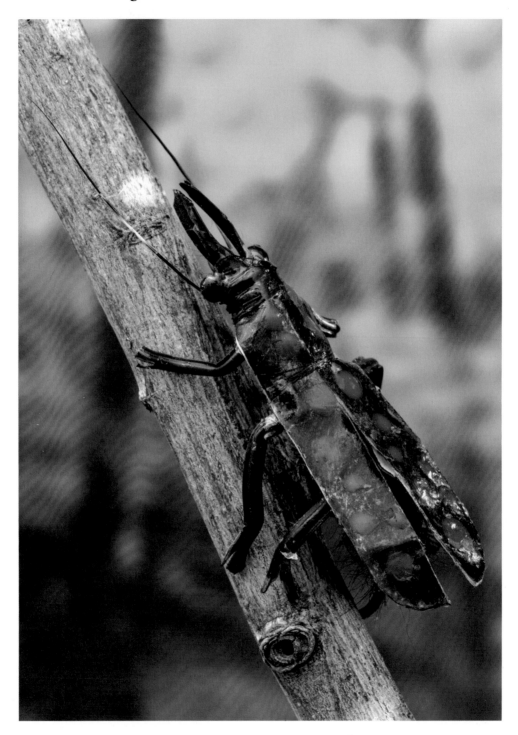

Hook: Mustad 38941, size 2 6x long, **Thread:** Danville black 6/0, **Body:** Black dubbing over body form, **Legs and pincers:** Pheasant tail, **Wings and head:** Tyvek paper, **Antennae:** Stripped woodcock.

Golden Stone Fly Life Stages—Ed Burgholzer

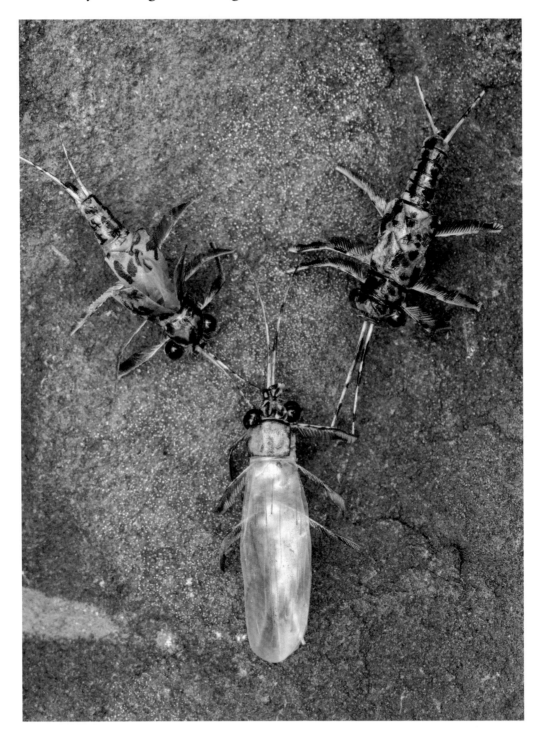

Hook: Mustad size 8, **Thread:** Danville tan 6/0, **Tail:** Stripped hackle, **Body:** Tyvek paper, over body form, **Wing case:** Tyvek paper, **Legs:** Hackle.

JUAN CARLOS CAMBRONERO GONZÁLEZ, MADRID SPAIN

I have dedicated the last twelve years exclusively to fly fishing. Initially starting with trout and predators, I now only spend my time in the search of, and fishing for, large barbels, and of course always the joy of catch and release.

This passion for fly fishing, especially "fishing with your eyes," led me to investigate the habits of fish and inspired me to give more importance to realistic flies and started my interest in entomology.

For me, tying my own flies is not a duty, it is a passion, and it is part of fishing. I could not imagine fishing with a fly that I have not made with my own hands. One of the things that motivates me the most is making a new fly pattern and going to the river to see how it performs.

My first flies were simple nymphs for trout, but I was quickly fascinated with some semi-realistic imitations, usually made of foam, which was the material with which I began to experiment and tie my first terrestrial imitations, specifically ants and beetles.

I have always been a perfectionist. Now that I have a child and he's like me, I start to think that being a purist is too much. Now I look for a beautiful aesthetic in my flies, good proportions, good finishes in general, a good performance of the fly at the time of fishing and colors that I liked. But, at the time I didn't pay enough attention to the insects I was imitating. I would define this stage as an impressionist and not as a realist or semi-realist.

The first realistic fly I tied was a beetle and the second was a caterpillar: a simple pattern that I tie in the shows I attend. And although the caterpillar is an imitation used by few fishermen, it works very well. I also tied some semi-realistic nymphs and mayflies, learning from videos by Oliver Edwards. But the information at that time was sparse and found in specialized magazines. In Spain, only *Danica* magazine published some step-by-step instructions for realistic or semi-realistic flies.

Now things have changed, and there is more information about fly fishing and tying, but in the case of realistic tying, there is still not too much. This lack of information makes you think a lot about how to do things on your own, what materials to use, and for me, this is where the challenge and fun begins.

At the beginning of 2018 and after having been a Guest Fly Tier at the EWF in Germany, I presented my first realistic fly to the "11th Open German Fly Tying Championship." It was a beetle in flight position (see below). I won first prize, but still I was not satisfied since the second-place fly was very good and it could have won. Then, I decided for the following year to tie something really difficult. I was not thinking about winning, but as a personal challenge, and of course if there is a complex imitation for me it was a mantis (see page 84). I knew the challenge was complicated and that I might not get the expected result.

At the end of 2018, I started tying my first mantis. The objective was to tie a mantis by developing the best process. I started looking for information on the real insects, catching and releasing some, visiting an insectarium, talking with entomologists, reading some books, looking for information on the net . . . but without seeing the work of other realistic fly tyers.

My intent was to know the principal characteristics, like disposition of spines, numbers of spines, exact position of compound eyes, ocellus, texture of the wings, colors etc. All parts of this fly are tied with thread. I understood this work was to be an exhibition fly, and for this reason I removed the eye of the hook. I started by drawing all the "step by step" of the assembly process before I started tying. I still remember that I used a complete bobbin of Nano Silk 30D and a few meters of one of Nano Silk 50D. I think I spent up to a hundred hours on this fly, not counting the research hours.

This fly changed my thinking and gave me confidence to do anything. From this moment, I stopped paying attention to the work of other fly tyers and found satisfaction in finding for myself the solutions to the difficulties of such a complicated imitation. In some cases, I found several ways to perform a part of the imitation and chose one. But, I knew that there were several ways to achieve a similar result.

This was also the first imitation for which I did an entomological study before starting construction. I even had my own live mantises at home to observe its biological process, from its birth, until it reaches the adult state. Currently, I keep some mantises and even several fertilized ootheques (egg masses) that I am waiting to hatch. Due this hobby of entomology, in addition to fishing and tying, I have been fortunate to be able to share it with my nine-year-old son, who has enjoyed these exciting insects with me. There are many people who cannot understand why I have insects at home, but they also cannot understand fly fishing, let alone catch and release!

Until 2018, my realistic flies were designed for fishing. For me, it was essential that they be durable. When people saw my boxes of flies, they did not understand that I fished with those realistic flies. Some told me it was sad to throw them into the water and one disbeliever told me that realistic flies do not fish properly. Nothing is further from reality!

One of the things that I like most is to tie three or four flies of a new pattern. I usually keep the best fly as a sample and put the others in my fly box to try them. For me, testing them motivates me a lot and I try all the patterns that I tie, except for the realistic flies that are for exhibition.

Juan Carlos won the "Realistic Fly" category in the 2018 Open German Championship. He also won Second prize 2019 Open German Championship in Fly Tying in the same category.

Ladybug (Red, Orange, Blue, and Yellow)—Juan Carlos Cambronero González

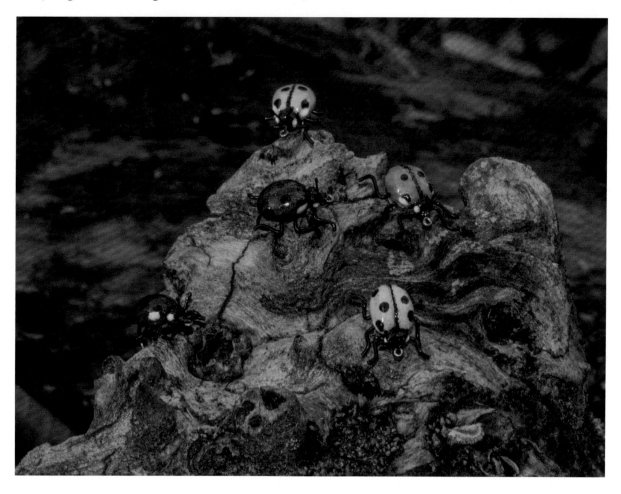

Hook: TMC 2499SP-BL #12, **Thread:** Semperfli Nano Silk 8/0—Black, **Body:** Semperfli Sheet Foam, **Finish:** Acrylic painted, **Coating:** Solarez Flex UV resin.

Heliotaurus ruficollis—Juan Carlos Cambronero González

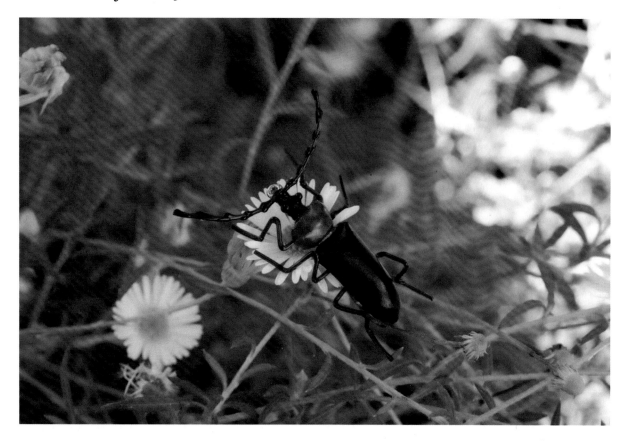

Hook: Kamasan B830 #8, **Thread:** Semperfli Nano Silk 8/0—Black, **Body:** Semperfli Sheet Foam, **Wings:** Synthetic material, **Finish:** Acrylic painted, **Coating:** Solarez Flex UV resin.

Beetle in Flying Position—Cambronero González

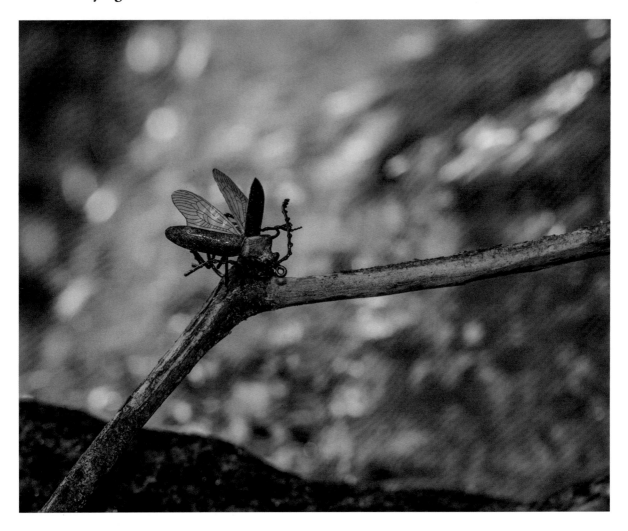

Hook: Daiichi 1710 #4, **Thread:** Semperfli Nano Silk 8/0—White, **Body:** Semperfli Sheet Foam, **Wings:** Synthetic material, **Finish:** Acrylic painted, **Coating:** Solarez Flex UV resin.

Blue Beetle with Open Elytrons—Cambronero González

Hook: Daiichi 1710 #4, **Thread:** Semperfli Nano Silk 8/0—White, **Body:** Semperfli Sheet Foam, **Wings:** Synthetic material, **Finish:** Acrylic painted, **Coating:** Solarez Flex UV resin.

Gold and Green Beetle—Cambronero González

Hook: Daiichi 1710 #4, **Thread:** Semperfli Nano Silk 8/0—Black, **Body:** Semperfli Sheet Foam, **Wings:** Synthetic material, **Finish:** Acrylic painted, **Coating:** Solarez Flex UV resin.

Red Beetle—Cambronero González

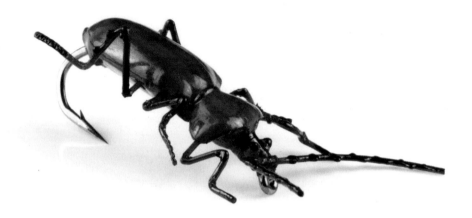

Hook: Daiichi 1710 #4, **Thread:** Semperfli Nano Silk 8/0—White, **Body:** Semperfli Sheet Foam, **Wings:** Synthetic material, **Finish:** Acrylic painted, **Coating:** Solarez Flex UV resin.

Black Beetle—Cambronero González

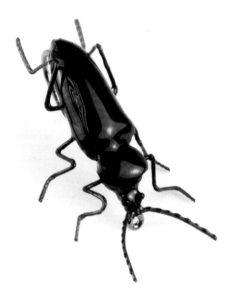

Hook: Daiichi 1710 #4, **Thread:** Semperfli Nano Silk 8/0—black, **Body:** Semperfli Sheet Foam, **Wings:** Synthetic material, **Finish:** Acrylic painted, **Coating:** Solarez Flex UV resin.

Physomeloe corallifer—Cambronero González

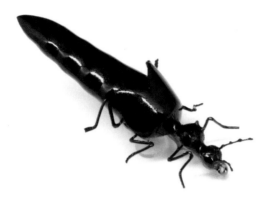

Hook: Daiichi 1710 #4, **Thread:** Semperfli Nano Silk 8/0—black, **Body:** Semperfli Sheet Foam, **Wings:** Synthetic material, **Finish:** Acrylic painted, **Coating:** Solarez Flex UV resin.

Hopper—Cambronero González

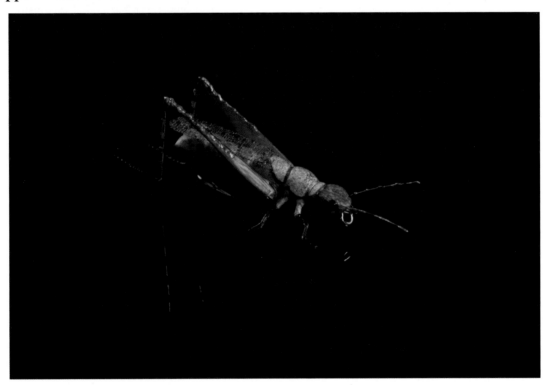

Hook: Daiichi 1710 #4, **Thread:** Semperfli Classic Waxed Thread 8/0—Brown Olive, **Body:** Semperfli Sheet Foam, **Wings:** Semperfli Synthetic material.

My First Mantis—Cambronero González

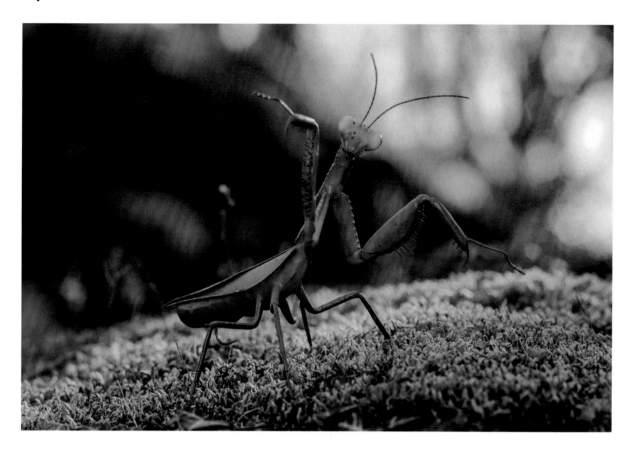

Hook: Daiichi 1710 #4 (modified and welded to a wire), **Thread:** Semperfli Nano Silk 8/0—White (In this fly I used a complete bobbin of Semperfli Nano Silk 12/0 and a few meters of Semperfli Nano Silk 8/0), **Body:** Semperfli Sheet Foam, **Wings:** Synthetic material, **Finish:** Acrylic painted, **Eye coating:** Solarez Thin UV resin.

SCOTT CESARI, PENNSYLVANIA

I began fly fishing in 2004 after a vacation to Maine. L.L.Bean was offering a one-day seminar on fly fishing. I purchased a basic fly-tying kit after the seminar. What began as a casual interest quickly developed into a fervent passion. Now, it's rare that a day goes by where I don't do something related to fly tying. It has become a wonderful complement to my day job as a physical therapist at my local Pennsylvania hospital.

Over the years, I have been fortunate enough to be the recipient of several fly-tying accolades, including the titles of Pennsylvania State Fly Tying Champion and Federation of Fly Fishers World Champion. I teach tying classes for local TU chapters, and I provide presentations and tying demonstrations to multiple organizations throughout the northeastern United States. I've created museum-quality displays for several organizations, and I've been invited to participate in some of the industry's biggest shows. My work has been featured in both national and international publications, and I have been featured on both radio and television programs. Participation in this industry has been, and continues to be, very rewarding on many levels, and I am truly appreciative that may work has been received so generously.

I did not set out to be a realistic tier. In fact, I was firmly against the notion during the early years. The idea of investing such a large amount of time on a fly that you wouldn't want to fish with was beyond me. But, I found I wasn't satisfied with the conventional patterns, either. While driven by practicality, the creative side of me yearned for an outlet.

I was mulling this over one summer day when my two little girls rushed into my tying room, out of breath with excitement, wanting to play outside to indulge in our favorite summer pastime—catching butterflies. Before long, our netted cages were filled. We offered sugar water to monarchs, swallows, sulfurs, and others with their soft, fuzzy bodies, long, delicate legs, and beautifully patterned wings. That's when it hit me. *Large . . . beautifully patterned . . . wings.* That night I looked at all those materials I had collected. All those feathers, with their large, beautifully patterned surfaces. I tore into them, and before long the butterfly fly was born (shown on pages 86 and 87). And with it, a newfound appreciation and love for realistic fly tying. It was satisfying to utilize standard tying techniques in innovative ways to create different effects on a fly.

I suddenly began to look at everything differently, to see the potential tying use in any and all materials, conventional or not. Dustpan brush bristles became spider legs, acrylic fingernails became beetle shells, and so on. The creativity that had been nagging at me finally had an outlet, and so I was set on the path of realistic fly tying, a path I've stayed on ever since.

Butterfly—Scott Cesari

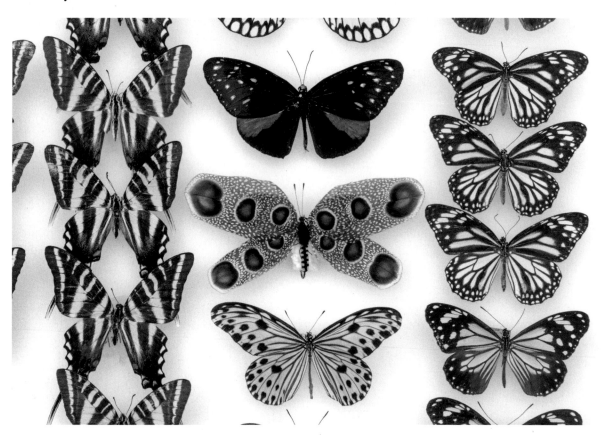

Hook: Mustad 79580, size 6, **Thread:** Danville 6/0, waxed, **Body:** Ultra chenille, 2 colors, braided, **Legs:** Bristles from a dustpan brush, bent to shape, **Proboscis:** Bristle from a dustpan brush, curled to shape using a bodkin, **Antennae:** Hackle feather, stripped, with tip clipped to shape, **Thorax:** Marabou feather, **Wings:** Feathers of choice.

Butterfly—Scott Cesari

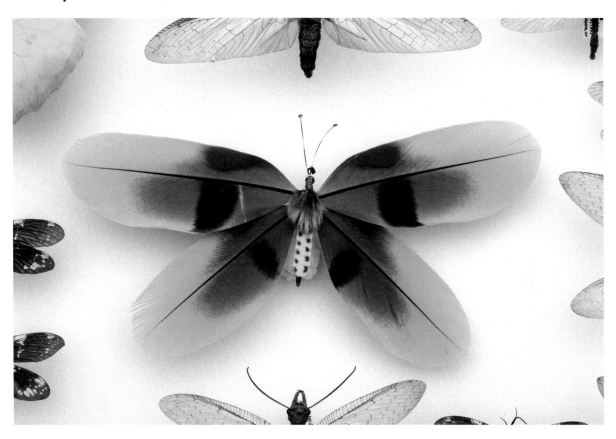

Hook: Mustad 79580, size 6, **Thread:** Danville 6/0, waxed, **Body:** Ultra chenille, 2 colors, braided, **Legs:** Bristles from a dustpan brush, bent to shape, **Proboscis:** Bristle from a dustpan brush, curled to shape using a bodkin, **Antennae:** Hackle feather, stripped, with tip clipped to shape, **Thorax:** Marabou feather, **Wings:** Feathers of choice.

Leaf Beetle—Scott Cesari

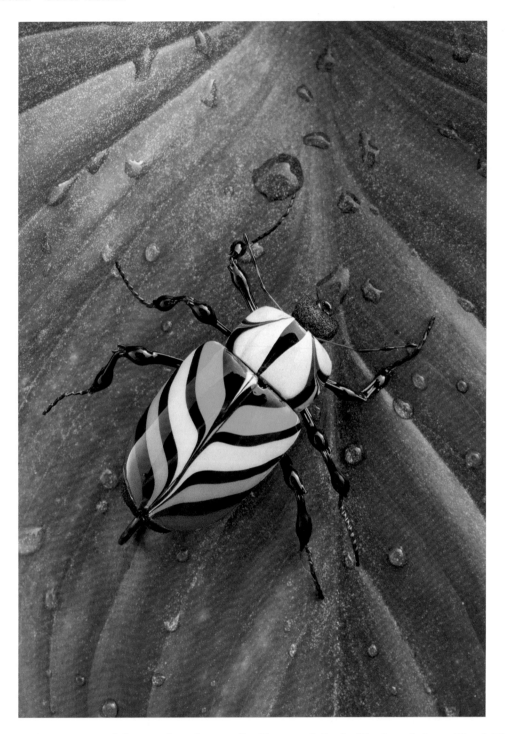

Hook: Mustad 79580, size of choice, **Thread:** Danville 6/0, waxed, **Body:** Thick craft foam, **Head:** Thin craft foam, **Legs:** Bristles from a dustpan brush, bundled, contoured with epoxy and black nail polish, **Antennae:** Stripped hackle, bent and contoured with black nail polish, **Shell and Pronotum:** Fake acrylic fingernail, sanded to shape and painted as desired.

Leaf Beetle—Scott Cesari

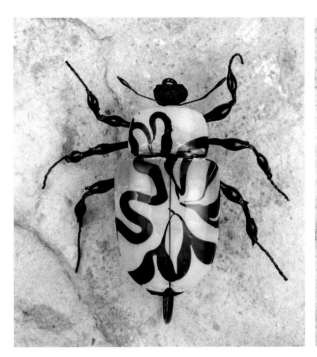 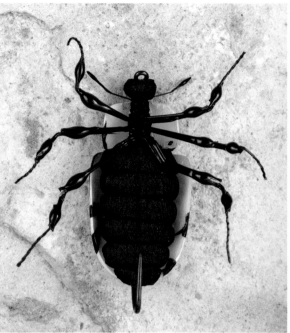

Hook: Mustad 79580, size of choice, **Thread:** Danville 6/0, waxed, **Body:** Thick craft foam, **Head:** Thin craft foam, **Legs:** Bristles from a dustpan brush, bundled, contoured with epoxy and black nail polish, **Antennae:** Stripped hackle, bent and contoured with black nail polish, **Shell and Pronotum:** Fake acrylic fingernail, sanded to shape and painted as desired.

Longhorn Beetle—Scott Cesari

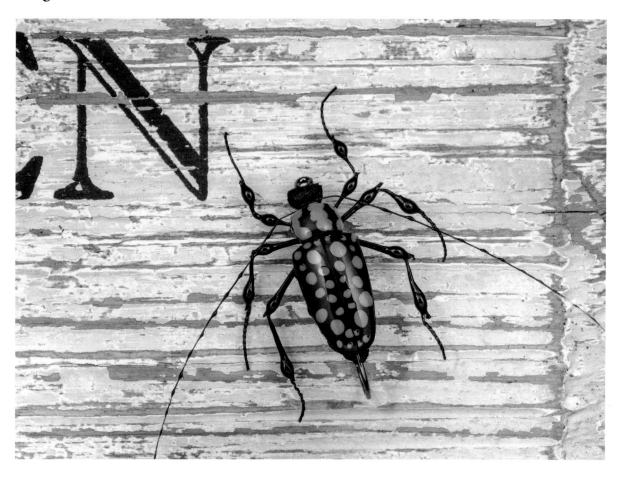

Hook: Mustad 79580, size of choice, **Thread:** Danville 6/0, waxed, **Body:** Thick craft foam, **Head:** Thin craft foam, **Legs:** Bristles from a dustpan brush, bundled, contoured with epoxy and black nail polish, **Antennae:** Porcupine guard hair, bent and contoured with black nail polish, **Shell and Pronotum:** Fake acrylic fingernail, sanded to shape and painted as desired.

Spider—Scott Cesari

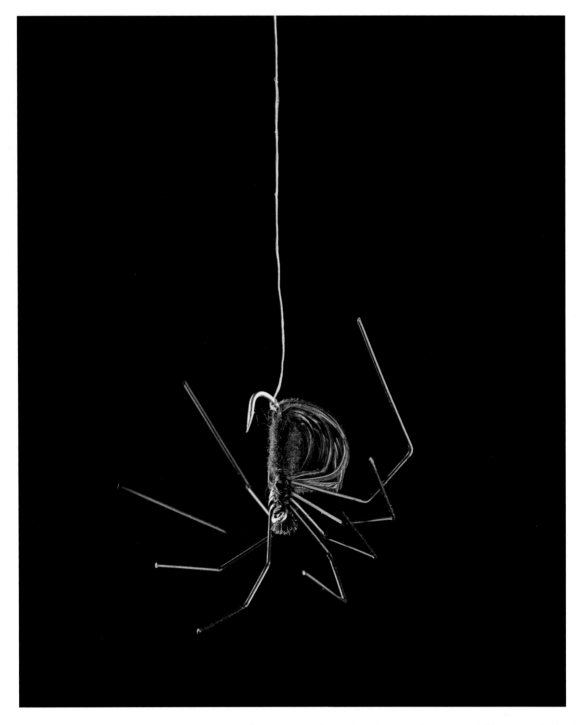

Hook: Mustad 94840, size 14, **Thread:** Danville 6/0, waxed, **Body/Thorax:** Pheasant tail fibers, **Underbody:** Dry fly dubbing or foam, applied over the butt ends of the pheasant tail fibers, **Legs:** Bristles from a dustpan brush, heat kinked to shape.

Grasshopper—Scott Cesari

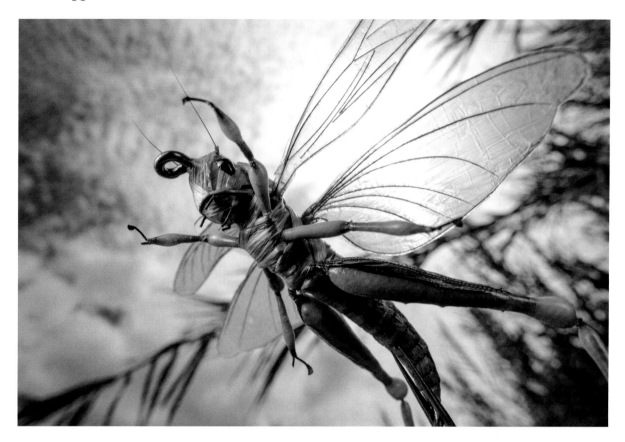

Hook: Mustad XL wet fly, 4/0, **Thread:** Danville 6/0, waxed, Abdomen/Thorax/**Body:** Foam base, individually segmented and wrapped with raffia, colored with blended Sharpie marker, **Head:** Foam base, covered with raffia, **Mouth Parts:** Bristles from a dustpan brush, **Antennae:** Porcupine guard hair tips, porcupine quill base, **Eyes:** Pigmented epoxy, **Legs:** Dustpan brush bristles built up and contoured with pigmented epoxy, overlaid with black hackle feather to create the outer markings, **Wings:** Porcupine guard hairs for the major veins, clippings of my own hair for the minor veins, enveloped between sheets of raffia and sealed with cement, **Pronotum:** Acrylic fingernail sanded to shape and wrapped in raffia.

DAMIEN DEPREZ, FRANCE

I have always been passionate about fly fishing. I pursued this passion in several additional areas such as fly tying, entomology, and photography. Year after year, I specialized in super-realistic fly tying. Since 2006, I have participated in the most prestigious fly-tying championships all around the world, especially the Mustad Scandinavian Open, which was considered the World Fly-Tying Championship.

By continually working on my patterns, I have slowly developed my own fly-tying techniques and style. I really consider the hook as an artistic support, as would a painter with a canvas. The main use of natural materials and feathers is a personal choice and a true artistic approach to fly tying. All parts of my realistic art flies are tied individually with fly-tying thread. The use of glue is limited to only the necessary minimum.

Each new creation is the result of a lot of work, research, and attempts. I can spend all night long working and thinking about a way to tie a fly I have in mind. The realization of an art fly could require a hundred hours' work on the vise.

I am also involved in fishing flies and salmon flies. The fly-tying area is a world of its own and each kind of fly has its own specifics. So, do not hesitate to get off the beaten track, be creative and curious, and you will improve your fly-tying skills.

From 2006 to 2013, I participated in international fly-tying championships worldwide, especially the Mustad Scandinavian Open, which was the most prestigious and considered to be the World Fly-Tying Championship. I have never been a part of competition just to simply win prizes. For me, it was a very good way to improve my techniques and create new patterns again and again.

But winning prizes is not an end in itself. Humility and challenging yourself every day is the key to be better and better. Below, are some of my accomplishments.

2013:
Gold Medal, super realistic category, Mustad Scandinavian Open.
Gold Medal, dry fly category, Mustad Scandinavian Open.
Silver Medal, salmon fly category, Mustad Scandinavian Open.
Bronze Medal, wet fly category, Mustad Scandinavian Open.

2012:
Gold Medal, super realistic category, Mustad Scandinavian Open.

2009:
Silver Medal, super realistic category, Mustad Scandinavian Open.
Silver Medal, super realistic category, Germany International Fly Tying Competition.
Silver Medal, dry fly category, Germany International Fly Tying Competition.

2008:
Overall Category Winner British & International Fly Tying Championship.
Gold Medal, super realistic category, British & International Fly Tying Championship.

2007:
Gold Medal, super realistic category, British & International Fly Tying Championship.
Silver Medal, super realistic category, Mustad Scandinavian Open.

2006:
Gold Medal, super realistic category, Mustad Scandinavian Open.
Bronze Medal, nymph category, Ireland Durrow Fly Tying Championship.

Ephemera danica—**Damien Deprez**

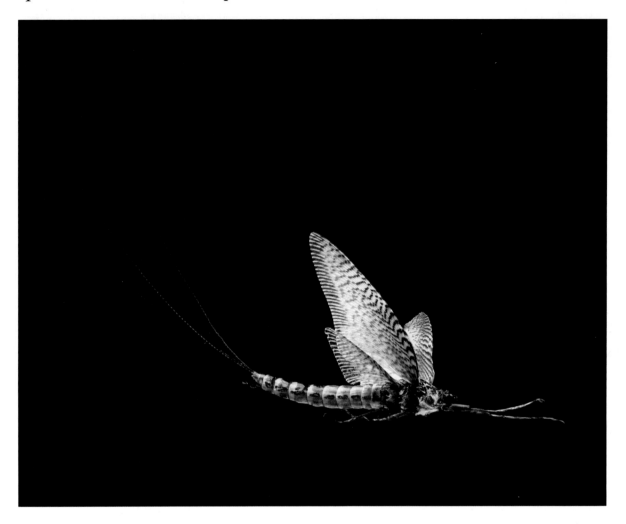

Hook: Size 14, **Thread:** 12/0 or 14/0 black, **Tail:** Cock feather quill, **Extended body:** Mix of synthetic and natural raffene, color and natural varnish, with some pieces of black cock feather incorporated, **Legs:** Raffene, bustard feather and natural cock quill, **Body and thorax:** Natural and synthetic raffene and colored varnish, **Wings:** Tented natural duck feather and varnish (origami style), **Head:** Fly tying thread, raffene, colored varnish, **Eyes:** Burned monofilament.

Plecoptera—Damien Deprez

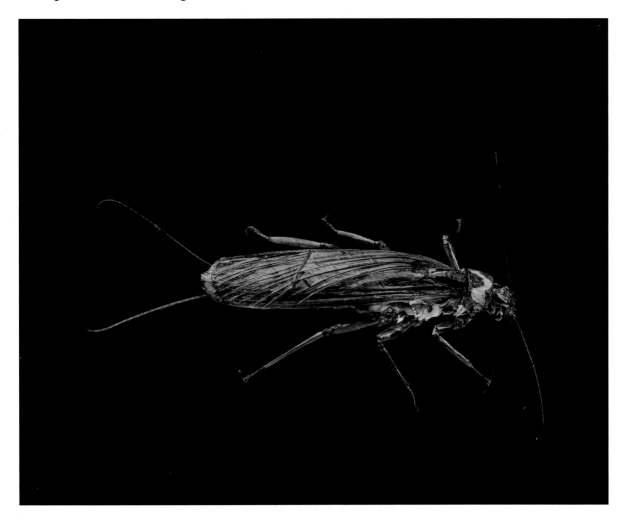

Hook: size 10, **Thread:** 12/0 or 14/0 black, **Tail:** Cock feather quill and colored varnish, **Extended body:** Wapsi Natural Thin Skin, varnish, and natural peacock quill, **Legs:** Raffene, natural cock quill, varnish, and fly-tying thread, **Body and thorax:** mainly done with a mix of different kinds of colored raffene and Wapsi Thin Skin, natural and colored varnish, **Wings:** Synthetic wing film, natural cock quill and varnish, **Head:** Fly tying thread, raffene, colored varnish, **Eyes:** Burned monofilament, **Antennae:** Natural cock quill feather.

Mosquito—Damien Deprez

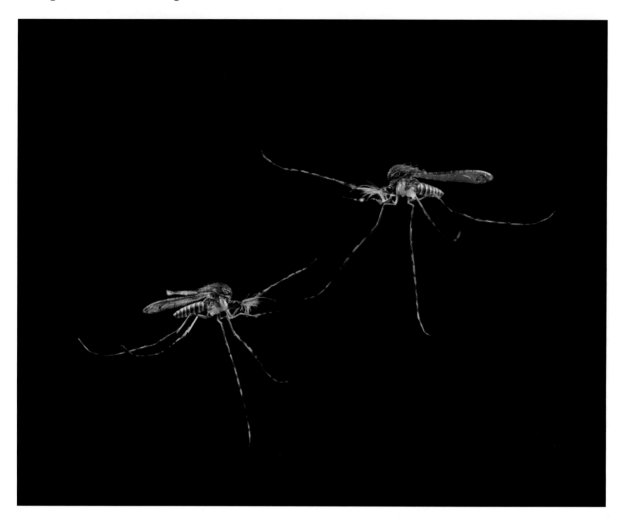

Hook: Size 20 to 26, **Thread:** 18/0, **Body:** Natural peacock quill and varnish, **Legs:** Natural grizzly cock feather and varnish, **Thorax:** Ostrich feather and raffene, **Wings:** Synthetic wings film, natural cock quill and varnish, **Head:** Fly tying thread and ostrich feather, cock feather quill, **Eyes:** Black varnish, **Antennae:** Ostrich feather.

Moth—Damien Deprez

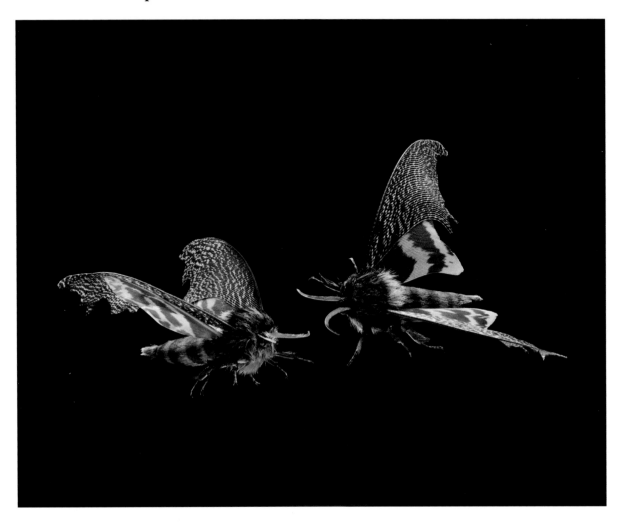

Hook: Size 8, **Thread:** 12/0 or 14/0, black, **Extended body:** Mix of brown and black ostrich feather, **Legs:** Ostrich feather, Wapsi Thin Skin, or plastic film, bustard feather, and varnish, **Body and thorax:** Ostrich feather, **Wings:** Bustard wing feather tip, **Head:** Ostrich feather, **Eyes:** Burned monofilament, **Antennae:** Natural cock quill feather.

Cricket—Damien Deprez

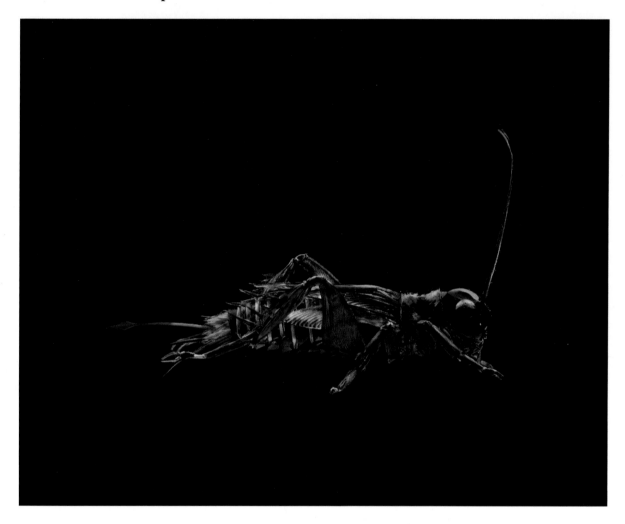

Hook: size 10, **Thread:** 12/0 or 14/0 black, **Tail:** Grouse feather quill and ostrich feather, **Extended body:** Black Wapsi Thin Skin, varnish and natural peacock quill, **Legs:** Goose biots, cock feather quill, fly-tying thread, grouse feather, and varnish, **Body and thorax:** Black Wapsi Thin Skin, raffene, **Wings:** Synthetic wing film, natural cock quill, grouse feather, and varnish, **Head:** Epoxy, black varnish, black Wapsi Thin Skin and cock feather quill, **Eyes:** Burned monofilament, **Antennae:** Natural cock feather quill.

OLIVER EDWARDS, ENGLAND

Here in the North of England, we have used region-specific flies such as "North Country Spiders" since at least the seventeenth century. When I took up the fly rod at the age of fifteen they were just about the *only* flies you could purchase—no dries, no nymphs, and certainly no streamers!

Then I became very interested in what brown trout and grayling seasonally ate—and I became fascinated. This led me on to designing my own patterns from autopsy samples (catch and release was then far in the future). Even my early crude attempts were mostly a revelation, particularly the nymph and larva patterns, which I have refined over the years. I am totally self-taught.

I initially tied these patterns because they were completely unavailable. The *only* decent representative form of our Olive nymph (aka Spring Olive, or *Baetis rhodani*) was Sawyer's Pheasant Tail Nymph, then *only* available from the Sawyer family. I loved tying these small patterns with some important trigger details that were soon upping my catch rate very noticeably. It wasn't too long before I was being invited to angling clubs to demonstrate and talk about entomology and fly tying. This important stepping-stone also soon led to invitations to big shows, including the famous Chuck Furimsky shows in New Jersey, as well as many others in other countries such as the Dutch Fly Fair and even as far east as the Tokyo Fly Fair.

I published *Flytyers Masterclass* (Merlin Unwin Books, 1994) which was also published in the United States—(Stoeger) and translated into German, Italian, Finnish, Norwegian, and Czech. It's been reprinted as part of *The Flyfishers Classic Library* (Coch-y-Bonddu Books, 2009). I've also published eight videos—six on various fishing techniques and two on fly tying. I've published articles in *Salmon & Trout, Salmon, Trout & Sea Trout, Flyfishing & Fly Tying* (UK); *Fly Tyer* (USA); *Trout Fisherman* (New Zealand); and *Perhokalastus* (Finland).

I entered three fly-tying competitions and won three.

(Author's Note: You will find Oliver Edwards's name mentioned by many tyers in this book. His pioneering contributions to realistic fly tying are recognized around the world. It is exciting to see Oliver's work here, among the work of so many others he has influenced.)

Tea Bag Caddis—Oliver Edwards

Hook: #10 to 14, wide gape, 1x short preferred—(any brand, your choice), **Thread:** Roman Moser Power Silk, orange (or equivalent-fine super strong), **Abdomen and Thorax:** Chenille or Vernille, orange or dark orange. Tied in as a detached body, with abdomen tip much less than extremity of wing envelope, **Legs:** (on abdomen area) Deer hair dyed slightly darker than wing color, spun in a loop, **Wing:** Non-woven polypropylene. This wing material—so far—is *not* listed as a fly-tying material. However, it is very commonly in use almost everywhere from dust cloths and gardening fleece to single-use pillowcases and to shopping bags. Preparation as follows: Have your electric iron and ironing board set up and ready. Set the iron on steam and also either synthetics or silk. Cut a strip twice the width of the wing you require. Fold equally down the long center. Then iron it with liberal steam and rapid movement of the iron (pausing for a millisecond will result in a disaster). If it was done correctly, you will have produced a permanent crease which is the top of the tent-wing., **Legs:** (On thoracic area and collar) Identical to legs on abdomen.

Ascending Caddis Pupa—Oliver Edwards

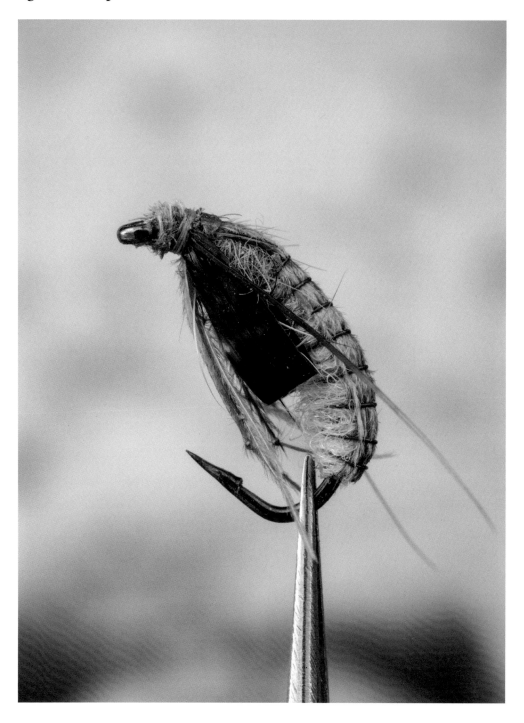

Hook: Wide gape wet fly, #14, 12, 10, **Thread:** Danville's 17/0 Spiderweb or your favorite 15/0 to 17/0, **Weight:** Fine adhesive-backed lead foil, a 2–3 mm wide sliver (amount to suit conditions or presentation depth), **Abdomen:** Fine bright green dubbing, **Abdomen and Thorax, Dorsal Cover:** Quill feather slip a little wider than abdomen (to partly cover sides of abdomen), **Rib:** Fine gold or brass wire.

Rhyacophila Larva—Oliver Edwards

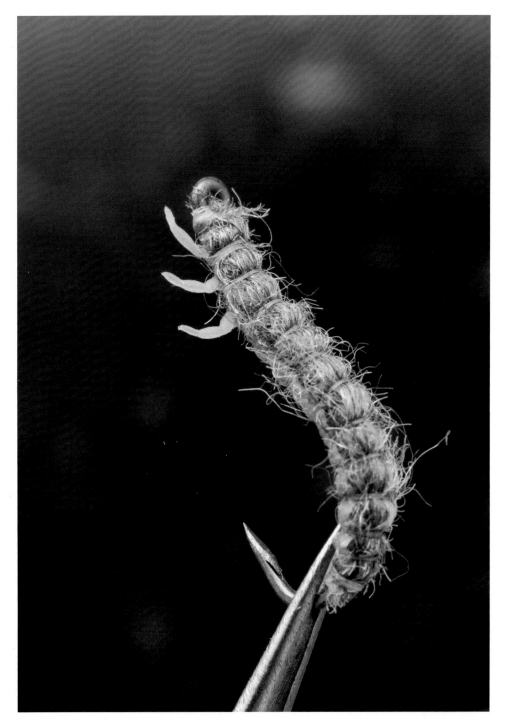

Hook: #8, 10, 12, 14 Grub type, **Thread:** Roman Moser Power Silk—(or any equivalent fine super strong GSP), yellow, **Weight:** Thin, adhesive-backed, lead sheet, 2–3 mm wide sliver, **Rib:** Light green, narrow "Lurex" tinsel, (0.5mm wide), or pale green mono 3–6 #, **Body:** Any soft 3-ply "sparkle yarn" (from Kaufmann's originally), **Legs:** Preformed synthetic leg sets from Json (Sweden), **Head:** Yellow tying thread.

Freshwater Shrimp—Oliver Edwards

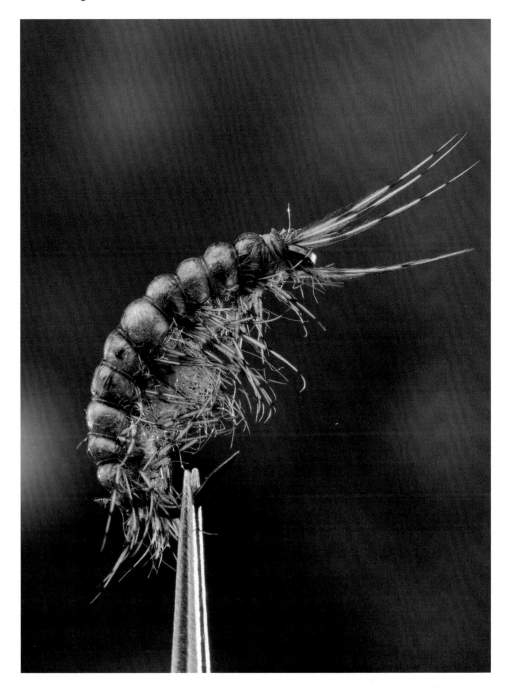

Hook: #8, 10, 12, 14 Grub type, **Weight:** Lead Foil. Cut strip 2–3mm wide, Tying **Thread:** 12/0 to 17/0, **Tail:** Small clump of Partridge back barbs—tied in shorter than antennae, **Shellback:** "Boat"-shape clear poly sheet, **Rib:** Clear 4- to 6-pound monofilament, **Antennae:** As tails, but twice as long and 4–6 barbs only, **Body Dubbing:** Fine, natural, olive shades, pink shade or a mixture of both, Body **Legs:** Partridge back feathers, 4 or 5. One side stripped off each one, other side entered into a spinning loop, stem cut off, then spun to stand individual barbs at 90 degrees to loop . . . then pulled into body dubbing tightly when wrapping on.

Peeping Caddis Larva—Oliver Edwards

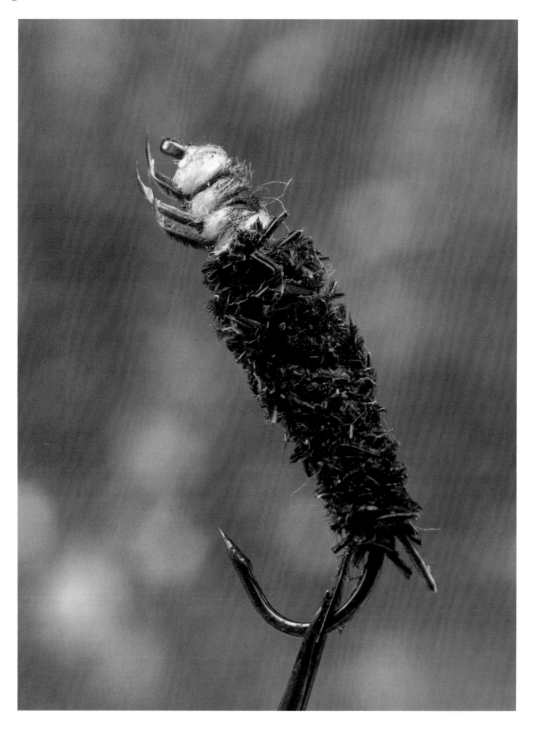

Hook: 2X long nymph, # 6, 8, 10, **Weight:** Lead foil cut strip, 2–3mm wide, **Thread:** Roman Moser Power Silk or equivalent fine GPS, **Legs:** "Velli Autti" legs, dark PT, **Peeking Larvae:** 2 to 4-ply synthetic yarn, white, cream, pale yellow, pale green, etc, **Case:** pheasant tail or other feather barbs plus a mixture of medium/coarse dubbing as binder.

Hydropsyche Larvae—Oliver Edwards

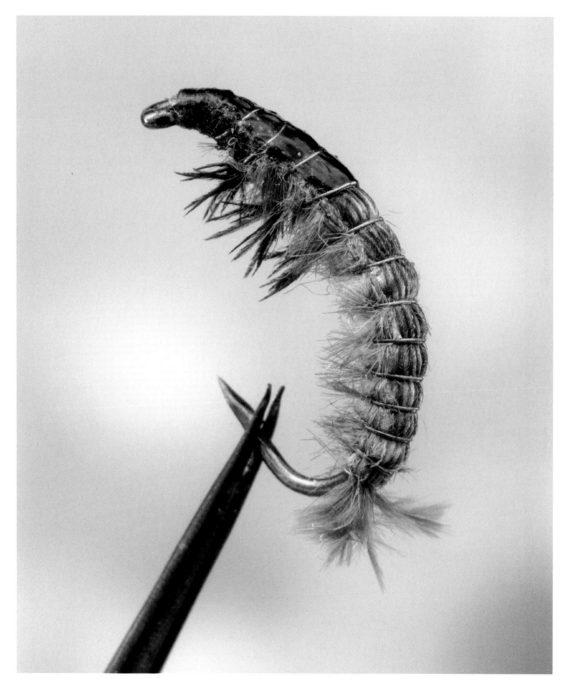

Hook: Any brand, grub type, size 12 to 8, barbless, **Thread:** Roman Moser Power Silk or any equivalent fine GSP, **Weight:** Thin adhesive-backed lead sheet, 2–3mm wide sliver, **Tail Appendage:** Pheasant Filoplume cut to produce a vee, tied in "flat" as a short tail, **Dorsal Cover** (abdomen and thorax): 3–4mm cut section from a gray/brown mottled turkey tail quill, **Abdomen gills:** Gray ostrich herl, **Abdomen and thorax:** Soft 3-ply "sparkle yarn" to match abdomen of natural, **Legs:** 3 distinct clumps of hen hackle tips 2–3mm long, black, **Tinting:** Black Sharpie waterproof permanent marker. Thorax and head, dorsal side only.

Small Black Stone Fly Nymph—Oliver Edwards

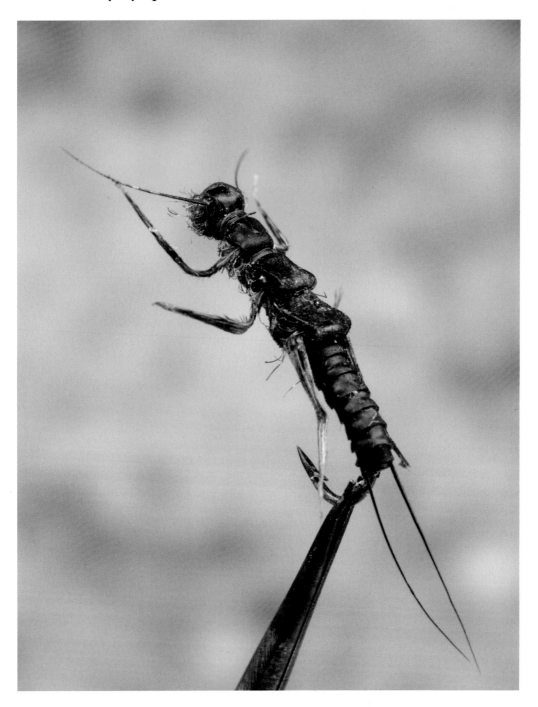

Hook: #14 to 18, 2 or 3x longshank nymph, barbless, **Thread:** Danville's "Spiderweb" 17/0, black or very dark brown, **Weight:** Thin adhesive lead sheet, 2–3mm wide, **Tails:** two moose body hairs, **Abdomen:** Black "Flexibody" or equivalent, 1.5mm wide strip, **Wing Buds and Head Cover:** Black "Flexibody" or equivalent, 1.5mm wide strip, **Legs:** Tip of black hen hackle, folded forward, barb pairs separated out, heat kinked, **Head:** A small balled head of tying thread, tinted black, **Antennae:** 2 moose body hairs.

Mayfly Nymph—Oliver Edwards

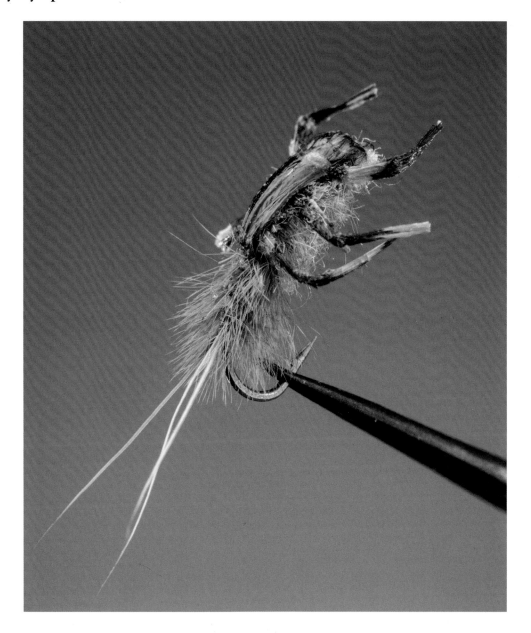

Hook: #14 to #20, nymph hook, any brand, 2x long, up-eye, wide gape, medium wire, barbless, **Weight:** Thin adhesive-backed lead sheet, 2 mm wide sliver. **Thread:** Danville's 17/0 "Spiderweb" **Head Capsule Cover:** Light brown Raffine, double thickness (Folded), **Head Capsule 90-degree foundation quill:** 15- to 20-pound clear mono, heat flattened at ends (but not balled as eyes), **Tails:** 3 any straight, stout, tapering guard hairs—color to match natural, **Abdomen Gills:** Ostrich herl, color to match gills on natural, **Abdomen:** 2–3 mm wide strip of "Flexibody" or equivalent, color to match natural, **Wing Pad:** A section of turkey feather from wing or tail quill, black or very dark brown, **Legs:** Any well mottled soft body feather, dyed to suit. I tend to use well-spotted guinea fowl, **Thorax and Head Capsule build-up:** Any brand, fine dubbing, color to match underside of natural being copied.

Baetis Nymph—Oliver Edwards

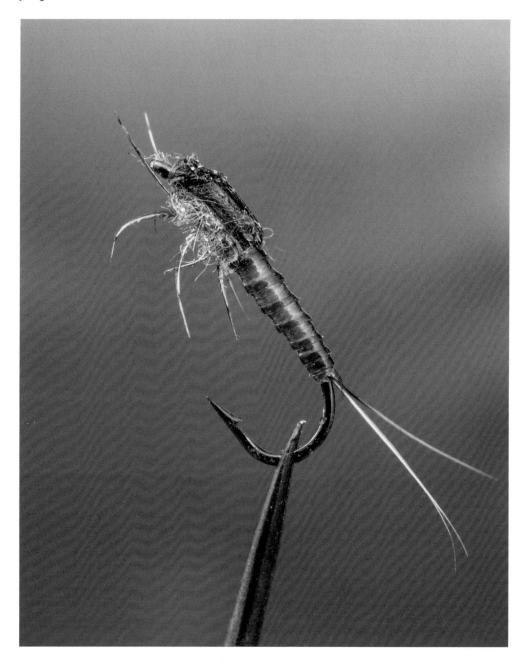

Hook: #14 to #20, nymph hook, any brand, 2x long, up-eye, wide gape, medium wire, barbless, **Weight:** Thin adhesive-backed lead sheet, 2 mm wide sliver, **Thread:** Danville's 17/0 "Spiderweb," **Tails:** Three dark moose body hairs, tips aligned, two outer hairs veed outward, Abdomen: "Flexibody" or any dyed translucent plastic e.g. vinyl, color to match natural, **Legs:** European grey partridge (Hungarian partridge) small back hackle, the very tip section, with barbs stroked at 90 degrees to stem. **Wing-buds:** Slip section from any black or very dark brown wing or tail feather, 2–4mm wide, **Thorax:** (under), fine dubbing, color to suit under thorax of natural.

Mohican Mayfly—Oliver Edwards

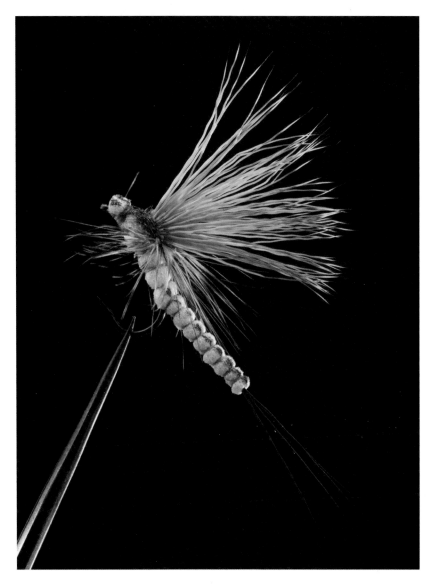

Two-part tying:
Body: tails and abdomen tied on a very fine sewing needle, Clamp needle at eye end, with approximately 2 inches of pointed end protruding, **Thread:** Roman Moser Power Silk, **Tails:** 3 or 4 stout moose body hairs, aligned, **Body:** 2–3 mm art foam, white or cream.

Hook part
Hook: Any brand, wide gape, medium wire, wet fly, barbless, **Wing:** Top-quality straight deer hair dyed dark olive and yellow, a 50/50 mix. The well-mixed hair clump must be tied in as a thin "blade" configuration.

Now add body to hook (Tie-on)
Hackle: Dark grizzly dyed yellowish olive, parachute style, **Wing Pads:** Tag ends of art foam, **Head:** Tag ends of art foam, **Marking:** Black waterproof permanent marker.

FABIO FEDERIGHI, FLORENCE, ITALY

My name is Fabio Federighi, and I live in Florence in the beautiful Tuscany area. One of the passions of my life was fishing, and since childhood I have fished with various techniques, which then led me to fly fishing. A technique that allowed me to be able to fish not only in Italy but also around the world: Europe, Alaska, Russia, hunting for trout, grayling, sea trout, salmon, but also fishing in salt water, hunting sea bass and blue fish.

So immediate was the passion for fly tying, it led me to range from dry flies, wet flies, nymphs, streamers, salmon, and hyperrealistic flies, as well as artificial ones for the sea. For several years I have been writing fly-tying articles for various magazines. I have written together with Gianluca Nocentini the *Manuale del Moderno Costruttore di Mosche Artificiali* (GEA, 2012), and my flies are in several foreign books such as *Flytyers of the World*.

Among the most beautiful experiences I participate in every year are the fly festivals in Europe, where I find myself tying together with great foreign tyers. Denmark, Germany, Sweden, Holland, Ireland, and England are some of the countries where these events take place. I also take part in the American experience in Somerset, New Jersey, at the Fly-Tying Symposium.

I am part of the pro teams of Ahrex, Deer Creek, and Swiss CDC. With the friend Federico Renzi and in collaboration with Eddy Peruzzo, we organize the Pescare Show, the Fly Tying Experience, the most important fly-tying festival in Italy, featuring the best international and Italian fly tyers.

Surely fly fishing is the passion of my life. It is a healthy activity that has given me the opportunity to live and see the world, to be able to appreciate and love nature in its beautiful forms and visions, and also to have allowed me to meet many wonderful people. Fly tying is therefore an activity that gives me the opportunity to create something and to use manual skills. I think it is therapeutic and a deep expression of our passion. I wish everyone would experience fly fishing in all its forms.

Ephemera danica **Dun Female—Fabio Federighi**

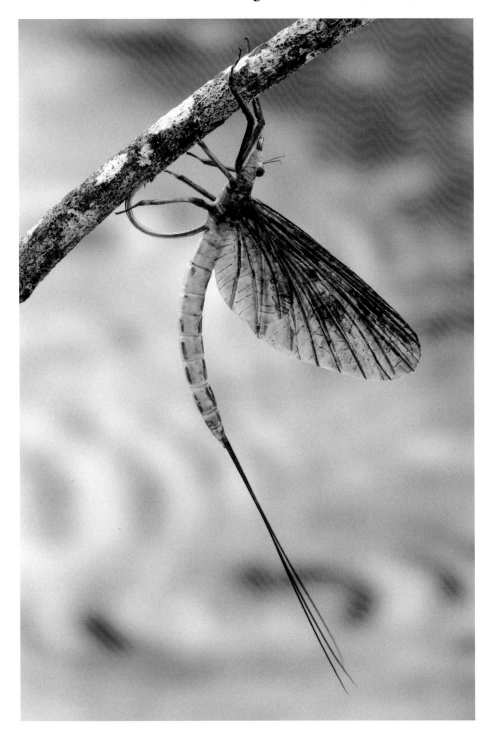

Hook: Kamasan B100, size 14, **Thread:** GSP, 12/0, **Body/thorax:** Teflon tape, **Wing:** Plastic sheet, **Legs:** Bristle brush, **Tail:** Bristle brush, **Eyes:** Black nylon, burned.

Ecdyonurus venosus **Spinner Male—Fabio Federighi**

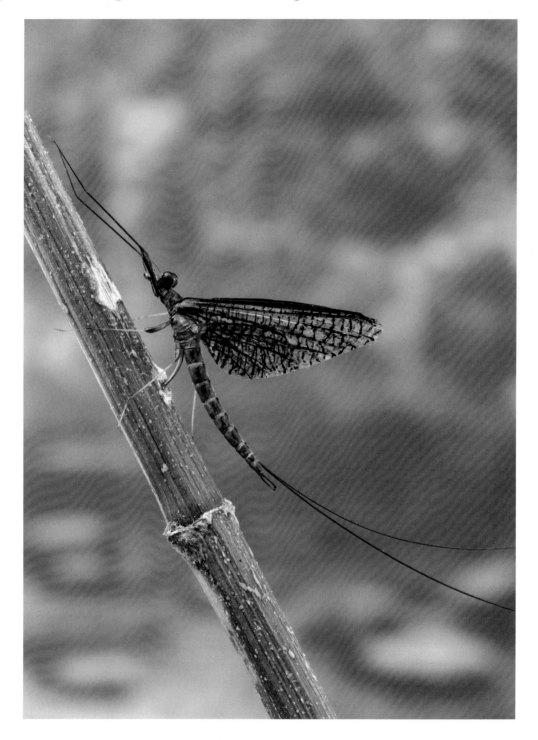

Hook: Kamasan B100, size 14, **Thread:** GSP, 12/0, **Body/thorax:** Teflon tape, **Wing:** Plastic sheet, **Legs:** Bristle brush, **Tail:** Bristle brush, **Eyes:** Black nylon, burned.

Halesus radiatus (caddis)—**Fabio Federighi**

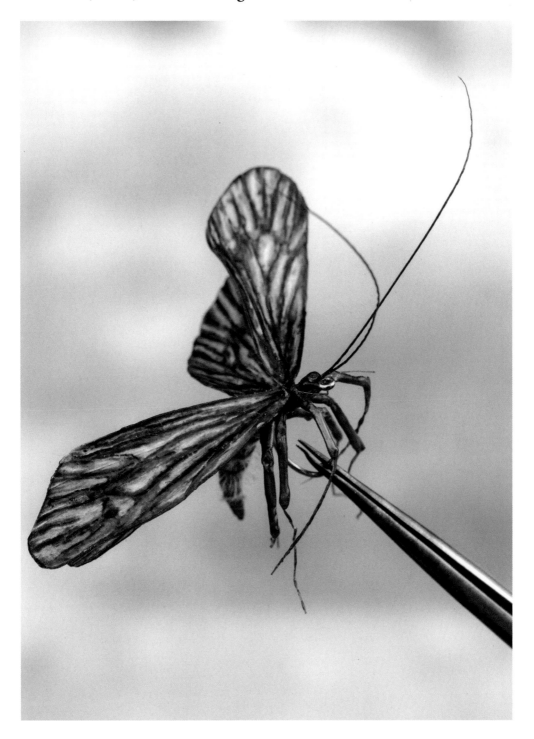

Hook: Kamasan B100, size 14, **Thread:** GSP, 12/0, **Body/thorax:** Teflon tape ribbed with ostrich, **Wing:** Plastic sheet, **Legs:** Bristle brush, **Antennae:** Bristle brush, **Eyes:** Black nylon, burned.

Gammarus Pulex (semi-realistic)—**Fabio Federighi**

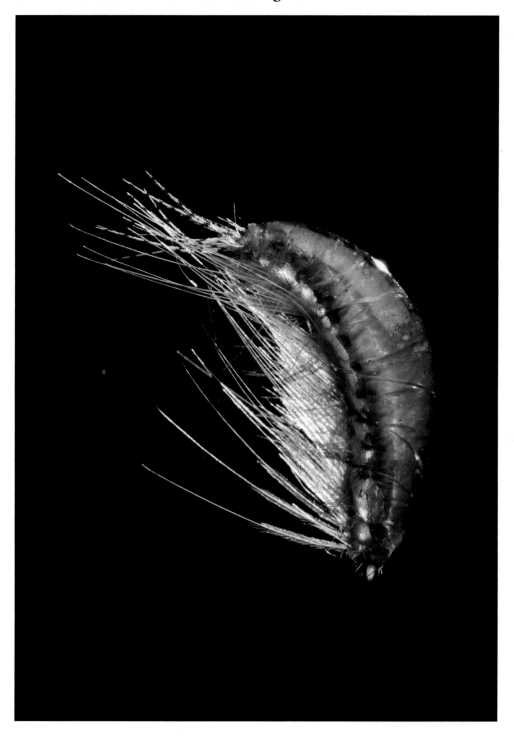

Hook: Kamasan B100, size 12, **Thread:** GSP, 12/0, **Body:** UV glue covered with latex and Sili Skin, **Legs:** Hen, **Antennae:** Lemon wood duck.

Ephemera danica **Nymph (semi-realistic)—Fabio Federighi**

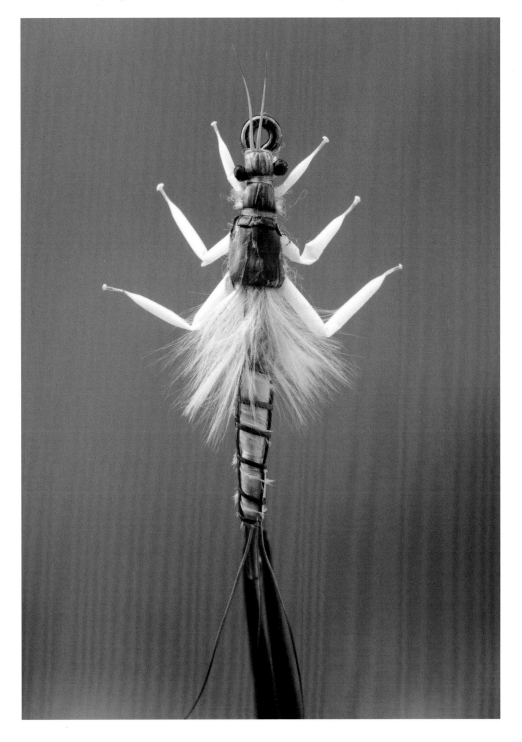

Hook: TMC 200R # 8, **Thread:** GSP 12/0, **Body:** White rayon floss, ribbed with turkey biot and moose mane hair, **Thorax:** Fine poly, **Wing case:** Medallion sheeting.

FABRIZIO GAJARDONI, RIMINI, ITALY

I started fly fishing and fly tying in 1981. My first love were classic flies for trout and grayling. Then, I looked to pike and bass flies. After fifteen years of usual flies, I saw for the first time the full-dress salmon flies. My mind was opened to the great world of artistic flies. A special thanks to my best unforgotten friend Claudio D'Angelo for his help teaching me to tie the classic salmon flies. From 1981 to the end of the century, it was not easy to find information about the tying world in Italy. The internet was in its early stages, and the only source was books. Looking to books, I discovered some realistic flies that blew my mind.

In the first years of this century, I tied my first realistic flies. They were beetles for fishing and they gave me a lot of success with trout and grayling. In 2006 I was lucky to be invited by Paul Schmookler to the International Symposium in Somerset, New Jersey, where I met many great international tiers. Attendees like Bob Mead and Bill Logan helped me to understand the world of realistics.

Many of my flies are as realistic as they can be, but they are intended for fishing. Many others are intended to be realistic and artistic, if I can use this adjective for my flies.

My flies have been published in many magazines such as *Art of Angling Journal* (USA), *Flydresser's Guild* (UK), *Fly Fisher* (Japan), *Freshwater Fishing* (Australia), *Sedge & Mayfly* (Italy) and *Fly Line* (Italy). My work has appeared in many books such as *Fly Tyers of the World* (UK), *Classic Salmon Fly Patterns* (USA), *A World of Pike Flies* (Holland), *Fly Patterns by Fishing Guides* (USA), *Fly Tying* (Italy), and *Salmon Fly Hooks* (USA). I also published my own books, *The Chatterer Portfolio* and *Some of My Favorite Flies*.

Blue Butterfly—Fabrizio Gajardoni

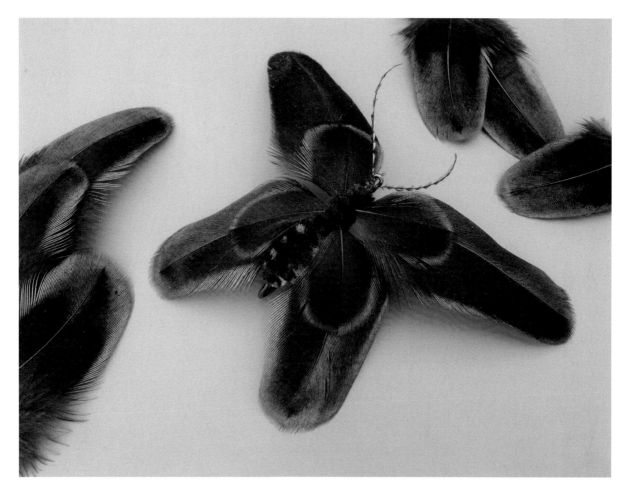

Hook: Salmon/steelhead Blue, size # 1/0, **Thread:** Veevus black #6/0, **Body:** Chartreuse and purple chenille woven, **Wings:** Greenish-blue Malayan pheasant coverts, **Antennae:** Peacock sword fibers.

Bombus—Fabrizio Gajardoni

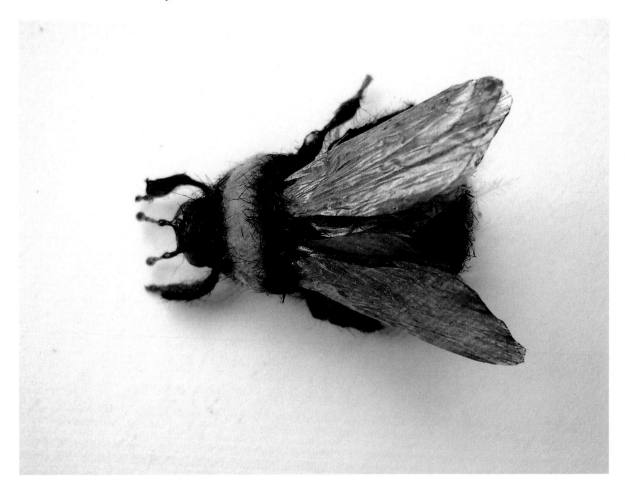

Hook: Tiemco 5212 #8, **Thread:** Veevus black #6/0, **Underbody:** Shaped white foam, with colored yellow and black acrylic hand stripes, **Legs:** Black broom hair with Devcon 5 Minute Epoxy and black ostrich herl chopped and applied over the glued legs, **Body Cover:** A thin line of Devcon 5 Minute Epoxy for each stripe. Apply in sequence, white chopped ostrich herl, black chopped ostrich herl, yellow chopped CDC and again black chopped ostrich herl. **Wings:** Golden yellow raffia doubled in two sizes. The wings are inserted in a small cut on the foam and fixed with Devcon. **Head Cover:** Paint the three stripes of black, yellow, and black with acrylic colors, apply a thin coat of Devcon for each stripe and apply, one by one, black chopped ostrich herl, yellow chopped CDC, and at the end black chopped ostrich herl. **Antennae:** Two black broom hairs inserted in the foam top head. The antennae are covered with Devcon and black chopped ostrich herl. **Eyes:** Two little drops of Devcon 5 Minute Epoxy mixed with golden yellow acrylic color.

Orange Squid—Fabrizio Gajardoni

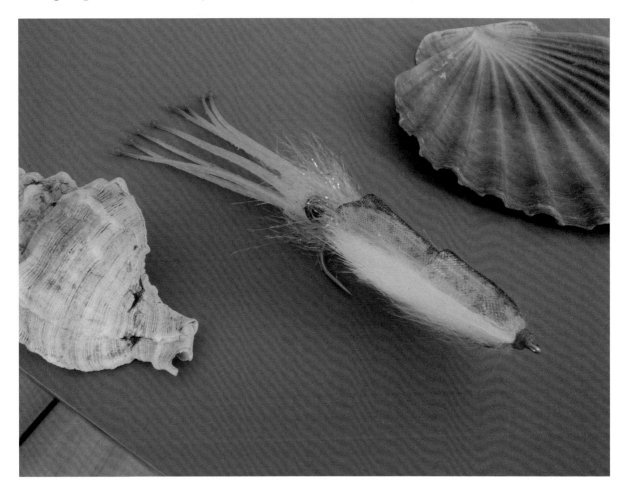

Hook: Tiemco 511S, #2/0, **Thread:** Veevus GSP white #100DEN, **Tentacles:** Silicone imitation anemone, white with pink points. Suckers made with Power Zap Tool at 1200 degrees, colored with permanent orange marker. **Extended Head:** Oval plastic bead. The tentacles are fixed by thread and Devcon 5 Minute Epoxy. Top is a piece of pearl Flexi-Cord. **Eyes:** Plastic eyes, **Hackle:** Natural tan emu feather, **Body:** Pearl Flexi-Cord colored with orange permanent marker with red point.

Gaja's Gobbler—Fabrizio Gajardoni

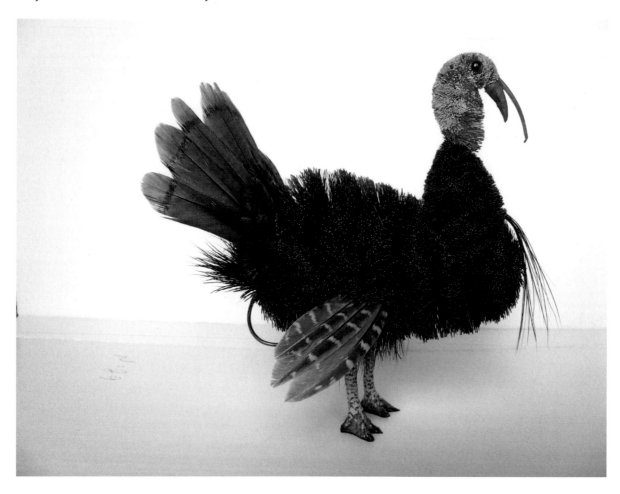

Hook: Tiemco 96P #9/0, **Neck:** 1 mm steel wire, **Snood:** Pink silicone, **Beak:** Foam, **Eyes:** Plastic red eyes, **Head:** Light blue, pink, and gray mixed deer hair, **Body:** Dark brown and rusty brown mixed deer hair. **Wings:** Feathers from partridge wings, **Tail Feathers:** Partridge tail, bleached and dyed in rusty brown, light rusty brown, and black stripe with permanent marker. **Legs:** White foam painted with permanent marker and dark brown and rusty brown mixed deer hair, tied at the end of the legs. **Beard:** Brown heron.

Hot Orange Pike Streamer—Fabrizio Gajardoni

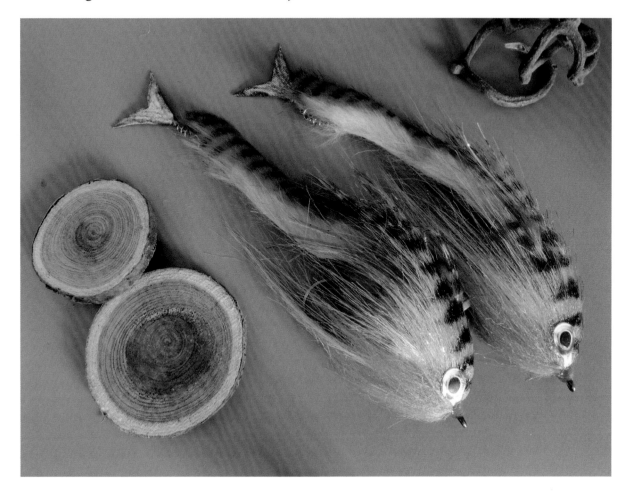

Hook: Partridge Absolute Predator Hook, size #4/0, **Thread:** Veevus fluorescent hot orange, **Tail:** Doubled silver laminated fabric, tied on Owner CPS centering pin, **Long Tail:** Yellow/hot orange barred rabbit zonker tied on Owner CPS centering pin. **Body:** Yellow/hot orange barred rabbit zonker tied around the hook shank with Sili orange/orange black flake, **Head:** Yellow and hot orange craft fur, **Eyes:** Tabbed eyes 10mm.

Micro Mouse—Fabrizio Gajardoni

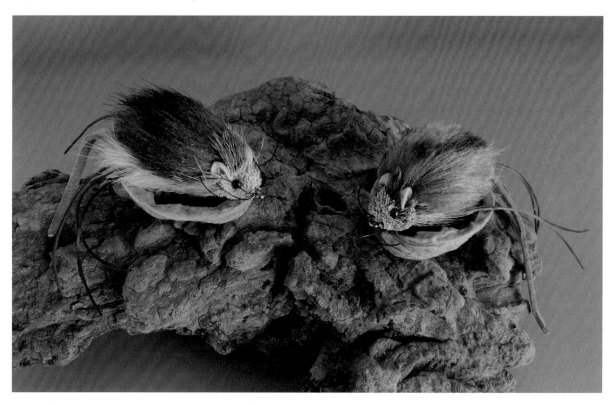

Hook: Tiemco 8082 #2, **Thread:** Veevus brown, #6/0, **Tail:** Natural chamois dyed brown, **Underbody:** Foam cylinder fixed on hook with Devcon 5 Minute Epoxy. **Legs:** Brown rubber legs, **Belly:** Tan rabbit zonker wrapped over the cylinder foam. Fixed with Max Repair Pattex. **Back:** Brown syntethic fur, **Head:** Natural deer hair, **Ears:** Tan suede fabric, **Eyes:** Micro plastic eyes, **Whiskers:** Brown rubber legs.

Platypus—Fabrizio Gajardoni

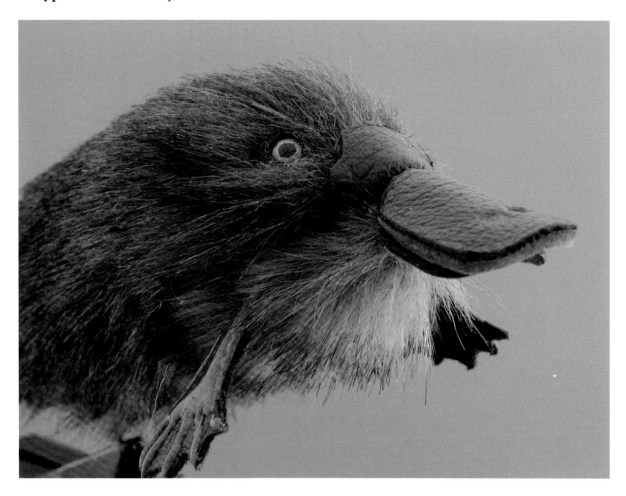

Hook: Tiemco 96P, #9/0, **Thread:** UNI Thread Big Fly Black, **Tail:** Shaped foam with brown synthetic fur, **Underbody:** Foam cylinder fixed with Devcon 5 Minute Epoxy, **Legs:** Shaped brown natural skin, Devcon 5 Minute Epoxy mixed with rusty-brown acrylic color, **Belly:** Rusty synthetic fur zonker wrapped over the foam cylinder. Fixed with Max Repair Pattex. **Back:** Brown syntethic fur fixed on shaped foam. **Eyes:** Small plastic eyes 3mm, **Bill:** Brown foam fixed to natural skin brown.

Beagle Dog—Fabrizio Gajardoni (Tied as a Christmas gift for my friend Massimo Masi. Poldo was his dog)

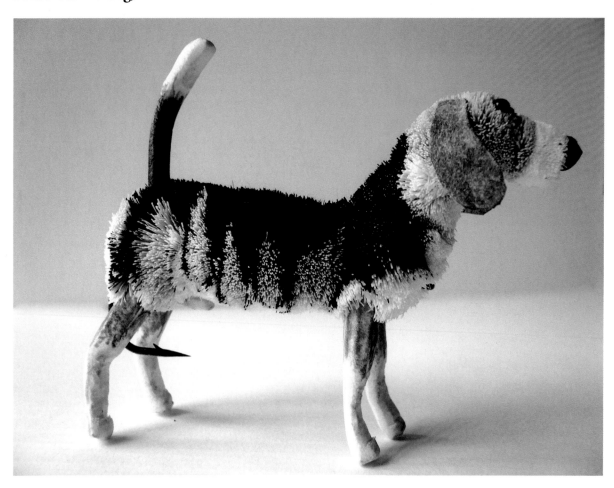

Hook: Tiemco 96P #9/0, **Thread:** UNI Thread, Big Fly, white, **Neck:** 1mm steel wire, **Tail:** White foam colored by permanent marker, **Body:** White, tan, brown and black deer hair, **Head and Neck:** Same as body, **Ears:** Chamois fabric colored with permanent marker, **Eyes:** Small plastic black eyes, **Nose:** Black foam.

Winged Beetle—Fabrizio Gajardoni

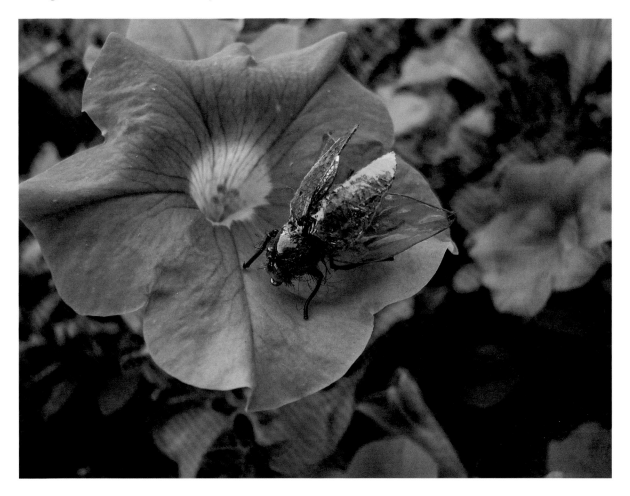

Hook: Tiemco 2312, size 12, **Thread:** Veevus black, 8/0 , **Body:** Orange seal fur with black foam over, **Legs:** Black plastic tube, **Wings:** Transparent gray plastic foil over iridescent green foil. **Head:** 2mm black foam painted with iridescent acrylic color.

Jurassic Dragonfly—Fabrizio Gajardoni

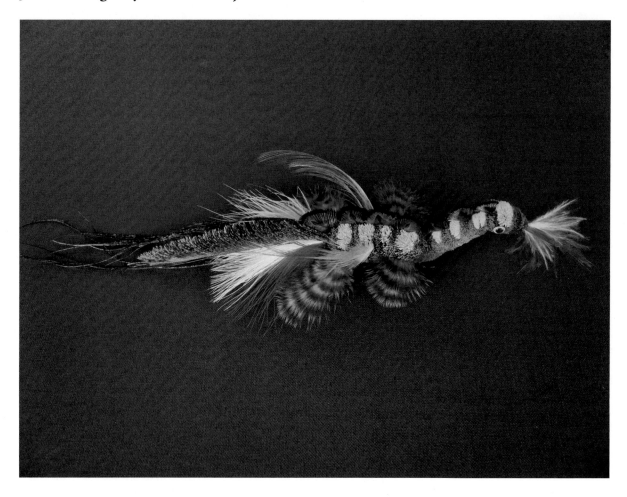

Hook: Daiichi 2051, size2/0, **Thread:** Veevus 6/0 light brown, **Extended Body:** Small foam cylinder cover by jungle cock nails, **Legs:** Peacock sword fibers with Devcon 5 Minute Epoxy mixed with amber acrylic color, **Underbody:** Amber Ice Chenille, Over **Body:** Foam painted with dark olive-golden acrylic, **Wings:** Plain pearl film, hand embossed by a needle, four jungle cock nails over the plastic wings, **Eyes:** Devcon 5 Minute Epoxy mixed with phosphorescent acrylic.

Scrat—Fabrizio Gajardoni

Hook: Partridge Attitude Streamer and 1mm steel wire, **Nose:** Black FIMO, **Head:** Natural deer hair, **Eyes:** 10 mm white plastic beads and 4 mm Live Eyes, **Ears:** Tan chamois fabric, **Upper Legs:** Tan chamois fabric, Lower **Legs:** Tan chamois fabric with two pieces of natural deer hair pasted on, **Body:** Bleached and natural deer hair, **Fangs:** White foam, **Acorn:** Bronze hook shank with rusty brown and dark brown deer hair, **Scrat's Rod:** Pheasant wing quill with natural chamois handle, **Reel:** Gray button, **Tippet:** Antique silkworm gut, **Fly:** Red Tag, size 28.

GABRIEL DUMITRU GREBENISAN, ICELAND

I live in Iceland and was born in Romania, forty-five years ago. I started dressing flies almost three years ago. I say better late than never. At the beginning of the adventure with fishing, the first trout came hard, very hard. For this reason, I started to tie realistic flies. I thought if it looks good to a man it looks good to a fish, too. I now believe it is not really like that because people are easier to impress. Fish are not so easily impressed. Fly fishing is not only about presentation, water temperature, weather, season, exploration of life in water, equipment, and finally about flies.

What realistic flies bring to me is a lot of friends, challenge, and relaxation. This is what I call satisfaction, and the fishing time became more special, adding emotion, self-control, patience and attention to detail so in the end I understood why I need one hundred meters of backing on my fishing reel.

As you can see in this book, I'm not the only one passionate about this. I definitely have more to discover to bring art to the fishing side, which many people appreciated and encouraged.

I always look to the new tyers who tie wonderful new artistic and realistic patterns. I believe that the world of realistics will improve even more now with the new synthetic materials that come out each day.

Amata phegea—**Gabriel Dumitru Grebenisan**

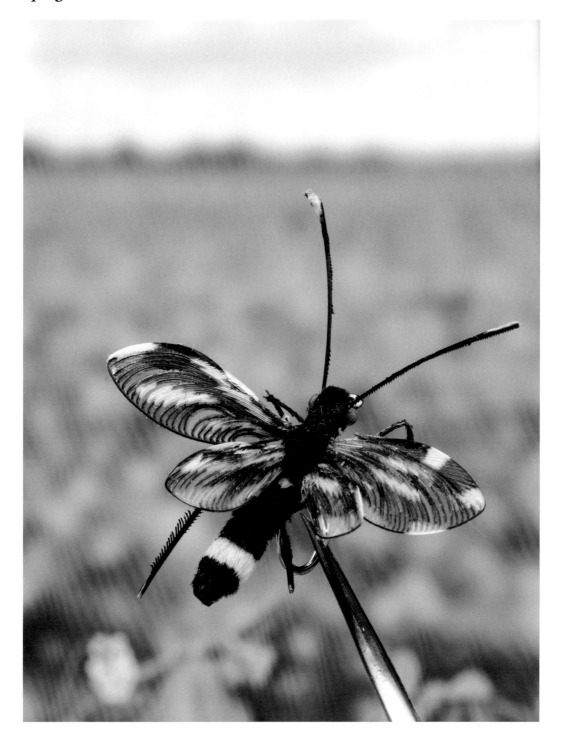

Hook: #8 Grubber (Kamasan), **Thread:** UNI-Thread 8/0w, black, **Head:** Black foam, turkey feather fibers, olive mono nymph eyes, feather rachis (stem), **Wings:** Guinea fowl feathers, **Body:** Black rooster tail feather barbs and yellow turkey feather barbs, **Legs:** Feather rachis (stem), **UV resin:** Loon Outdoors.

Damselfly—Gabriel Dumitru Grebenisan

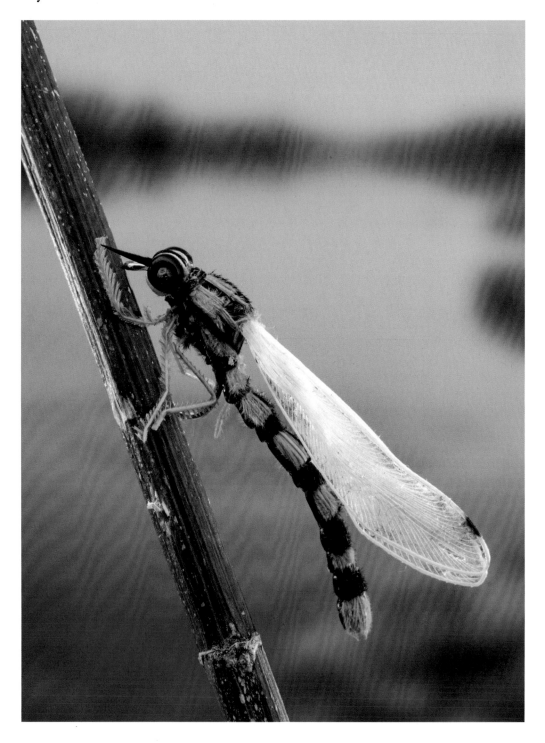

Hook: #10 Grubber, **Thread:** UNI 8/0w black, **Head:** Tan goose biots, damsel large eyes (Veniard), blue foam, **Wings:** White rooster back large feathers, **Body and tail:** Light blue turkey feather barbs, Veniard's black body stretch, **Legs:** Feather rachis (stem), **Cement:** UV resin.

Green Butterfly—Gabriel Dumitru Grebenisan

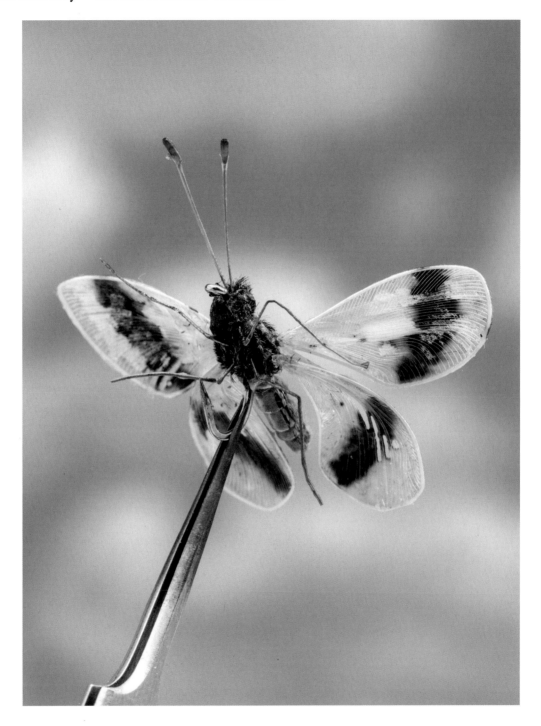

Hook: #10 Grubber, **Thread:** UNI 8/0w black, **Head:** Black foam, rachis of feather, peacock feather barbs, **Wings:** Green large rooster feathers, black marker, **Body:** Foam, peacock feather barbs, **Tail:** Olive turkey feather barbs, green UNI-Floss, olive body stretch (Veniard) and foam, **Legs:** Rachis of feather, **Cement:** UV resin.

Honeybee—Gabriel Dumitru Grebenisan

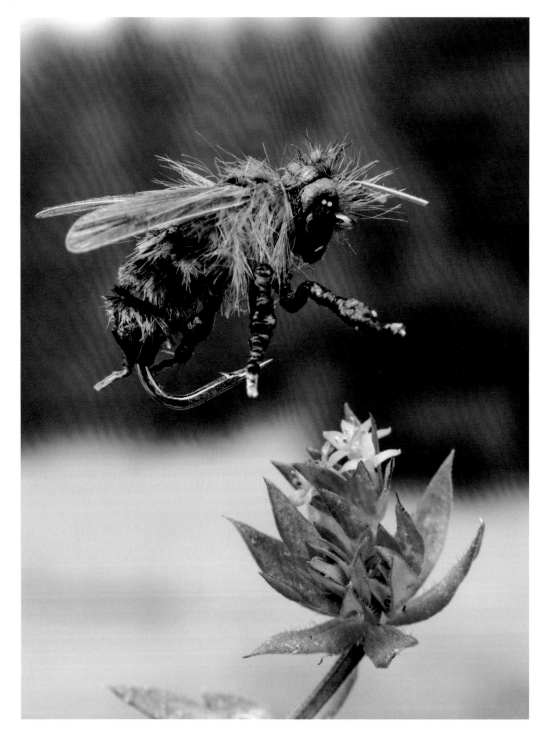

Hook: #10 Grubber, **Thread:** Black UNI-Thread, 8/0w, **Head:** Brown foam, rachis of feather, ostrich feather barbs, black nail polish for eyes, **Wings:** Short brown rooster feathers, **Body and tail:** Ostrich feather barbs, black body stretch, **Legs:** Thread tie up around the rachis of feather and superglue, **Cement:** UV resin.

Wasp—Gabriel Dumitru Grebenisan

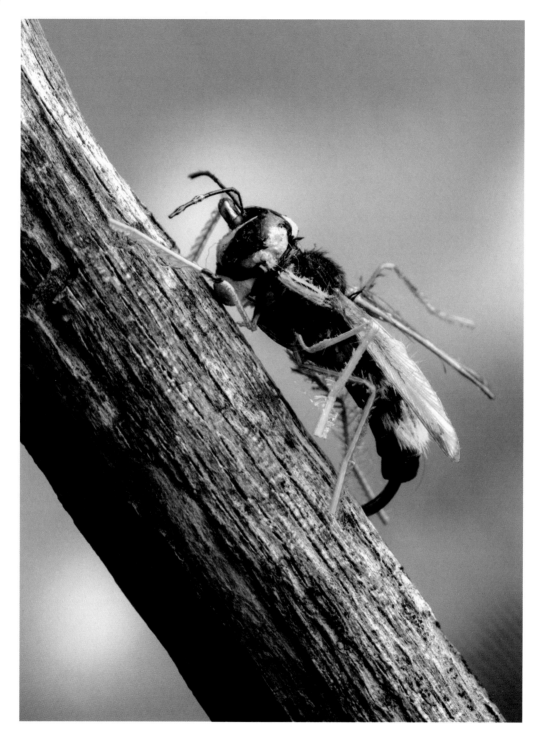

Hook: #8 trout heavy traditional, **Thread:** UNI 8/0w black, **Head:** Yellow foam, black UNI-Floss, brush wire and black nail polish, **Wings:** Brown rooster feathers, **Body and tail:** Black and yellow turkey barbs feather, black body stretch, **Legs:** Rachis of yellow feathers, **Cement:** UV resin.

Black Ant—Gabriel Dumitru Grebenisan

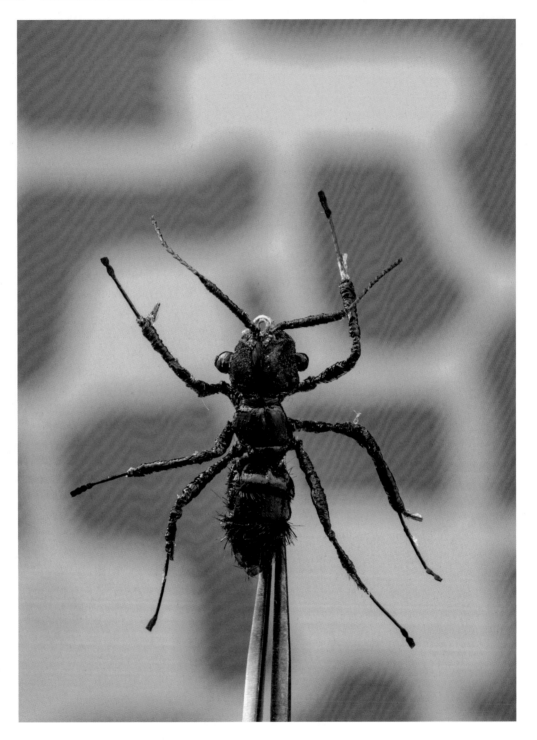

Hook: #16 salmon single, **Thread:** UNI-Thread, 8/0w black, **Head:** Black foam, black UNI-Floss, manufactured eyes, brush wires, **Body:** Black foam, black body stretch, ostrich feathers, barbs, **Legs:** Brush wire with thread tied around it and pheasant feather barbs, **Cement:** Veniard's varnish clear (fine).

Caddis Fly—Gabriel Dumitru Grebenisan

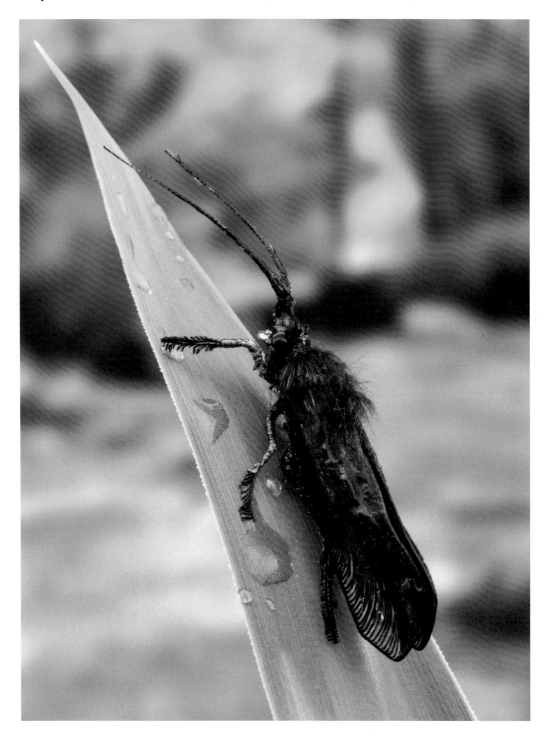

Hook: #10 Grubber, **Thread:** Black UNI 8/0w black, **Head:** Light brown thread 8/0w, manufactured eyes, rachis of feather, **Wings:** Brown large cock hackle, **Body:** Brown marabou turkey, yellow and black turkey fibers, **Legs:** Rachis of feather, **Cement:** Veniard's varnish clear (fine) and UV resin.

Green Mayfly Nymph—Gabriel Dumitru Grebenisan

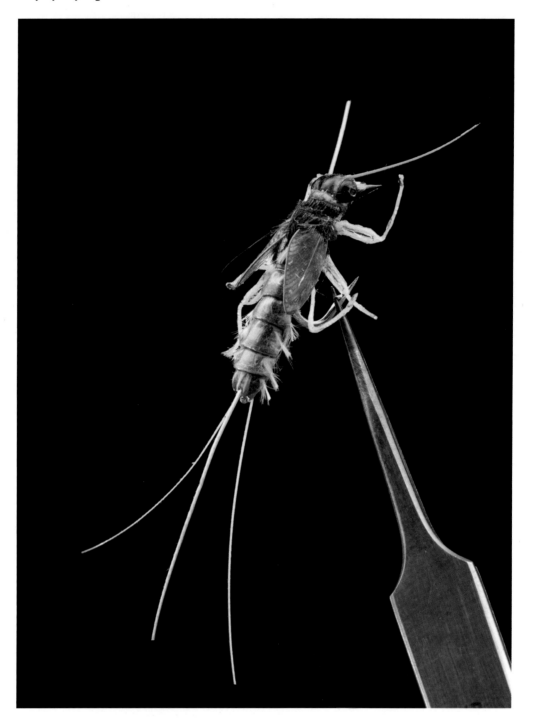

Hook: #10 Grubber, **Thread:** Black UNI-Thread 8/0w, **Head:** Green foam, .025 lead wire, heavy eyes, tan goose biots, olive body stretch, feather rachis, **Wings:** Olive cock hackle, **Body and Tail:** Green foam, black body stretch, olive body stretch, white ostrich barbs, green goose wings feathers (barbs), white UNI-Floss and feather rachis, **Legs:** UNI-Floss, **Cement:** Veniard's varnish clear (fine) and UV resin.

Mayfly—Gabriel Dumitru Grebenisan

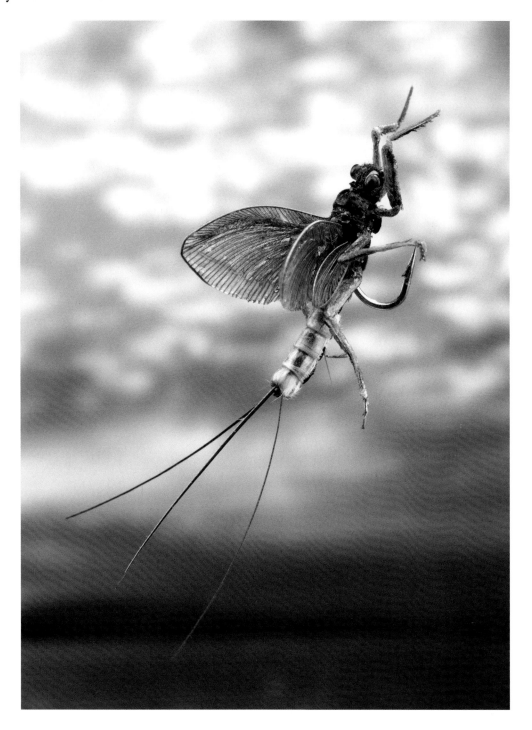

Hook: #10 Grubber, **Thread:** Black UNI-Thread 8/0w, **Head:** Brown foam, olive mono nymph eyes, pheasant tail barbs, **Wings:** Olive cock hackle, **Body and Tail:** Black and olive body stretch, white fiber of swan feathers, foam, feather rachis, **Legs:** Feather rachis and UNI-Floss, **Cement:** Veniard's varnish clear (fine) and UV resin.

Stone Fly Nymph—Gabriel Dumitru Grebenisan

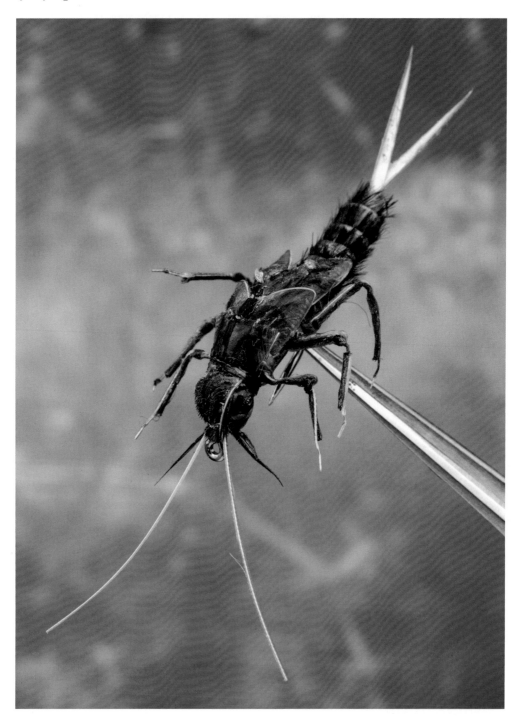

Hook: #10 Grubber, **Thread:** UNI-Thread 8/0w black, **Head:** Brown foam, tan goose biots, heavy eyes, brown cock neck hackle, feather rachis, **Body:** Yellow foam, brown body stretch, black UNI-floss, brown cock neck hackles, **Tail:** Brown body stretch, black ostrich feather barbs, tan goose biots, **Legs:** UNI-Floss and feather rachis, **Cement:** Veniard's varnish clear (fine) and UV resin.

Stone Fly Adult—Gabriel Dumitru Grebenisan

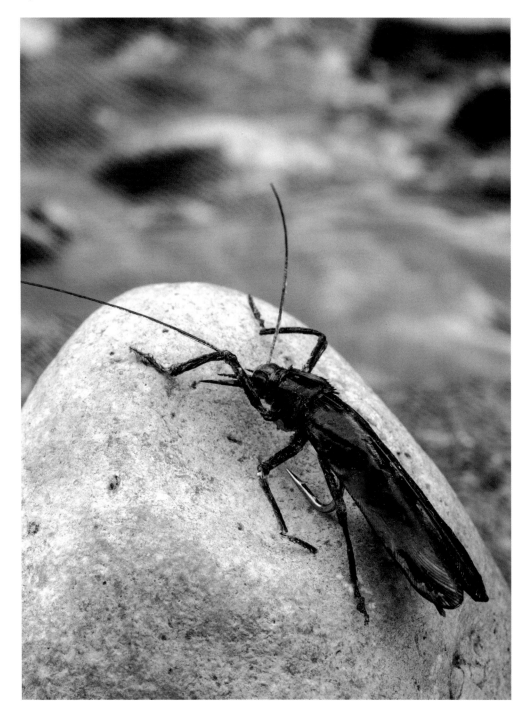

Hook: #10 Grubber, **Thread:** UNI-Thread 8/0w black, **Head:** Light and dark brown foam, black goose biots, mono nymph eyes, clear body stretch, feather rachis, **Wings:** Brown large cock hackle, **Body and Tail:** Yellow foam, brown body stretch, black barbs from turkey feather, feather rachis, **Legs:** UNI-Floss and feather rachis ending with thin peacock barbs, **Cement:** Veniard's varnish clear (fine) and UV resin.

DAVIDE GUARNIERI, ITALY

I live in a small town in northern Italy. I have been fly fishing for more than twenty years, and from the first day I learned this technique, I was captivated by its beauty. Thanks to fly fishing I have met and am meeting wonderful people. I have a great love for this technique! In the early years I bought flies in various specialized stores. As time passed, I decided to learn how to tie flies, and from that day on I was fascinated. Now I tie flies of all kinds and enjoy sharing photos with friends on various Facebook groups. For a few months now, I've been trying to tie realistic flies. This way of tying flies amuses me, and I hope you will like my dressings. I consider myself a person who still has a lot to learn, and hope that you may value what I can humbly share with you.

Adult Stone Fly—Davide Guarnieri

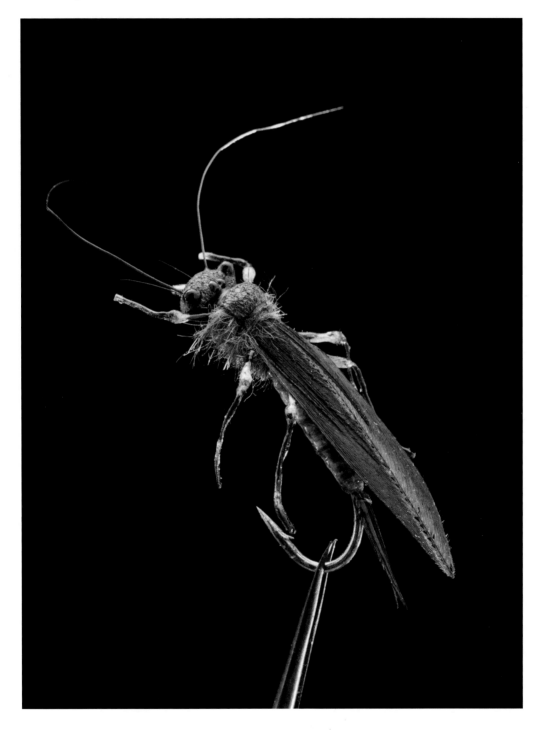

Hook: TMC 2302 # 6, **Thread:** Semperfli Nano Silk 14/0. **Tail:** Wapsi biots rusty brown, **Body:** Colored Teflon and Gulff Uv resin, **Thorax:** Brown rabbit dubbing, **Wing:** Whiting Coq de Leon bronze, **Legs:** UNI-Thread yellow 6/0 and Gulff Uv resin, **Head and wing bag:** Brown foam, **Eyes:** Gulff Uv resin, **Antennae:** Moose mane.

Black Widow—Davide Guarnieri

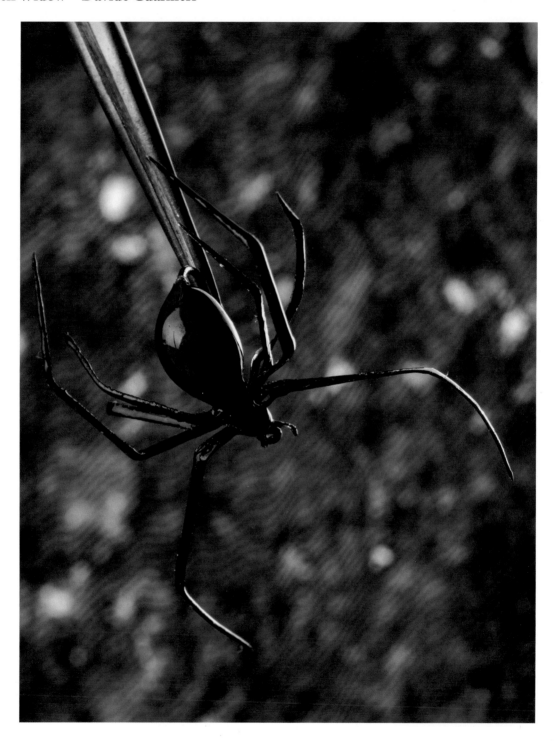

Hook: J:son Ultimate Grub #12, **Thread:** Veevus GSP 50D black, **Body:** Black foam, Veevus GSP and Gulff UV resin, **Legs:** Veniard black pheasant fibers and Gulff UV resin.

Reverse Ephemeral—Davide Guarnieri

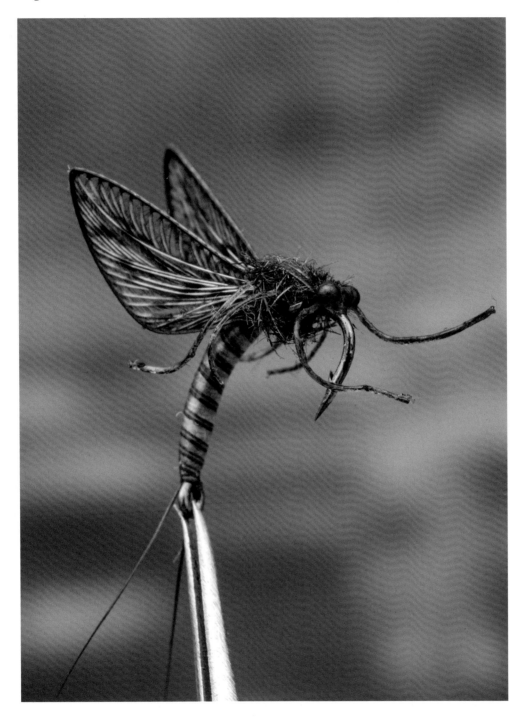

Hook: J:son Ultimate Grub #14, **Thread:** Semperfli Nano Silk 14/0, **Tail:** Wapsi moose mane, **Body:** Semperfli Nano Silk stripped peacock quill and Gulff UV resin, **Wing:** Whiting Coq de Leon bronze, **Wing sac:** Veniard pheasant fibers, **Legs:** Veevus GSP 100D and Gulff UV resin, **Thorax:** Hare's ear dubbing, **Eyes:** Nylon.

Metamorphosis—Davide Guarnieri

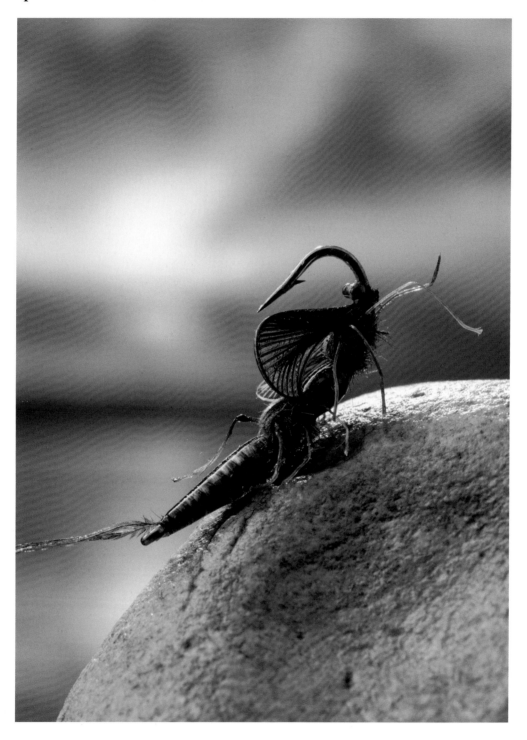

Hook: TMC 200r #8, **Thread:** Semperfli Nano Silk 14/0, **Tail:** Wapsi mallard bronze, **Body:** Semperfli Nano Silk, stripped peacock quill and Gulff UV resin, **Wing sac:** Veniard pheasant fibers, **Legs:** Veevus GSP 100D and Gulff UV resin, **Thorax:** hare dubbing, **Wing:** Whiting Coq de Leon bronze: **Eyes:** Nylon.

Brown Grasshopper—Davide Guarnieri

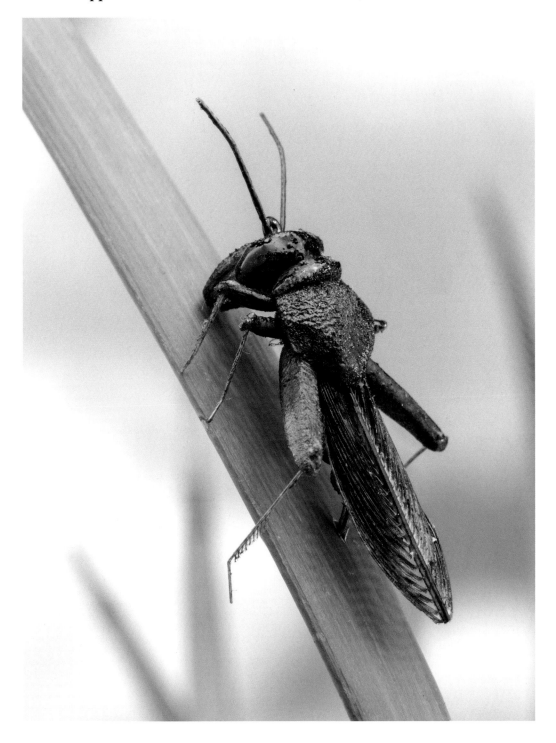

Hook: J:son Ultimate Nymph #8, **Thread:** Semperfli Nano Silk 14/0, **Body:** Brown foam, **Legs:** Brown foam and rooster calamus, **Wing:** Veniard pheasant, **Thorax:** Brown dubbing, **Wing bag:** Brown foam, **Head:** Brown foam: **Eyes:** Gulff Uv resin. **Antennae:** Cock calamus.

Wasp—Davide Guarnieri

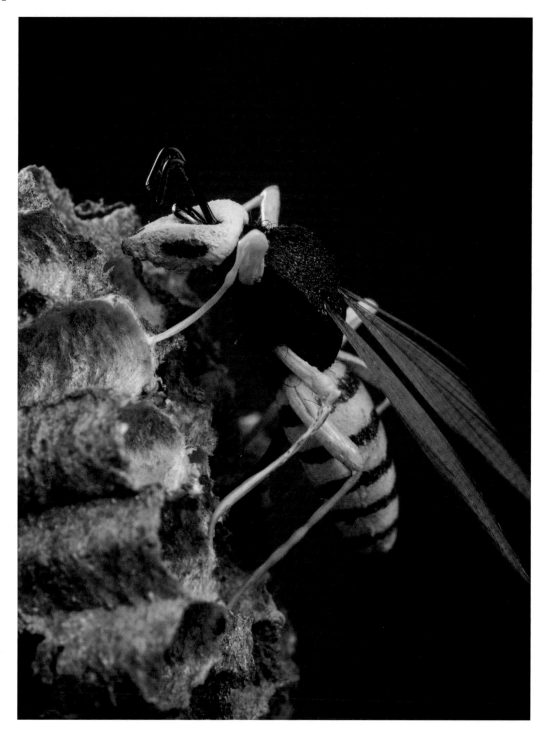

Hook: J:son Ultimate Grub # 12, **Thread:** Semperfli Nano Silk 14/0, **Body:** Yellow colored foam with marker, **Legs:** Veevus GSP 100D and Gulff UV resin, **Thorax:** Black mole dubbing, **Wing bag:** Black foam, **Head:** Yellow foam, **Eyes:** Gulff UV resin, **Antennae:** Broom bristles.

Caddis Pupa—Davide Guarnieri

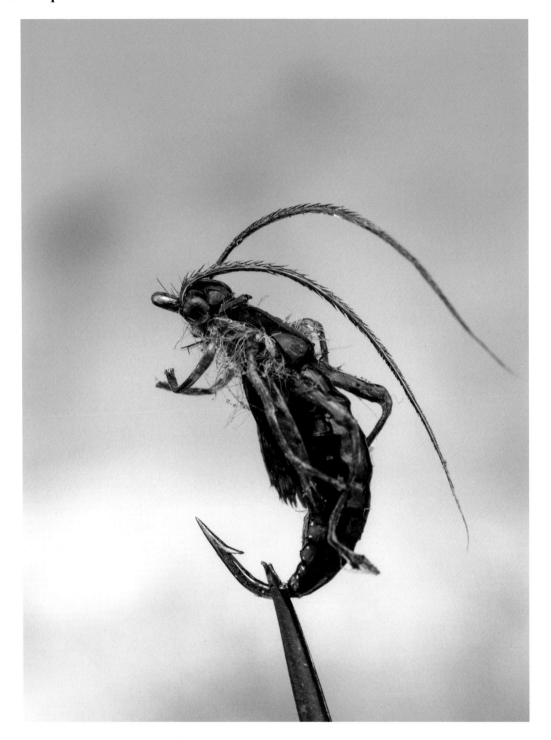

Hook: J:son Ultimate Grub # 12, **Thread:** Semperfli Nano Silk 14/0, **Body:** Skin Nymph colored with marker, **Legs:** Veevus GSP 100D and Gulff UV resin, **Wing bag:** Sybai flat body glass brown, **Thorax:** Hare's ear dubbing, **Eyes:** Nylon, **Antennae:** Veniard pheasant fibers.

Reverse Mayfly—Davide Guarnieri

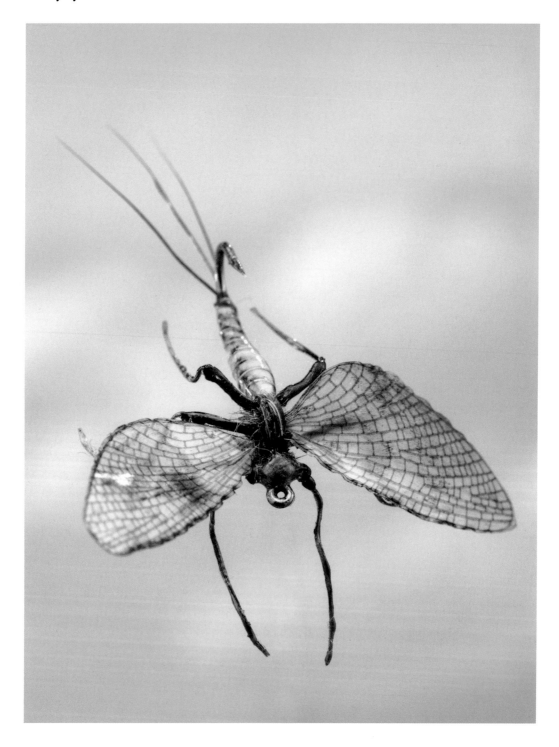

Shaped hook: TMC 200r #12, **Thread:** Semperfli Nano Silk 18/0, **Tail:** Wapsi moose mane, **Body:** Colored Teflon, **Rib:** Nylon, **Wing sac:** Veniard pheasant fibers, **Legs:** Veevus GSP 100D and Gulff UV resin, **Thorax:** Hare's ear dubbing, **Wing:** J:son Realistic Wing material M2, **Eyes:** Nylon.

Rhyacophila—Davide Guarnieri

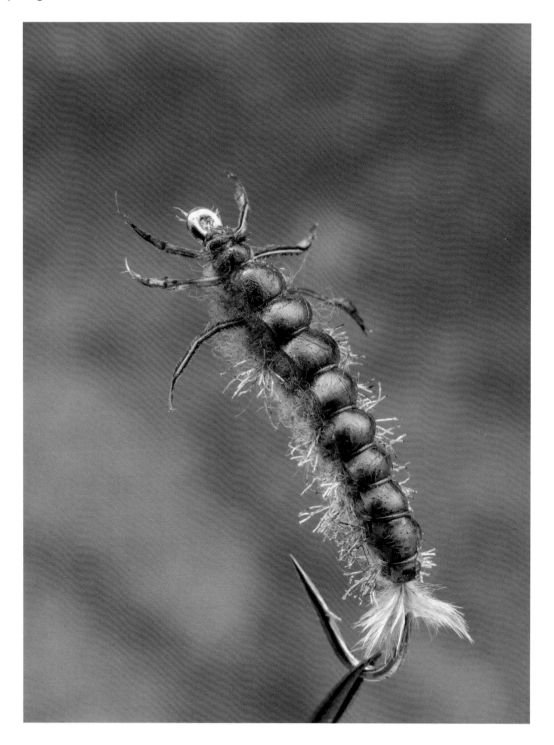

Hook: TMC 200r # 12, **Thread:** Semperfli Nano Silk 18/0, **Tail:** Under feather, **Rib:** Nylon, **Tracheo gills:** Puglisi Ep fibers, **Body:** Hareline superfine dubbing olive and Wapsi Thin Skin, **Legs:** Veniard pheasant fibers.

Gammarus—Davide Guarnieri

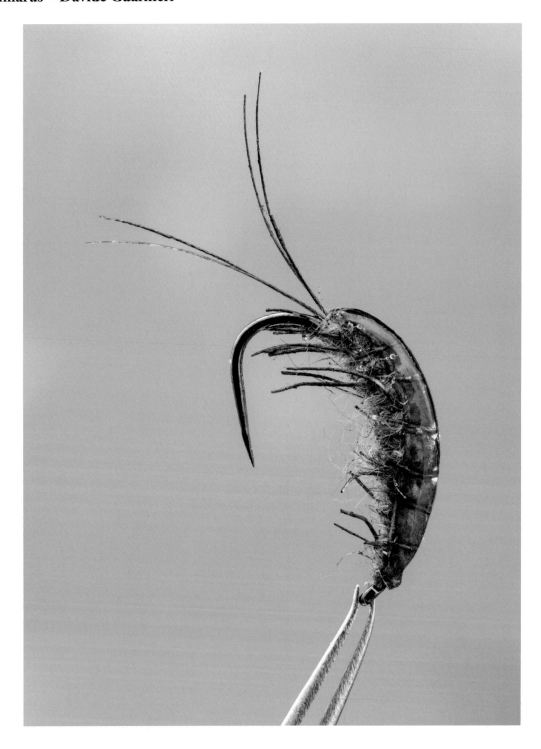

Hook: Hanak 300bl # 12, **Thread:** Semperfli Nano Silk 18/0, **Rib:** Nylon, **Back:** Wapsi Thin Skin colored with marker, **Body:** Hare's ear dubbing, **Legs:** feather quills, **Antennae:** Feather quills.

FRED HANNIE, LOUISIANA

I am a dental technician by trade, and spend most days making dental prosthetics to help people smile again. But, my passion has always been fly fishing, and subsequently, fly tying by extension. I started out by adapting cold water patterns to warm water situations. Eventually I decided to create flies that looked like the actual insects I was trying to mimic. I tried many different techniques and materials with modest results, and posted my flies for critique on various fly-fishing forums. Eventually, through the forums, I became friends with David R. Martin.

David was an incredible wildlife artist in various mediums (painting, sculpture) and brought his talents to tying realistic flies. David mentored me, teaching me many of his techniques and his philosophy for creating patterns. David used his techniques to create realistic flies to fish for trout. I adapted David's techniques to create flies to fish the warm- and saltwater fish of the gulf coast.

"Realistic fly tying," as it has come to be called, can seem to be a daunting endeavor for the average fly tyer, but I think learning the techniques will turn out to be a worthwhile effort. If you look at the evolution of bait-casting lures, they have moved to more and more realistic versions.

My flies have been featured in many magazine publications such as the *Fly Fishing & Tying Journal, Fly Fusion, Fly Fisher, Tail Fly Fishing Magazine,* and *Fly Tyer.* My flies have also appeared in several books such as *The Art of the Fishing Fly* (Tony Lolli), *Tying Bugs* (Kirk Dietrich), *Super Flies* (Pat Cohen), and *Fly Tying With Monofilament.*

My flies have also made it to Hollywood as movie props for television (*Castle,* season 8, episode 12) and for the big screen (*Scorched Ladders*).

Green Bird Grasshopper—Fred Hannie

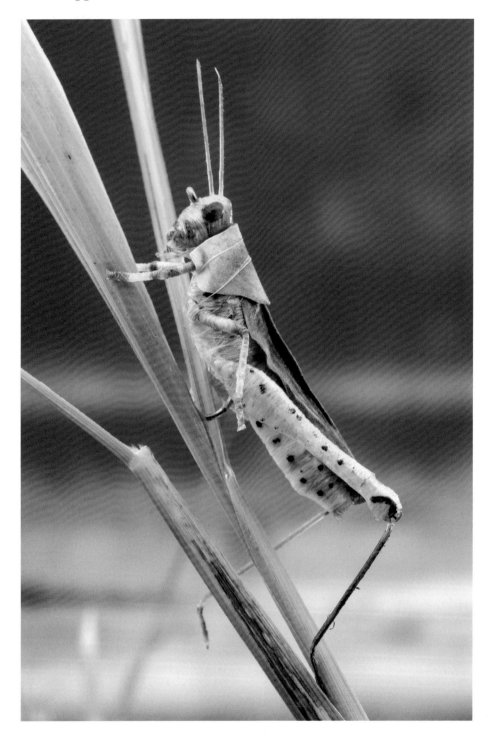

Hook: Size 6, **Body:** Deer hair and monofilament, **Wings:** Tissue paper and head cement, **Legs:** Monofilament.

Dragonfly Nymph—Fred Hannie

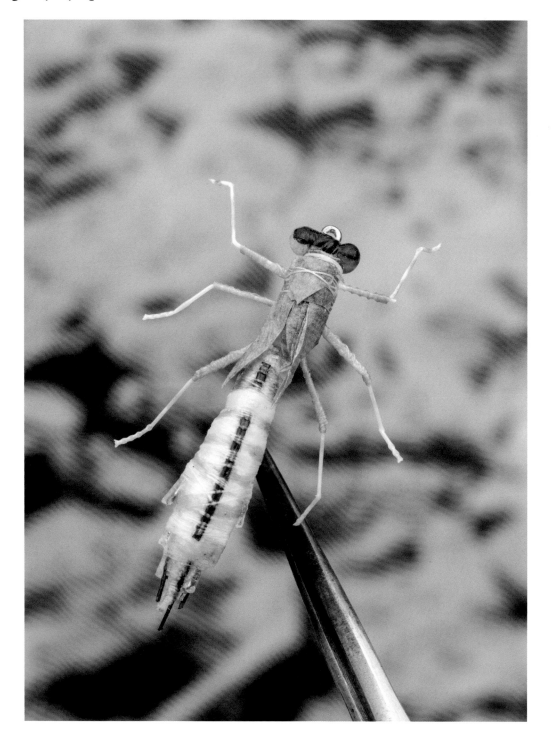

Hook: Size 10, **Body:** Monofilament and thread, **Eyes:** 50-pound monofilament, **Legs:** Monofilament.

Bumblebee—Fred Hannie

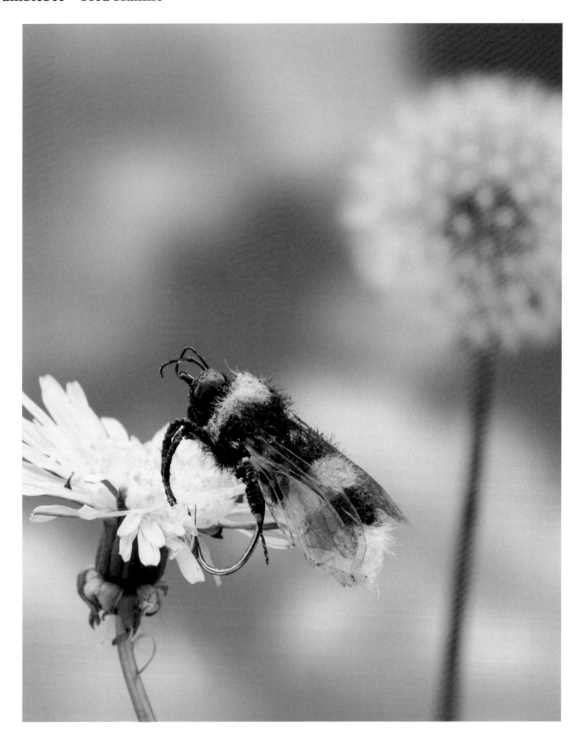

Hook: Size 10, **Body:** Deer hair, thread, and monofilament covered with Furry Foam, **Wings:** Clear acetate sheets, **Legs:** Monofilament.

Honeybee—Fred Hannie

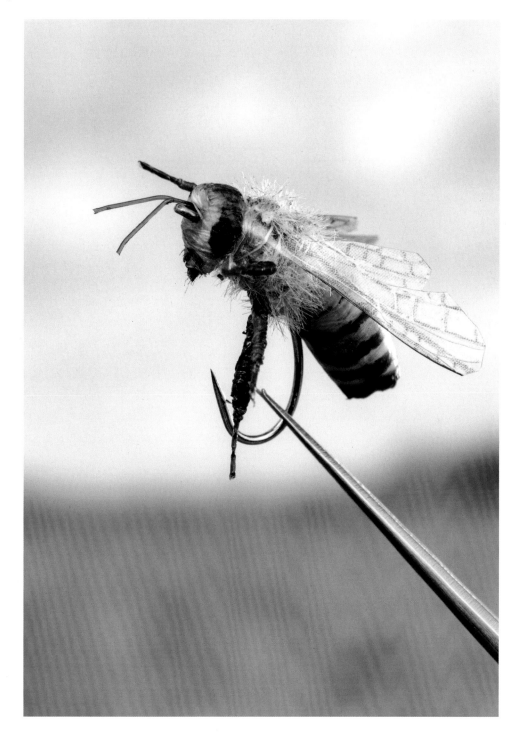

Hook: Size 10, **Body:** Deer hair, thread, and monofilament, **Thorax:** Covered with Furry Foam, **Wings:** Clear acetate sheets, **Legs:** Monofilament.

Flier—Fred Hannie

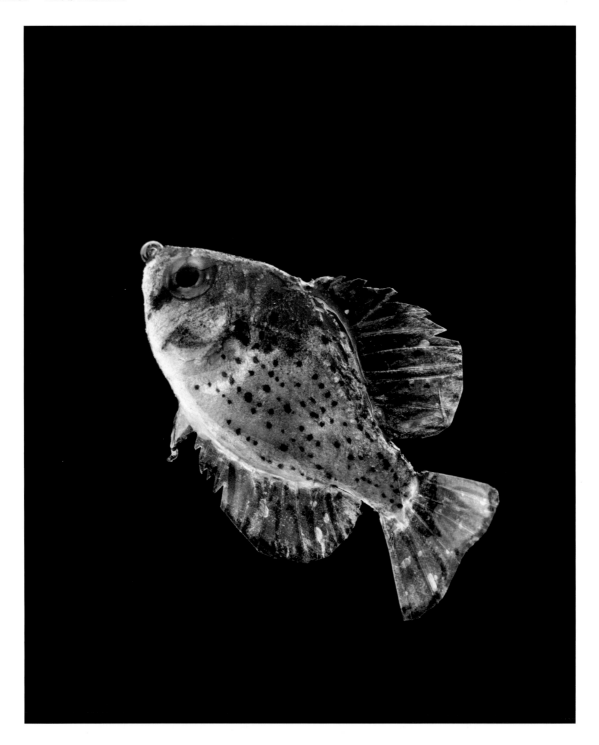

Hook: Stinger, **Body:** Foam, **Eye:** UV resin, **Fins:** Monofilament and tissue paper.

Dusky Grasshopper/Bird Hopper—Fred Hannie

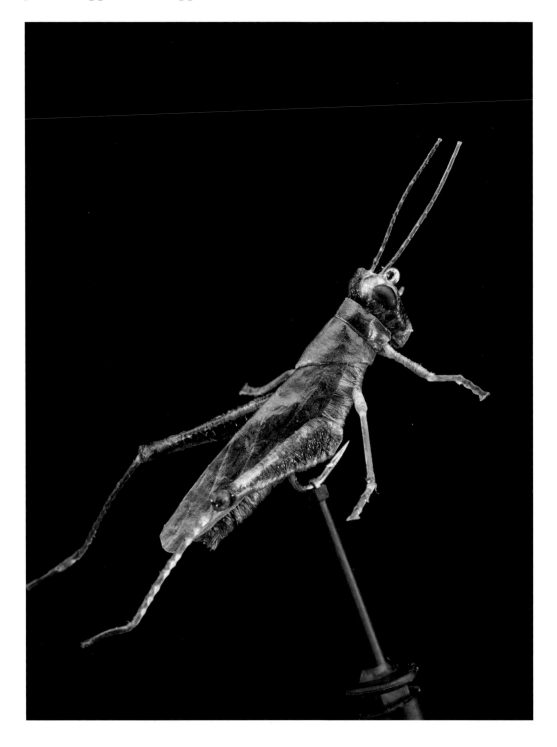

Hook: Size 6, **Body:** Deer hair and monofilament, **Wings:** Tissue paper and head cement, **Legs:** Monofilament.

Strawberry Poison Dart Frog—Fred Hannie

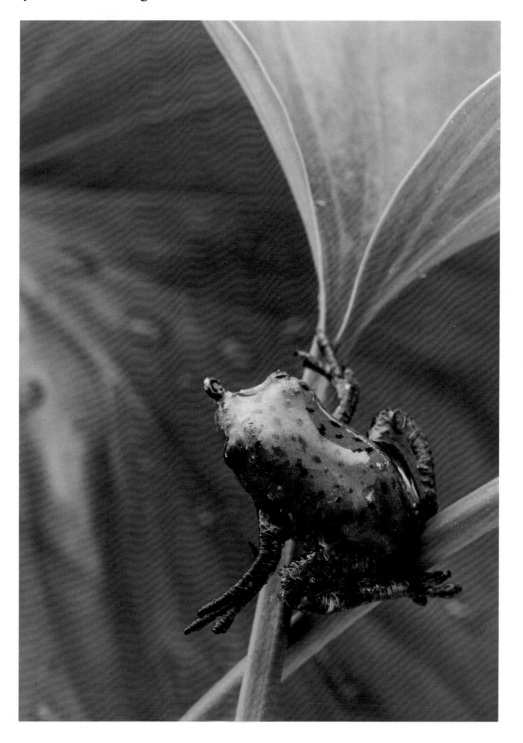

Hook: Size 8, **Body:** Foam, **Eyes:** 100-pound monofilament melted, **Legs:** Monofilament and thread.

Black Widow Spider—Fred Hannie

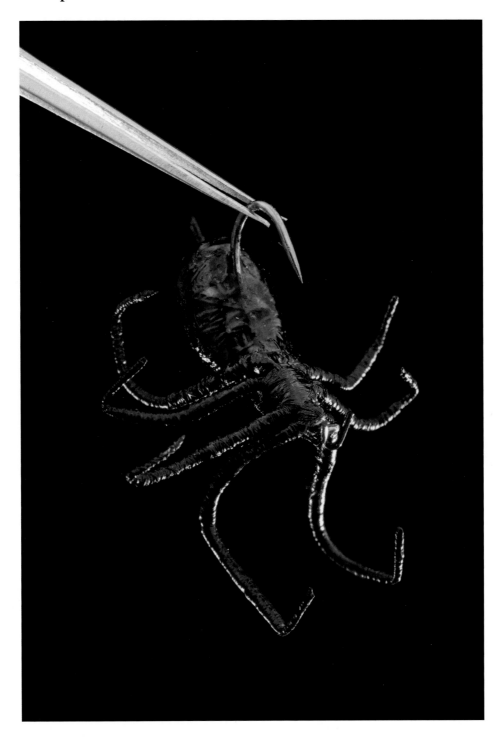

Hook: Mustad R73-9671, size 6, **Thread:** Danville's 6/0 white, **Body:** Deer hair, thread, and monofilament, **Legs:** Ultra wire, thread, **Markers:** Copic black, dark bark, lip red.

Fiddler Crab—Fred Hannie

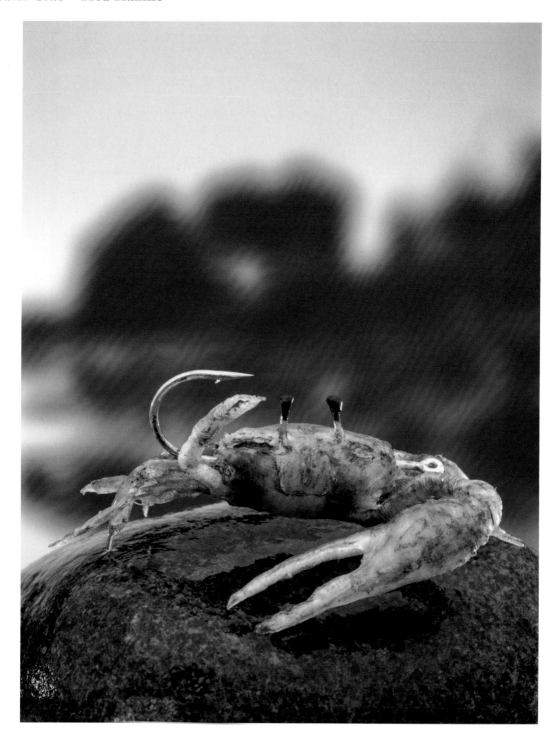

Hook: Mustad S71SZ-34007, size 6, **Thread:** Danville's 6/0 white, **Body:** Deer hair, thread, and monofilament, **Legs:** Thread, monofilament, **Markers:** Copic dark bark, brick beige.

Red Paper Wasp—Fred Hannie

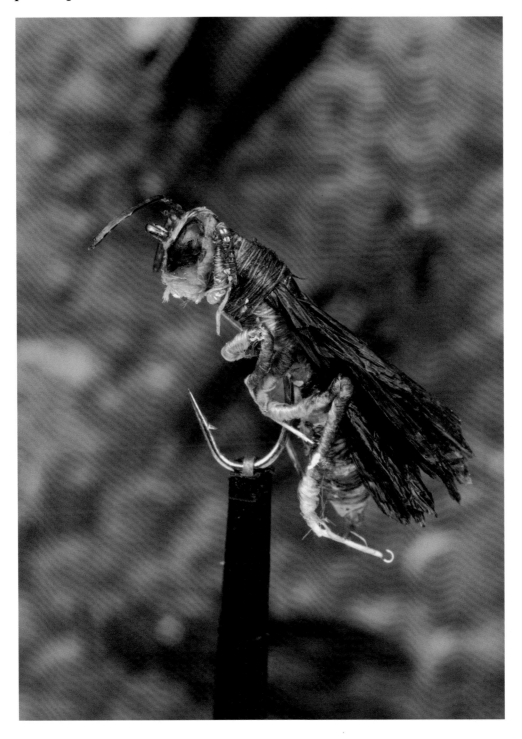

Hook: Daiichi 1160, size 14, **Thread:** Danville's 6/0 white, **Body:** Deer hair, thread, and monofilament, **Wings:** Swiss straw, **Markers:** Copic golden yellow, burnt sienna, dark bark.

Yellow Hornet—Fred Hannie

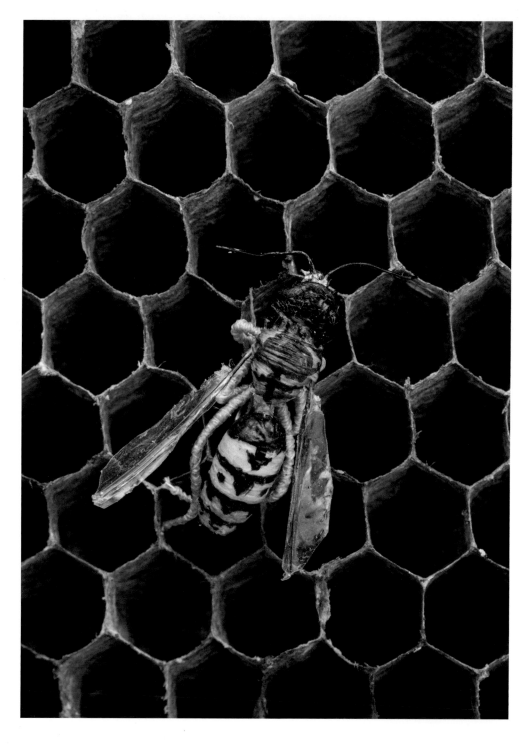

Hook: Daiichi 1160, size 14, **Thread:** Danville's 6/0 white, **Body:** Deer hair, thread, and monofilament, **Wings:** Plastic film, monofilament, **Markers:** Copic golden yellow, black, dark bark.

KENNETH HELD, UNITED STATES

I started my journey of fly fishing and tying some forty-seven years ago. I have tried to be as innovative with my tying as I can with durable and realistic new materials. I conduct tying demonstrations to pass my knowledge on to others that have the same passion for fly tying that I do, and then spend many hours on the river testing them.

In September 2014, some of my flies were published in Rick Takahashi's book *Modern Terrestrials*. I am on the Frosty Fly Pro staff and recently became part of the Northwest School of Fly Fishing instructor staff. I volunteer as a fly-tying instructor for the VA's Project Healing Waters here in Boise. In 2020 I was honored by having my Brown Drake fly used for the 2020 Boise Valley Fly Fishing EXPO pin and patch.

I started trying to tie realistic flies when I was sixteen, but the materials were very limited back then. It's only been in the last ten years that new materials have allowed me to start tying flies that can be fished and that have artistic qualities. I never really had any mentors: I just have a creative mind when comes to tying flies. I try to mimic the natural bugs as well as I can. When I come up with a new pattern it needs to be fishable, quick to tie, and most important, durable. However, the fish are the ultimate critics.

KLH Super Natural Brown Drake Nymph—Ken Held

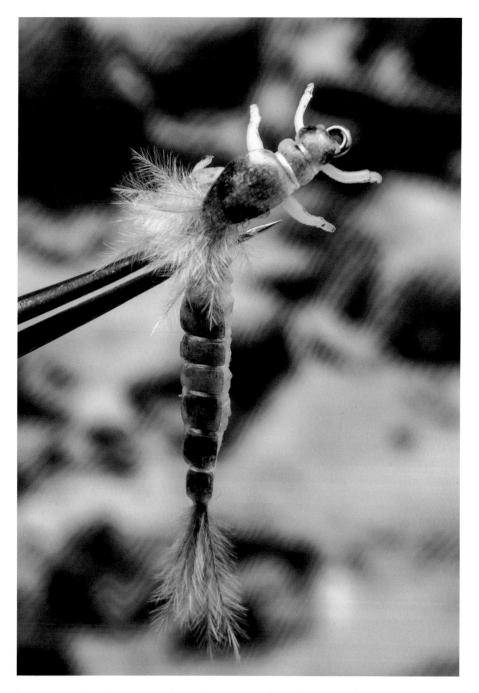

Hook: Dai-Riki 305 sz16 and articulated wiggle shank, **Thread:** Semperfli Nano Silk 18/0 white, **Tail:** Emu feather fibers, **Abdomen:** Underbody 1wt floating fly line tied either side of hook shank, **Abdomen:** Nymph skin 3mm translucent, **Abdomen:** Shell back Frosty Fly *Ephemera danica* shell back, medium, **Gills:** Hungarian partridge filoplume, **Thorax:** Lead wire tied each side of hook shank, **Legs:** Frosty Fly *Ephemera danica* legs, medium, **Underbody:** Build up thread colored with Chartpak pale yellow marker, **Shellback:** Frosty Fly *Ephemera danica* medium.

KLH Super Natural Brown Drake Emerger—Ken Held

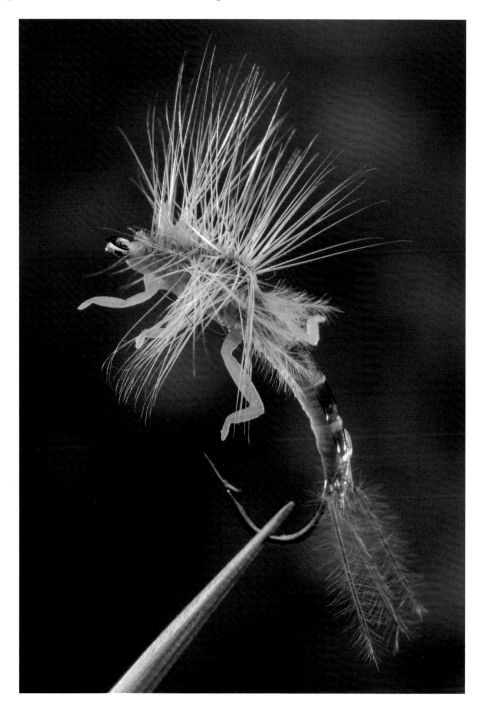

Hook: Daiichi 1160 sz10, **Thread:** UTC 70D white and Semperfli Nano Silk 18/0 white, **Tail:** Emu feather fibers, **Underbody:** 70D thread colored with Chartpak pale yellow, **Shellback:** Frosty Fly *Ephemera danica* shell back medium secure with Nano Silk, **Gills:** Hungarian partridge filoplume, **Legs:** J:son Sweden 2N nymph legs, **Hackle:** Whiting Sandy Dun tied hackle stacker style, **Underbody:** 70D thread colored with Chartpak pale yellow.

KLH Super Natural Brown Drake Cripple—Ken Held

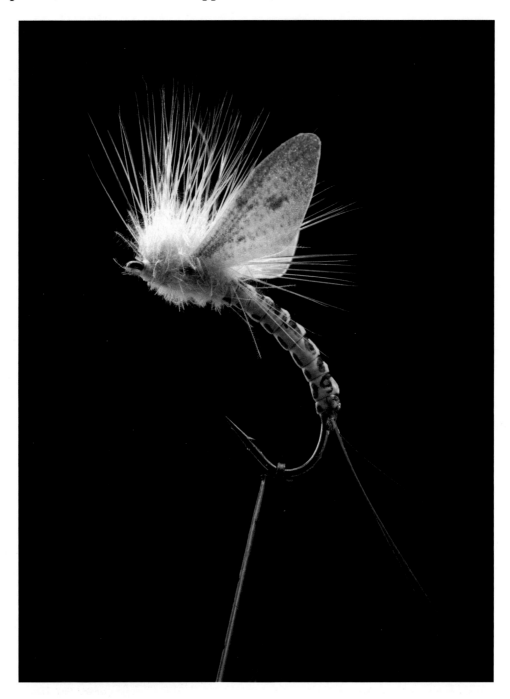

Hook: Daiichi 1160 size 10, **Thread:** UTC 70D white, **Tail:** Paint brush fibers colored with Chartpak Craft brown, **Body:** thread colored with Chartpak pale yellow **Overbody:** White nitrile glove tied Morrish caddis style colored with Chartpak pale yellow and Sharpie brown marker, **Wings:** Frosty Fly light gray size medium mayfly wings, **Thorax:** Pale yellow CDC dubbing, **Hackle:** Whiting Sandy Dun tied hackle stacker style.

KLH Brown Drake Parachute—Ken Held

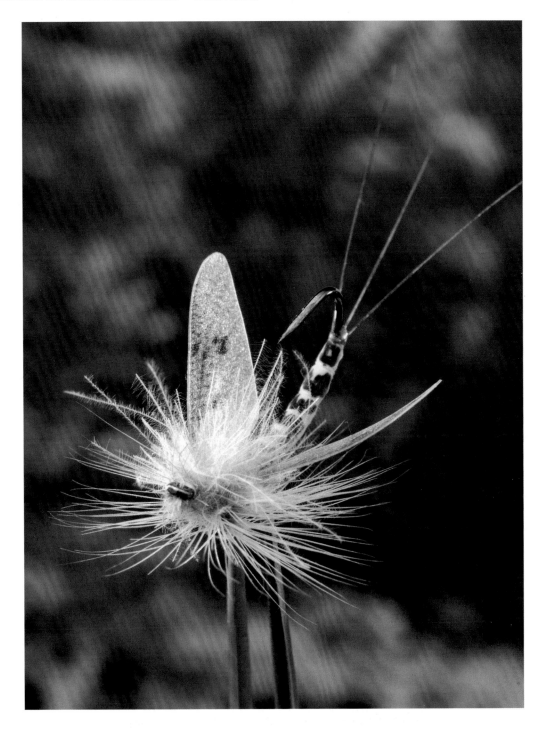

Hook: Daiichi 1160, #10, **Thread:** UTC 70D white, **Tail:** Paint brush fibers colored with Chartpak Craft brown, **Body:** thread colored with Chartpak pale yellow, **Overbody:** White nitrile glove tied Morrish caddis style colored with Chartpak pale yellow and Sharpie brown marker, **Wings:** Frosty Fly tan size medium mayfly wings, **Thorax:** Pale Yellow CDC dubbing, **Hackle:** Whiting Sandy Dun tied loop style on bottom.

KLH March Brown Emerger—Ken Held

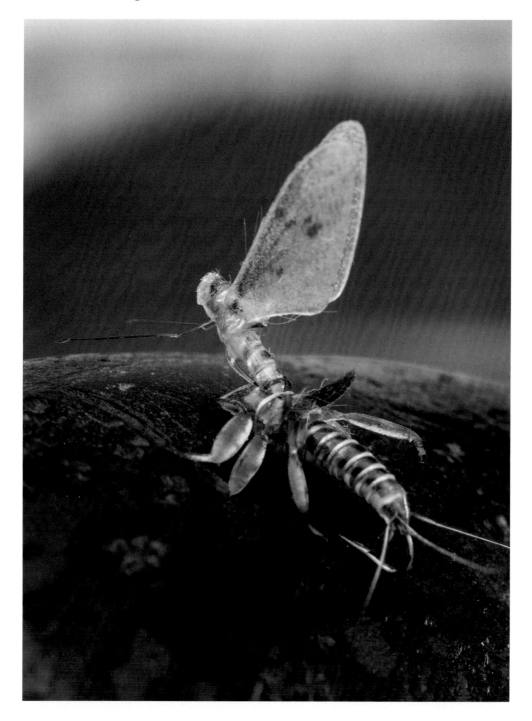

Hook: Dai-Riki 1270 size 16, **Thread:** UTC 70D white and Semperfli Nano Silk 18/0 white, **Tail:** Pheasant tail fibers, **Body:** thread colored with Chartpak pale yellow, **Legs:** Frosty Fly mayfly nymph, **Overbody:** Frosty Fly Mayfly buds and backs size small secured with nano silk, **Emerger:** 30-pound monofilament covered in thread and colored with Chartpak flesh, Frosty Fly Mayfly wings tan, size small, **Legs:** Micro fibets.

KLH Super Natural Golden Stone Nymph—Ken Held

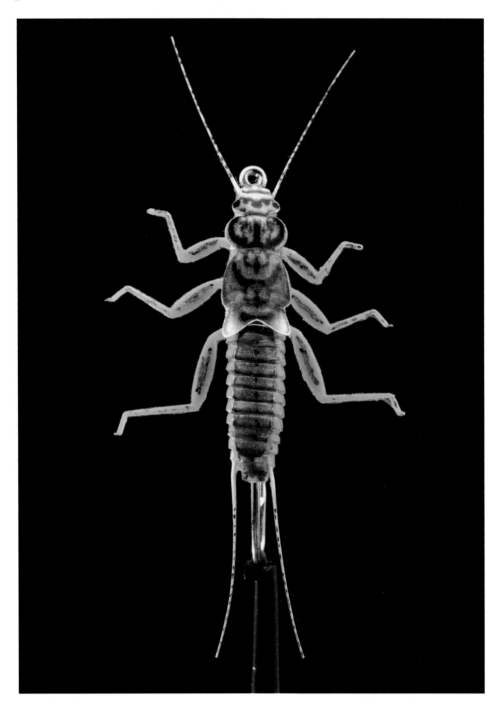

Hook: Dai-Riki 1270 size 6, **Thread:** Semperfli Nano Silk 18/0 white, **Tail:** Hen hackle stripped and colored Sharpie brown marker, **Abdomen:** Underbody T-10 sink tip tied either side of hook shank, **Abdomen:** Nymph skin 3 mm translucent, **Abdomen:** Frosty Fly golden stone shell back, medium, **Legs:** J:son Sweden S3 or Frosty Fly stone fly nymph legs Large, **Thorax:** Nymph skin 3mm translucent, **Shellback:** Frosty Fly golden stone shell back medium, **Antennae:** Hen hackle stripped and colored Sharpie brown marker.

KLH Super Natural Golden Stone—Ken Held

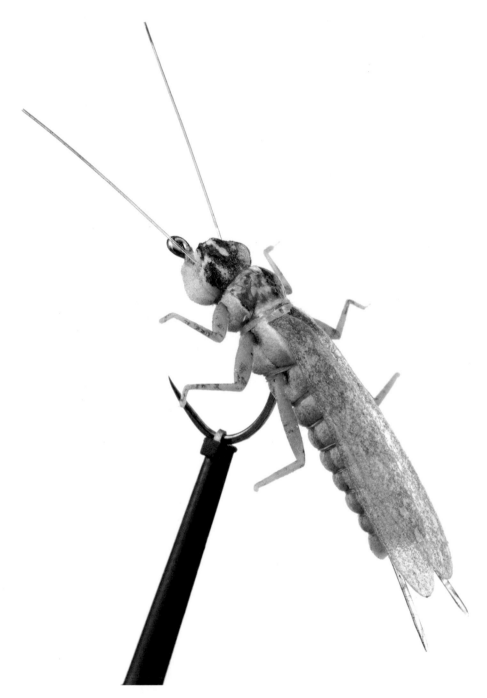

Hook: Masu K-3, size 8, **Thread:** UTC 70D white and Semperfli Nano Silk 18/0 white, **Tail:** Hen hackle stripped and colored Sharpie brown marker, **Abdomen:** two each 2 mm foam cut with size 6 River road creations foam cutter, sandwiched using extended body technique, **Legs:** J:son Sweden S3 or Frosty Fly stone fly nymph legs, large sandwiched between foam, **Wings:** Frosty Fly stone fly wings, large, **Antennae:** Hen hackle stripped and colored Sharpie brown marker.

KLH Super Natural Skawala Nymph—Ken Held

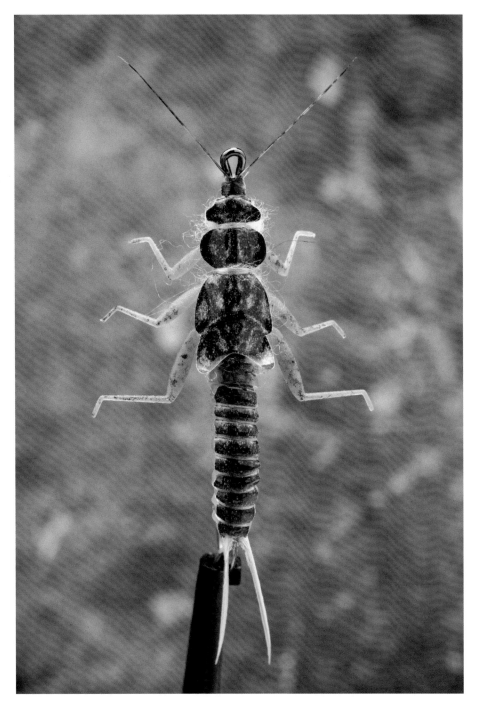

Hook: Tiemco 7999 size 10, **Thread:** Semperfli Nano Silk 18/0 white, **Tail:** Goose biots, **Abdomen:** Underbody T-10 sink tip tied either side of hook shank, **Abdomen:** Nymph skin 3 mm translucent, **Abdomen:** shell back Frosty Fly Dark shell back medium, **Legs:** J:son Sweden S4 or Frosty Fly stone fly nymph legs medium, **Thorax:** Tan Wapsi superfine dubbing, **Shellback:** Frosty Fly Dark shell back, medium, **Antennae:** Hen hackle stripped and colored with Sharpie brown marker.

KLH Super Natural Tube Hopper—Ken Held

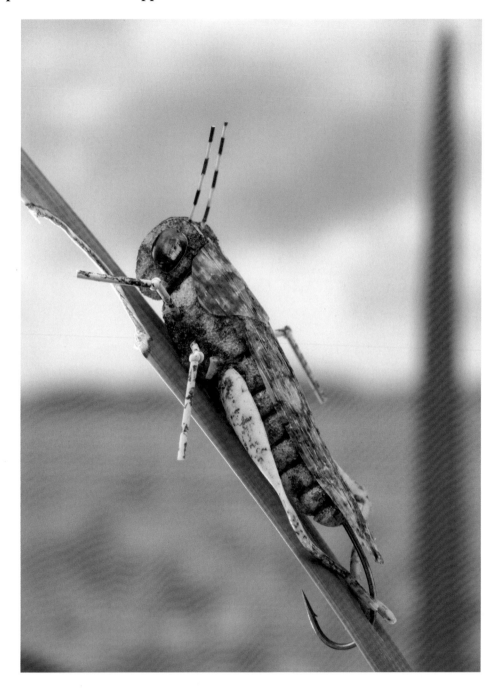

Hook: Masu K-3 size 8 or 3/32» HMH tube, **Body:** 2 mm foam cut with River Road Creations size 6–8 cutter, **Wings:** Tan Swiss straw laminated to Aleene's fabric fusion or 3M 300LSE cut with RRC wing cutter size 6–8, **Pronotum:** Tan Swiss straw laminated to Aleene's fabric fusion or 3M 300LSE size 6–8, Back **Legs:** TNT hopper legs, cream, **Front and mid legs:** Hareline natural cream medium round rubber, **Antennae:** Spirit River Tarantu-leggs, tan mini, **Eyes:** MFC Hopplze mottle brown 3.5 mm, Fine beading needles and Kevlar thread for attaching legs.

DANIEL HERRICK, UNITED STATES

I began tying flies in 1978, not knowing what or where it would take me. Some forty-two years later, it has brought me joy and happiness, to say the least. I had some friends that fly fished and tied their own flies and I became fascinated with fly tying. I practiced for two years on my own to hone my craft so I could tie flies for local fly shops. I did this to make money on the side to buy better equipment and take trips. What started out as a couple dozen turned out to be 800–1,000 dozen per year. For ten years I tied flies for stores. Then, I began tying flies for myself and filling my boxes and concentrating on matching the hatch and studying entomology on my own.

Years ago, I got a book by Oliver Edwards that started my interest in tying realistic flies. Upon trying to tie these I gave up thinking it was a pain to take so long to tie a fly. After I retired and had my fly boxes full, I became interested in tying more exact flies to fish so I could fool even the most finicky of trout. The book that really piqued my interest was the book *Flies as Art* by Paul Whillock. I became fascinated with how you could tie realistic flies and fish them. My first attempts were very bad but being persistent and knowing what materials to use made it a bit easier after tying each fly.

As for realistic tying, I see it as an art form; you must really be dedicated to the art and have an imagination. With the new materials that are coming out, the ability to create realistic flies is endless. With the publications coming out for realistic fly tying I see more people taking the plunge to try it. It's a great craft and is very rewarding when you create something from a hook and materials.

Articulated Hellgrammite—Daniel Herrick

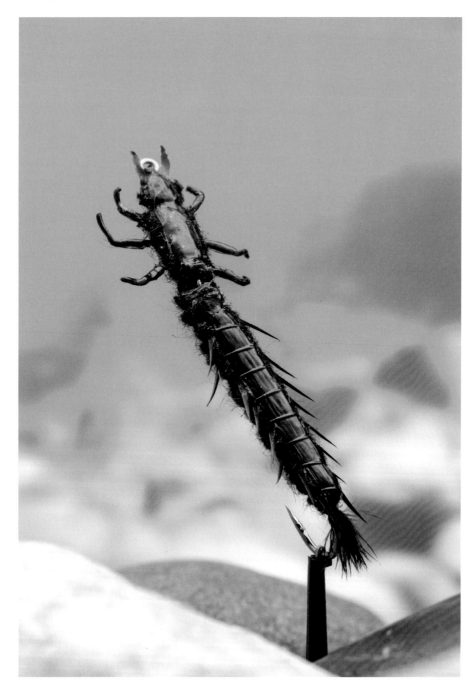

Hook: Daiichi #1750, size 4, **Underbody:** Strip Styrene size .020" x .188" cut and trimmed to shape, **Thread:** UTC 140 Black or any 6/0, **Rib:** 3x Maxima tippet material, **Tail:** Black marabou with black biots on each side, **Carapace:** Black raffia, **Gills:** Black goose biots, **Joint:** Fish Skull Articulated Fish Spine, size 25 mm (1"), **Wing case:** Black raffia, **Legs:** Black Spanflex bent to shape and coated with Softtex, **Thorax:** Kaufmann's SLF Black Stonefly dubbing, **Pincers:** Black Wapsi Thin Skin. After completion, coat carapace and wing case with Softtex.

Hellgrammite—Daniel Herrick

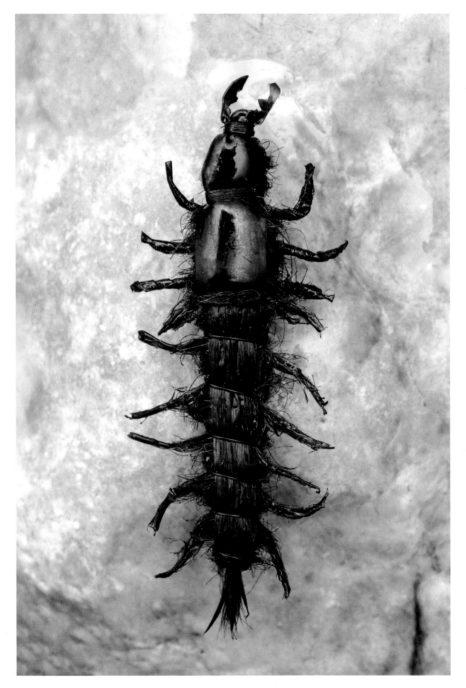

Hook: Mike Martinek Carrie Stevens Rangeley streamer, 8x long, size 6, **Underbody:** StripStyrene size .020» x .188" cut and trimmed to shape, **Thread:** UTC 140 Black or any 6/0, **Rib:** 3x Maxima tippet material, **Tail:** Black marabou with black biots on each side, **Back:** Black raffia, **Wing case:** Black Wapsi Thin Skin coated with a touch of Softtex to dull, **Body:** SLF Kaufmann's Black Stonefly dubbing, **Gills:** Pick out dubbing coat with Softtex and twist to shape and trim, **Legs:** Black Japanese Nymph wire wrapped with black raffia and bent to shape and coated with Softtex, **Pincers:** Black Wapsi Thin Skin trimmed to shape.

RAIMUND HINZ, BAVARIA

I started fly tying after a ten-year absence. Through colleagues at work, I came back to fishing and fly fishing. After that, I wanted to tie my own flies because I always was impressed by those awesome patterns. So, I read a lot of books and spent hours on YouTube, watching Barry Ord Clarke and Davie McPhail, to learn how to do it. I tried my best to copy them. Since then, I have become very addicted to fly tying and fly fishing.

One day at a fair, I saw a few very well-tied realistic Cased Peeping Caddis. It impressed me so much, that I wanted to do this also. I rolled stones over in the river to see what was living under them. I photographed them and made the image much larger to see their proportions.

I thought a lot about what I could use to imitate them. I also bought a book from Paul Whillock, *Flies as Art*, which helped me a lot. I started to tie caddis in several sizes and in different ways. With a helping hand on other patterns, friends from the Go-Fish-Experts, Evgeny Borovin, and several others, gave me a helping hand when I had questions. We are still in contact.

The patterns I tie are turning out pretty well now. It's very interesting to tie realistics. A lot of accurate and focused work and preparation of the materials is the key to bringing them to life. I think tying realistics make friendships and keeps people at the vise producing awesome results.

Cased Caddis—Raimund Hinz

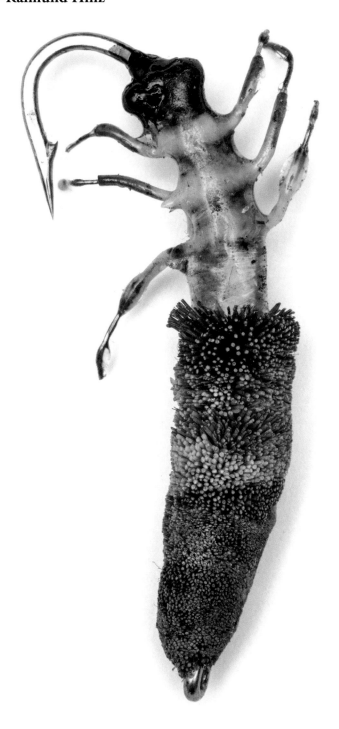

Hook: Tiemco #6, **Thread:** Go-Fish Maximus 20/0, **Body:** Raffene green colored with brown Edding pen, Gulff green resin, **Thorax:** Yellow Raffene colored with Edding yellow and Gulff Fluoro Green resin, **Legs:** Yellow model building wire, **Head:** Black Raffene and black Edding, **Eyes:** Melted brown monofilament, 0.35 mm Body covered with Rapidzap Flex.

Flying Ant—Raimund Hinz

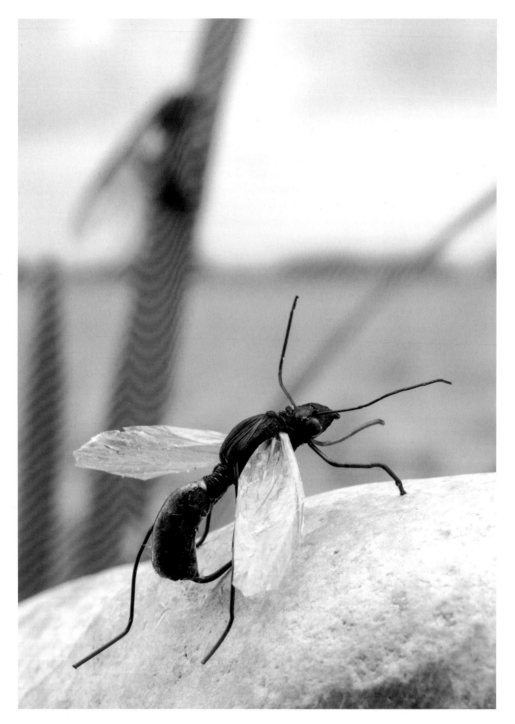

Hook: Hends BL400, size 10, **Thread:** Black Uni and Maximus, 8/0 **Tail:** Maximus 8/0 colored with Black Edding pen and cured with Loon UV resin, **Abdomen:** Maximus 8/0 and black Raffene for the back, **Wings:** Raffene trimmed to shape, **Legs:** 3 black fibers from my broom at home, **Thorax:** Black Raffene, **Head:** Uni thread, 8/0 **Eyes:** Black broom fibers, melted, 0.35 mm, **Antennae:** 2 black brush fibers.

Caddis Pupa—Raimund Hinz

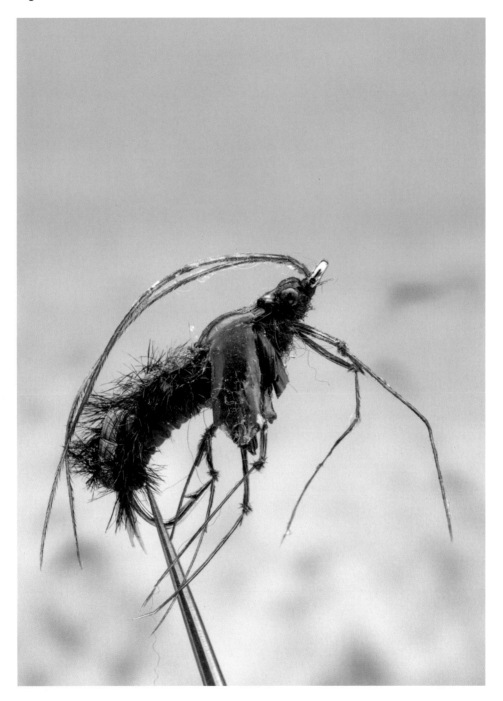

Hook: Hends Swimming Nymph Hook, size 6, **Thread:** Go-Fish Maximus 20/0, **Tail:** Gray goose biots, **Body:** Green Hends Nymph Skin, **Sidegills:** Ostrich, black, **Ribbing:** Monofilament 0.18 mm, clear, **Wing Case and Wings:** Black Raffene, cured with Loon UV, thin, **Legs:** Knotted pheasant fibers, **Thorax:** Dark brown dubbing, **Eyes:** Melted brown monofilament, 0.35 mm, **Horns:** Pheasant fibers, **Head:** Dark brown Uni 8/0.

KONSTANTIN "KODY" KARAGYOZOV, BULGARIA

My name is Konstantin Karagyozov. I was born and live in Plovdiv, second largest city in Bulgaria. Among fly tyers, I'm known as KODY. I've been fly fishing for more than fifteen years. I fish mainly for trout in small- and medium-sized mountain rivers. I'm a passionate fly fisherman and fly tyer and never looked at fly tying only as producing flies for fishing, but rather as an art. I love to create my own flies from the beginning. My flies are my own designs, and I don't like to make copies of other flies. In fly tying, we always take advantage of someone's previous experience and knowledge, but I always try to develop specific approaches and techniques to give my patterns a custom design and durability.

I never make pure display flies. I use durable materials and no matter the realistic appearance, all of them are always made for the purpose of fishing. I love to create and develop my patterns with appearance according to my vision for style and fishing and think it is always better to fish with a good-looking fly.

I tie almost all types of flies excluding classic salmon flies. I'm not a professional fly tyer and take orders only by request. Often, it happens that I create and develop flies according to a client's requirements and wishes without having real fishing opportunities to try them on my own. I can't call myself purely a realistic fly tyer, rather, some of my patterns are semi-realistic or a bit closer to realistic. I never tried to be hyperrealistic, because, according to me, it is not possible to imitate nature at that level.

What led me to realistic tying were my attempts, even from the beginning, to achieve more and more lifelike appearance in my fishing flies. The process was gradual through the years and started by trying to do some parts of the flies much more realistically because I thought these parts have very important meanings for fishing and will help me fool the fishes more easily. For one fly, it was legs, for another, wings or tail, etc. After so many years of tying and fishing experience I know we can't imitate nature in the way we want and a purely realistic fly is not necessary for successful fishing. But, for me it is always more rewarding to fish not a realistic fly, but a good-looking fly, and it is worth spending more time to tie it.

Techniques used in realistic fly tying helped me improve my tying skills in general and I feel more comfortable when using plenty of different materials and tools. Another reason I like a realistic approach in tying is the pure aesthetic. I love to see well-sized, proportional, and color-correct imitations. Fly tying itself could be called an art. I think, at some point, it is a totally different discipline from fly fishing.

Realistic tying itself is an art, and I always admire all the efforts, hard work, talent, creativity, and imagination of people doing it.

Crayfish—Konstantin "Kody" Karagyozov

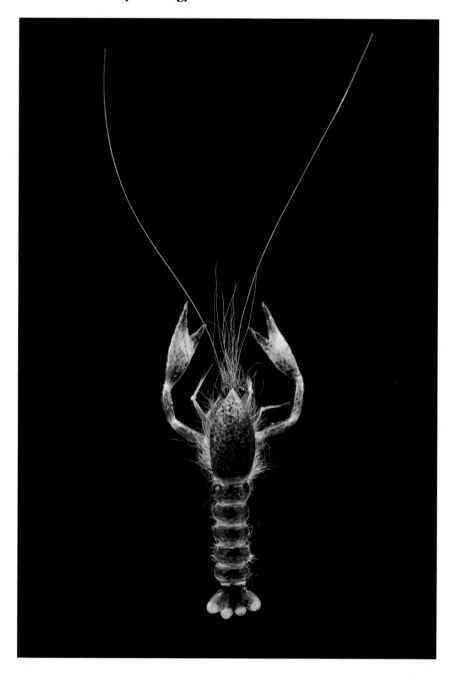

Hook: Any standard hook size 4/0, but 1x long shank, **Underbody:** Lead wire 1 mm, **Body:** Antron yarn and blend of hare's ear and ice dubbing, **Head:** Calf body fibers and mixture of hare's ear and ice dubbing, **Antennae:** Rooster feather stems, **Eyes:** Monofilament, UV resin, and black nail polish, **Claws:** Flat body tubing, copper wire as core, UV resin as coating, and colored by permanent markers, **Legs:** Turkey white feathers, knotted and covered with silicone glue and colored, **Ribbing:** Monofilament 0.16 mm, **Shellback:** Silicone strip, colored with permanent markers and UV resin as coating, **Tail:** Silicone strip segments, colored with permanent markers and UV resin as coating.

Prawn—Konstantin "Kody" Karagyozov

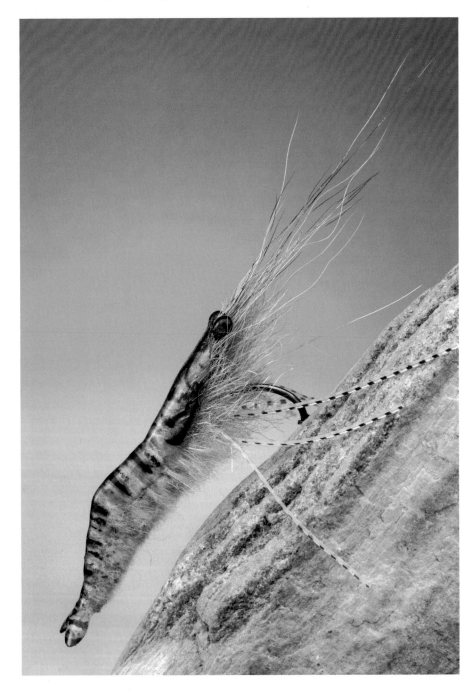

Hook: Sensey F408BN, #3/0, **Threads:** Multifilament threads 8/0 and 13/0, **Shellback and tail:** Transparent silicone sheet, **Head:** Bucktail and dubbing blend mixture of UV Ice dubbing and, hare's ear dubbing, **Body:** Any white synthetic fluffy yarn. Mixture of white UV Ice dubbing and hare's ear dubbing, **Legs:** Wapsi Sili legs, **Coloration:** Permanent markers in appropriate colors, **Coating:** Solarez UV resin Flex for the head and tail and Thin for the body, **Eyes:** 0,50 mm. monofilament, covered with Solarez hard UV resin and final coating with black nail polish, **Antennae:** Long bucktail hair fibers.

Cased Caddis—Konstantin "Kody" Karagyozov

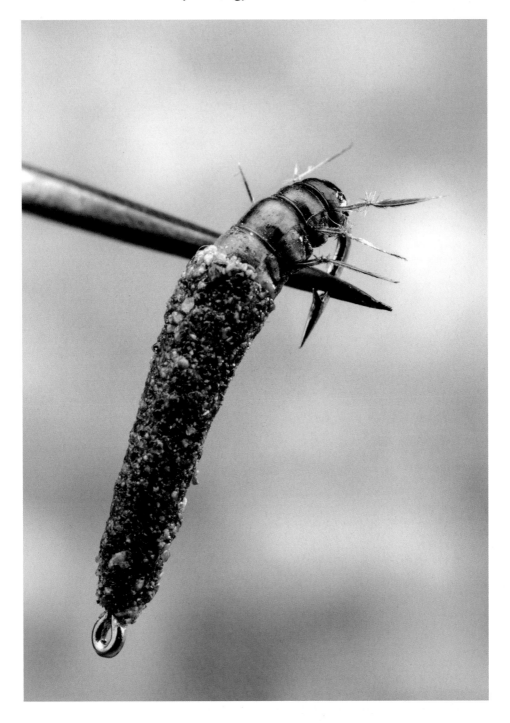

Hook: Wizard WD 903 BN, #6, Threads: Multifilament threads 8/0 and 13/0, **Undercase:** Lead wire 0.6 mm, **Case:** River sand covered with Solarez UV Thin resin, **Underbody:** Hare's ear dubbing, pale yellow/beige, **Body:** Latex strip from kitchen glove, **Legs:** Turkey feather fibers covered with silicone glue, **Shell:** Silicone strip covered with silicone glue and colored with permanent markers, **Ribbing:** Monofilament 0.12 mm.

Feather Stone Fly—Konstantin "Kody" Karagyozov

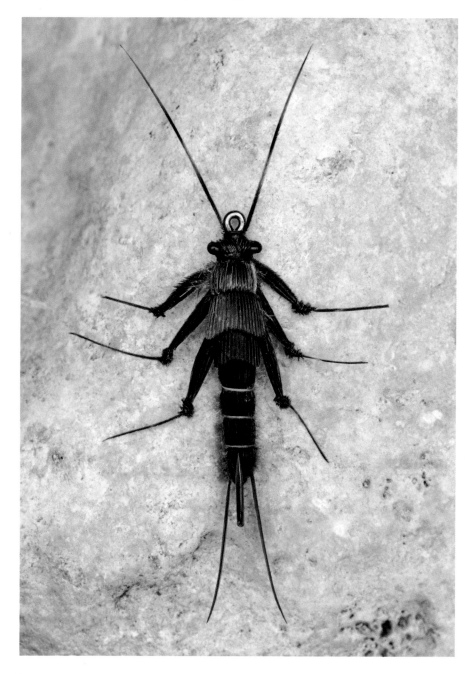

Hook: Wizard WD 903 BN, #6, **Thread:** Multifilament 13/0, **Underbody:** Round lead wire 0.6 mm mounted sideway on both sides, **Tail:** Two pieces of turkey body quill colored light brown, **Body:** Three pieces of bleached and yellow colored peacock tail feather fibers, **Back:** Turkey tail feather fibers, **Ribbing:** Yellow monofilament thread 8/0, **Wing cases:** Small hen cape feather fibers, glued, cut and burned in appropriate shape, **Thorax:** Hare's ear dubbing light brownish, **Legs:** Turkey tail feather fibers, **Head:** Turkey tail feather fibers, **Eyes:** Mono 0.50 mm burned both sides, covered with Solarez UV Thin resin and painted by permanent markers, **Antennae:** Turkey tail feather fibers.

Dragonfly Nymph—Konstantin "Kody" Karagyozov

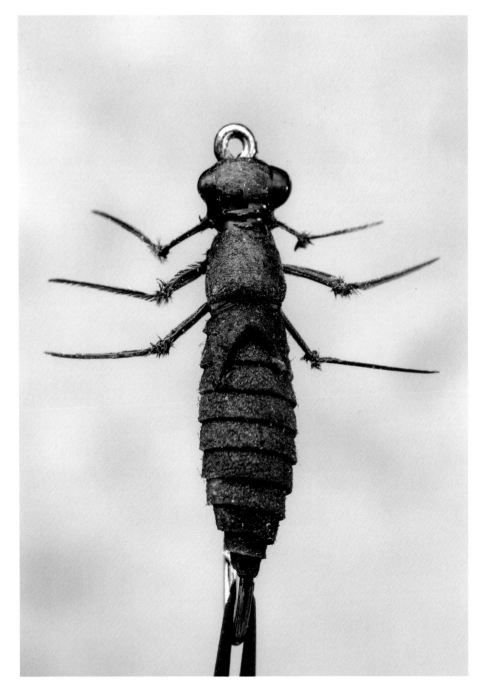

Hook: Wizard WD 903 BN, #6, **Underbody:** three layers of 1 mm flat lead applied sideways to achieve basic shape covered with multifilament thread to smooth the edges and surface, **Body:** Latex strip 6 mm colored by dark brown permanent marker, **Wing case:** Latex strip cut in appropriate shape and colored by permanent marker, **Eyes:** 5 mm piece of 0.50 mm monofilament, burnt and covered with Solarez thin UV resin, **Underhead:** UV resin applied over where eyes where fixed on the hook, **Head:** Latex strip colored by permanent marker.

CHRISTIAN KIRCHERMEIER, BAVARIA

I am thirty-four years old now and came to fly tying as a young boy. After a long break, I started tying again about five years ago. I focus on the standard patterns for fishing like parachutes, jig nymphs, and unweighted nymphs.

I began to practice realistic fly tying when I tied some caddis pupa patterns, and started to get better, and became more accustomed to the techniques. Then, I added some eyes and legs and so on. After that I decided to get more realistic every time, so it ended up as a realistic pattern. Now, sometimes, I get bored by tying standard patterns so then I start a new project on a realistic pattern. It's really nice to push your skills to a new level.

My opinion on realistic tying is there will always be a small group of people doing it, because it's hard to learn and you need a really high skill level to bring out good-looking things. Failure is a daily occurrence.

Green Dragonfly Nymph—Christian Kirchermeier

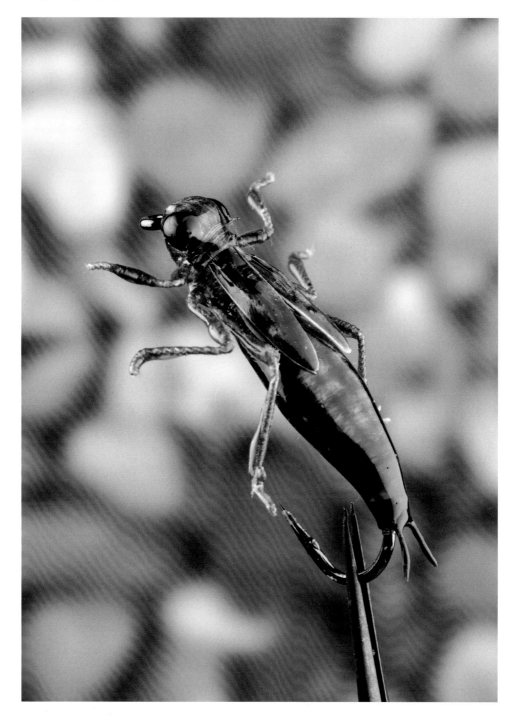

Hook: Gamakatsu F-16, size 6, **Thread:** Go-Fish UTC 70, light olive, **Underbody:** Toothpicks to create the shape of the back, **Body:** Go-Fish Bodystretch, olive, covered with Gulff Classic UV resin, **Legs:** Wire covered with thread, covered with Gulff Thinman and and Gulff Larva Brown UV resin, **Wings:** Grizzly Neck hackle fixed with Gulff Flexman UV resin, **Eyes:** Gulff Black Magic UV resin.

Winged Black Ant—Christian Kirchermeier

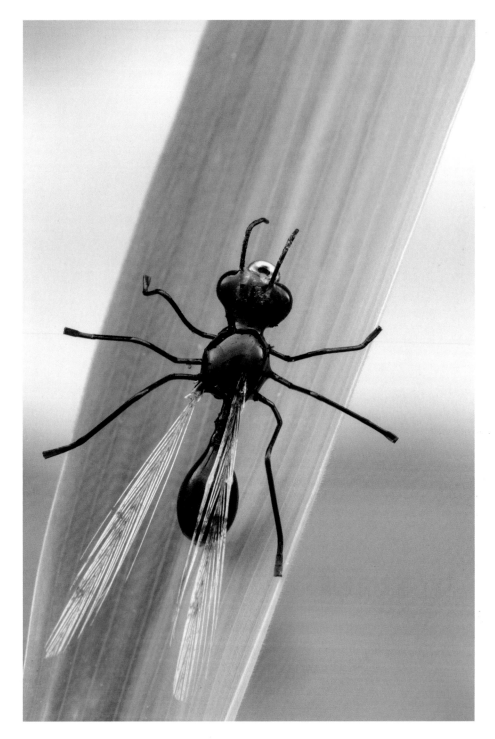

Hook: Go-Fish GF-2487BL, size 12, **Thread:** Go-Fish Maximus 30 DEN Dyneema, **Head and thorax:** Go-Fish Fly Foam 3 mm gray covered with Gulff Thinman UV resin, **Legs:** Nylon sticks, **Wings:** Dun hackle tips, **Antennae:** Black wire, **Abdomen:** Gulff Fatman UV resin.

Perfect Pupa—Christian Kirchermeier

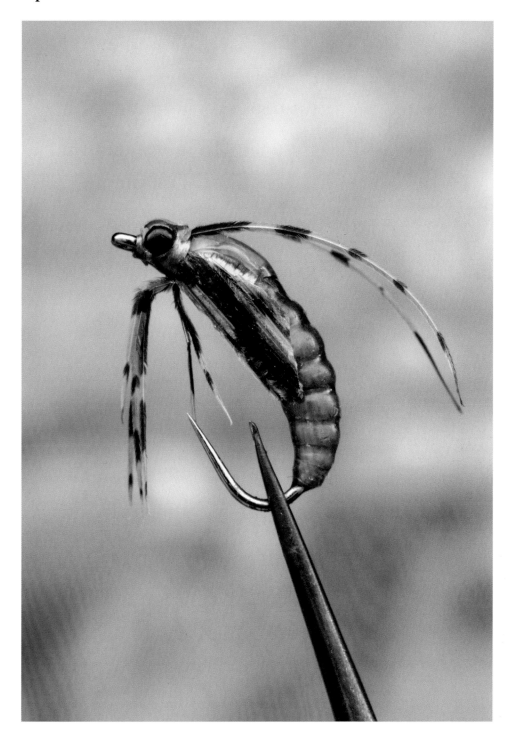

Hook: Hends BL550, size 10, **Thread:** UTC 70 light olive, **Body:** Go-Fish Latex sheet, gray/olive covered with Gulff Thinman, **Legs:** Golden pheasant tail fibers, **Wings:** Golden pheasant fibers, Gulff Classic covering wing case, **Eyes:** Melted nylon covered with Gulff Black Magic UV resin, **Antennae:** Golden pheasant fibers.

Caddis Fly Larva—Christian Kirchermeier

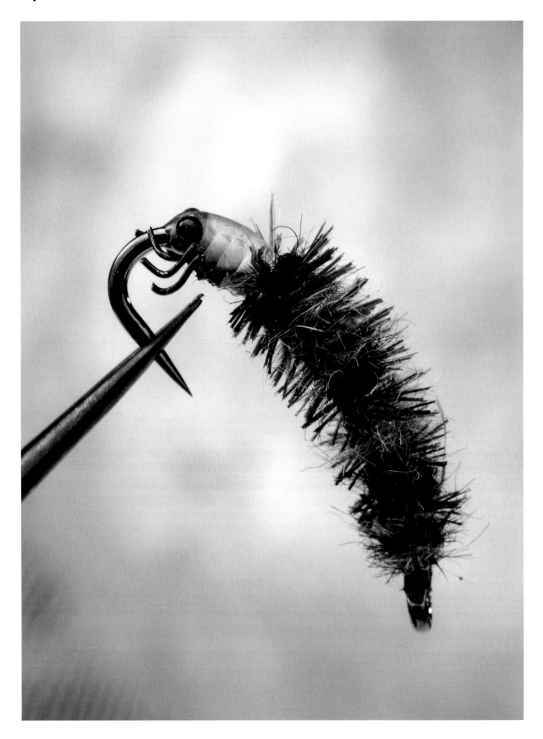

Hook: Maruto Stonefly, size 10, **Thread:** Go-Fish Maximus 30 denier Dyneema, **Eyes:** Melted nylon covered with Gulff Black Magic UV resin, **Head:** Gulff Larva Brown, **Body:** Go-Fish Latex sheet, metallic gold, **Legs:** Black wire, **Case:** Brown neck hackle, **Butt:** Hends gray and black superfine dubbing.

Origami Caddis—Christian Kirchermeier

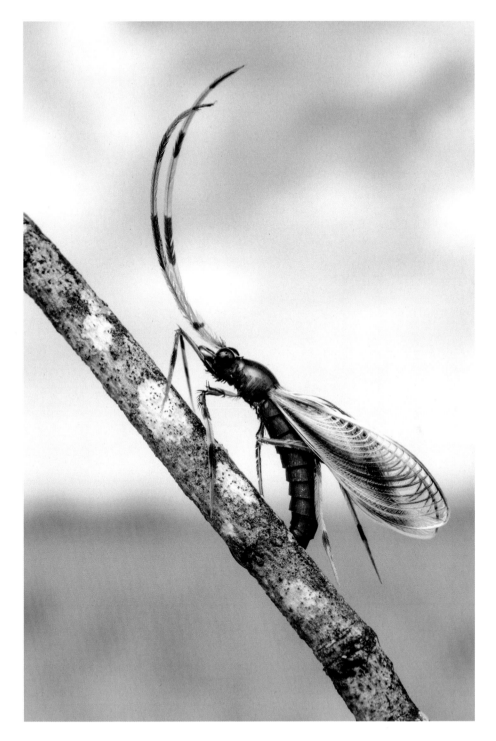

Hook: Hends BL550, size 12, **Thread:** Go-Fish Maximus 30 denier Dyneema, **Body:** Go-Fish Latex sheet, olive with Gulff Larva brown to cover thorax, **Wings:** Grizzly neck hackle, Legs and **Antennae:** Golden pheasant fibers, **Eyes:** Melted nylon covered with Gulff Black Magic UV resin.

Golden Stone Nymph—Christian Kirchermeier

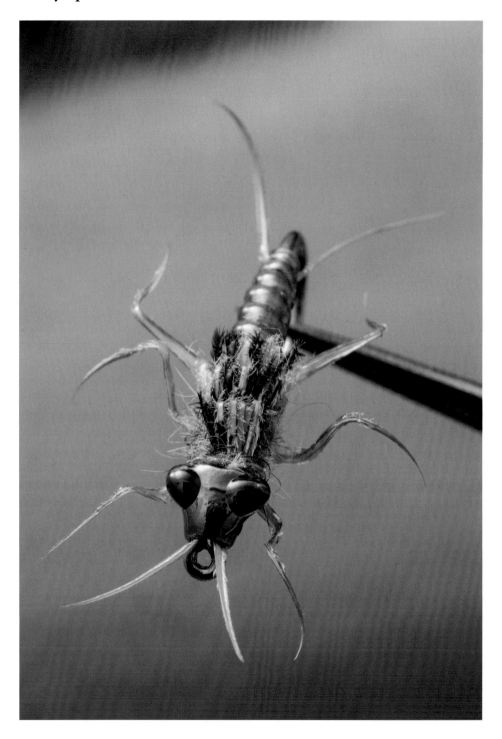

Hook: Gamakatsu F313, size 10, **Thread:** Go-Fish Maximus Thread 30DEN Dyneema, **Head:** Taimen Tungsten Stonefly head, metallic coffee, **Body:** Go-Fish Body Glass brown, Legs, tail and **Antennae:** Turkey biots golden brown, **Wing case:** Golden pheasant fibers, **Eyes:** Gulff Black Magic UV resin.

New Dun—Christian Kirchermeier

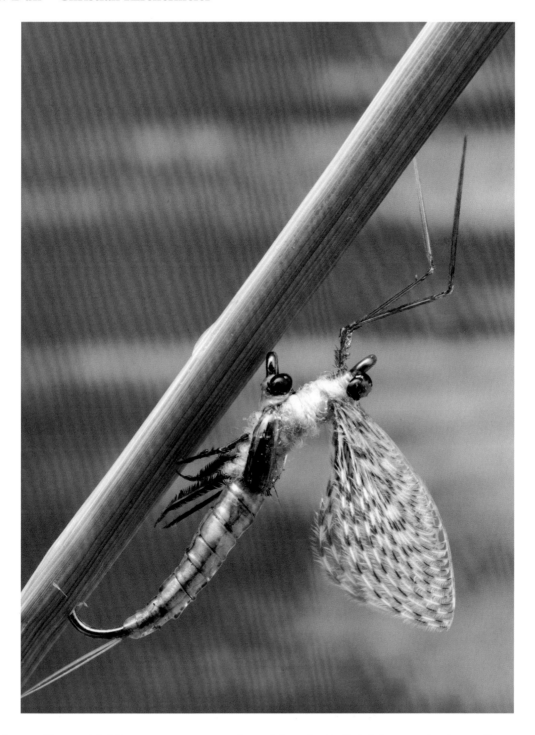

Hook: two Tiemco TMC200s, size 12, one is bent, **Thread:** Go-Fish Maximus 30 denier Dyneema, **Tail:** Microfibers, **Body:** Go-Fish Nymph Body, clear, **Wing case and legs:** Golden pheasant fibers, **Eyes:** Melted nylon covered with Gulff Black Magic UV resin, **Upper body part:** Wapsi Superfine Dubbing, pale morning dun, **Wings:** Mallard breast feather, **Split wing case:** Covered with Gulff Thinman UV resin.

Rhino Bug—Christian Kirchermeier

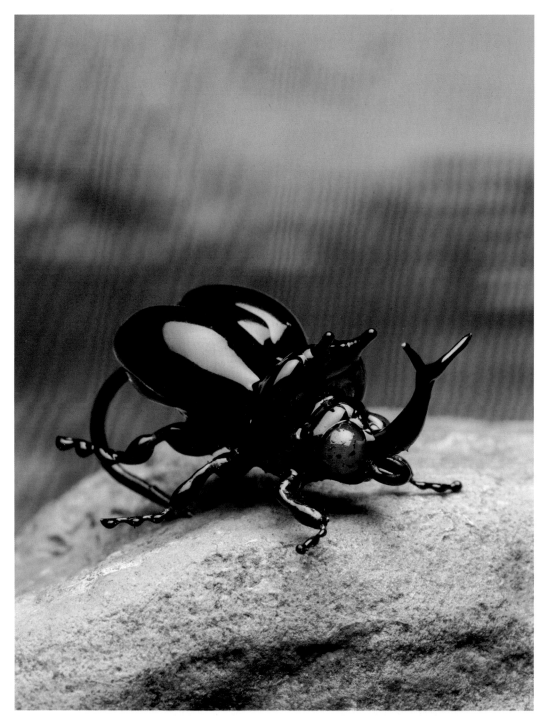

Hook: Gamakatsu LS-5413F, size 2, **Flat space underneath:** Toothpicks, **Thread:** Go-Fish Maximus 30 denier Dyneema, **Skeleton of legs and horn:** Black wire, **Under part:** Go-Fish Marker, brown, covered with Gulff Thinman UV resin, **Main parts like back shields and neck shield:** Gulff Classic UV resin, **Legs and cover all main parts:** Built up with Gulff Black Magic UV resin, **Eyes:** Gulff nymph brown UV resin.

JAMES LUND, SWEDEN

I'm 39 years old, living in Stockholm with my girlfriend and our two daughters. I work full-time as an actor/singer, and, of course, I'm a very passionate fly fisherman.

I started fly tying in the autumn of 2018 and quickly fell in love with it. I'm especially fond of working with natural materials like deer hair, CDC, and feathers for wings. There are a few tyers from Sweden that were really good with this kind of style. Thomas Roos, Mathias Åberg, Hugo Harlin and Ola Andersson really impressed me and inspired me to tie at a higher level.

Most fly fishers know that the fish doesn't really care if the fly looks exactly like an insect. Movement, impression, size, colors, presentation are often more important than some super-realistic fly. But for me, the fly is not only for the fish but also for my own amusement. Therefore, I really like to find a middle ground where both the fish and I like the look of the fly.

I really like to tie semi-realistic flies, just for fun, using mostly natural materials. Tying with plastic wings and legs that are made to look like super-realistic flies isn't my cup of tea. Therefore, my flies will always be in the category of semi-realistic. Thanks to Hugo Harlin, I learned to fold feathers into wings called "origami wings." For me, this is the pure beauty of nature. I've used and developed this technique making artistic flies and fishing flies that I really enjoy tying on to my leader.

I believe the time and dedication I spend on an artistic fly also helps me become a better tyer when I make my fishing flies. It gives my flies that extra spark that maybe the fish doesn't care about but makes my time by the water more enjoyable.

Mayfly Siphlonurus—James Lund

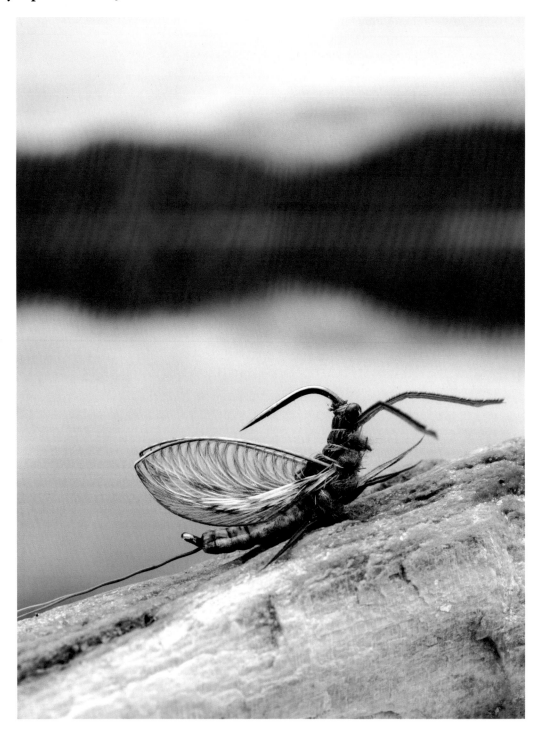

Hook: Hanak 300BL, size 10, **Thread:** Textreme Power Thread 50D, painted with brown marker, **Tail:** Deer hair, **Body:** Superfine dubbing, Body Stretch, Hare's mix dubbing, Deer hair, **Wings:** Coq de Leon, origami folded, **Legs:** Turkey biot, **Eyes:** Melted nylon tippet with Gulff Black UV resin.

Spent Origami Caddis—James Lund

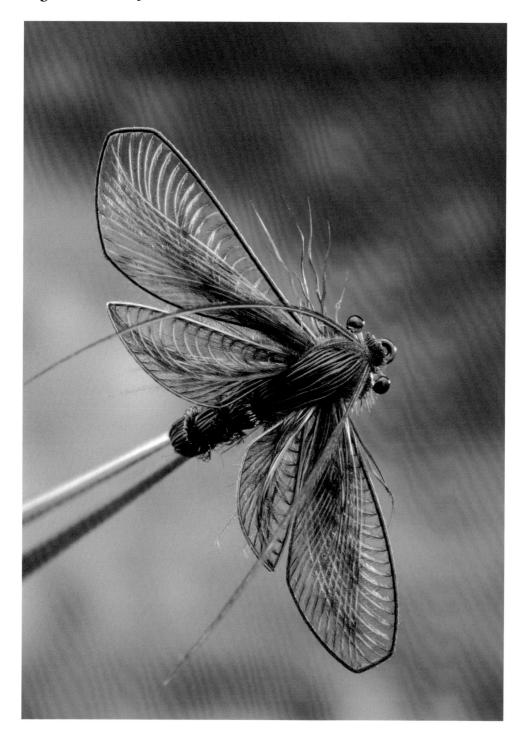

Hook: Hanak 530BL, size 10, **Thread:** Veevus GSP 30D white/transparent, **Body:** Deer hair, peacock, **Wings:** 4x Coq de Leon feather, origami folded, **Eyes:** Melted nylon tippet, Gulff Black UV resin, **Legs:** Chamois, **Thorax:** Peacock, CDC, **Antennae:** Pheasant tail.

Mayfly Emerging—James Lund

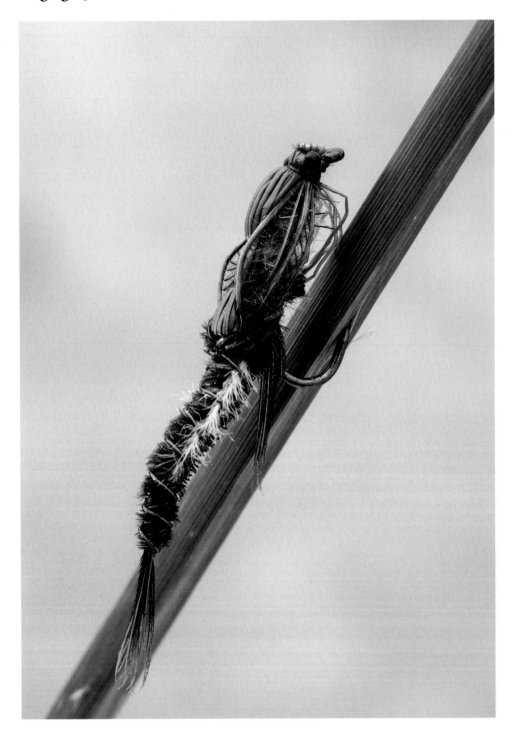

Hook: Hanak 333BL, size 12, **Thread:** Veevus GSP 30D, **Extended Body:** Nylon tippet, copper wire, pheasant tail, white peacock, **Body:** Deer hair, peacock, hare's mask, **Wings:** Coq de Leon, origami folded, **Legs:** Chamois, **Eyes:** Melted nylon tippet with Gulff Black UV resin.

Spent Mayfly—James Lund

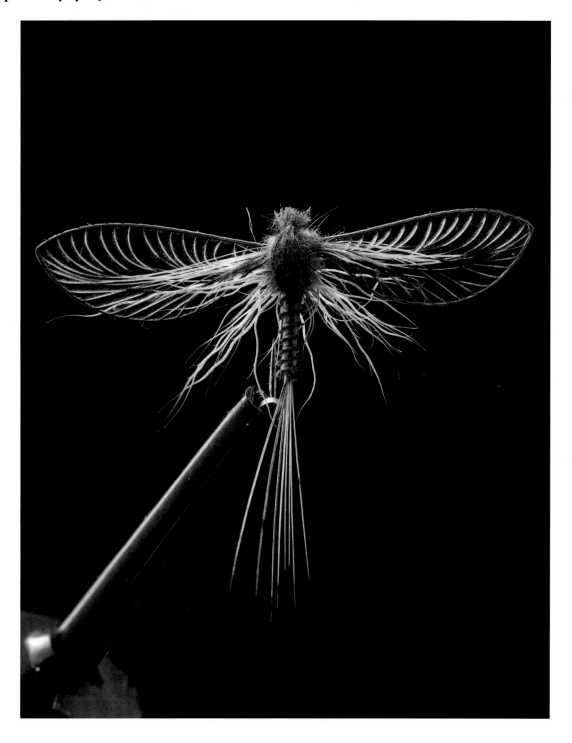

Hook: Hanak 100BL, size 14, **Thread:** Veevus GSP 30D, **Tail:** Coq de Leon, **Body:** Turkey biot, Wing case: CDC, **Wings:** Coq de Leon, origami folded, **Legs:** Chamois.

No Foam Hopper—James Lund

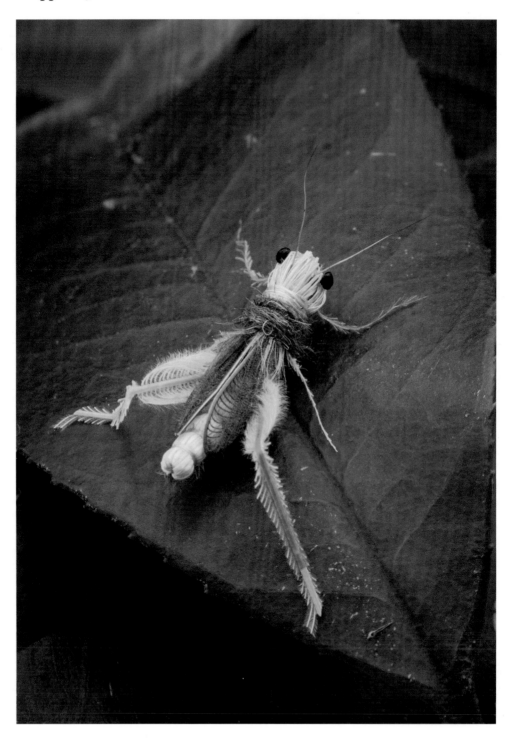

Hook: Hanak 530BL, size 12, **Thread:** UNI 8/0, Lt. olive, **Body:** Deer hair, hare's ear, **Legs:** CDC and CDC stems, **Wings:** CDC, origami folded, **Eyes:** Melted nylon tippet painted black, **Antennae:** Deer hair.

Knocked Down Mayfly—James Lund

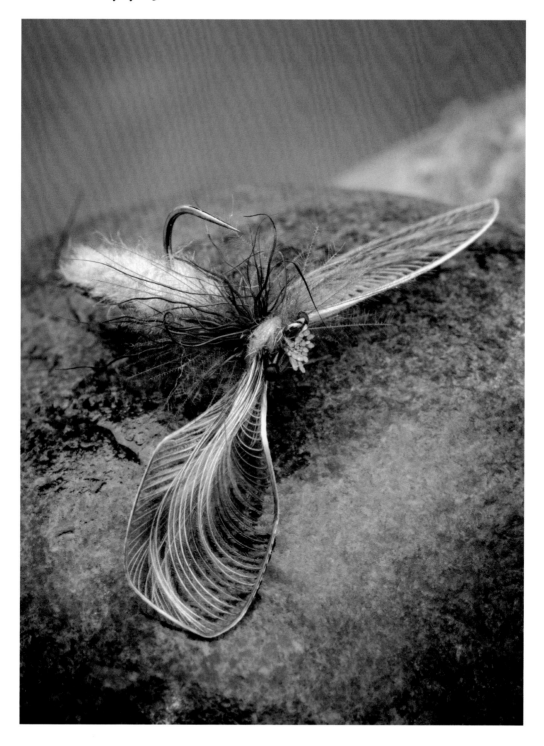

Hook: Hanak 300BL, size 14, **Thread:** UNI 8/0 tan, Veevus GSP 30D, **Tail:** Moose, **Body:** Moose, kapok, **Wings:** Coq de Leon, origami folded, **Legs:** Chamois, CDC, **Thorax:** Chamois, CDC, **Eyes:** Melted nylon tippet with Gulff Black UV resin.

The Bat—James Lund

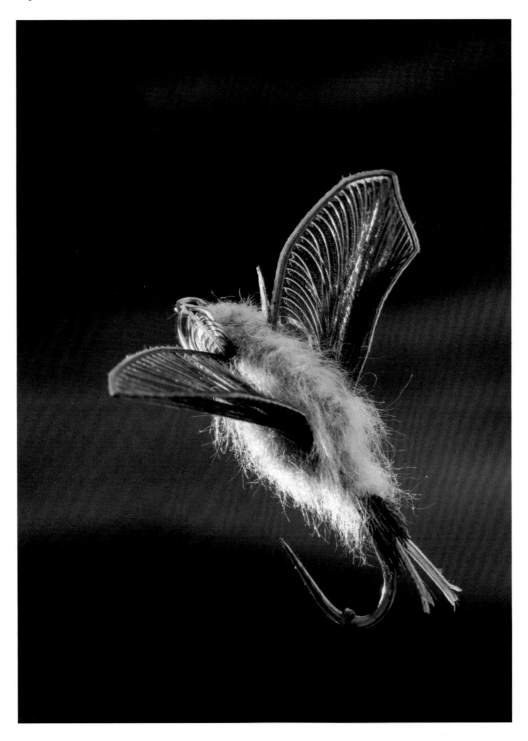

Hook: Hends BL 700, size 6, **Thread:** Textreme Power thread 50D, **Wings and legs:** Coq de Leon, origami folded, the stems become legs, **Body:** Kapok spun, **Eyes:** Melted nylon tippet with Gulff Black UV resin, **Ears:** Coq de Leon, reversed.

Phryganea grandis—James Lund

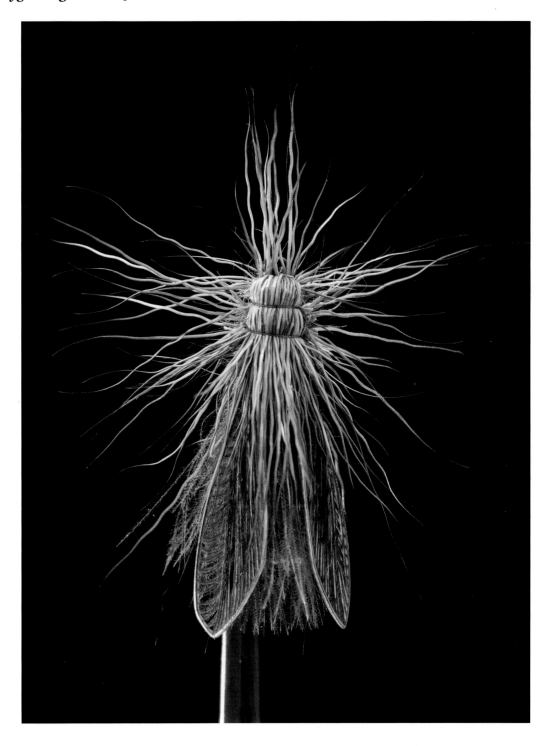

Hook: Hanak 530BL, size 10, **Thread:** UNI 8/0 Lt. olive, Textreme Power Thread 50D, **Body:** Deer hair, Ice Dub fluorescent green, hare's mix dubbing, **Underwing:** Chamois, CDC, **Wings:** Coq de Leon, origami folded, **Thorax, legs:** Chamois, hare's mix dubbing, **Antennae:** Chamois.

Kapok Bumblebee—James Lund

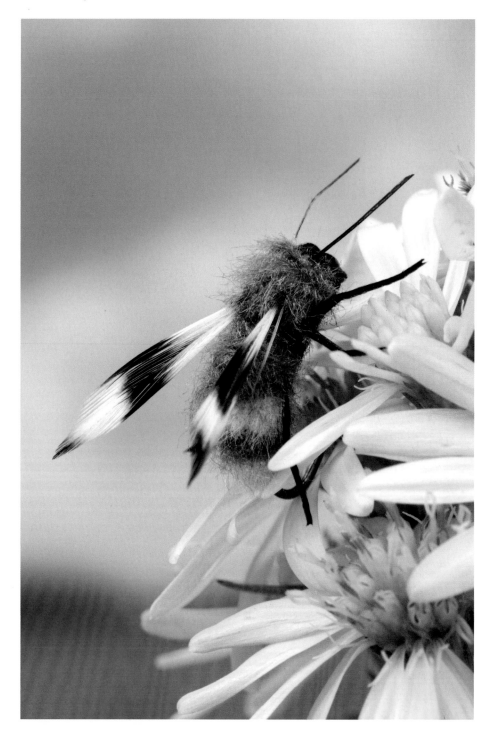

Hook: Hanak 300BL, size 12, **Thread:** Textreme Power thread 50D dyed with black marker where necessary, **Body and head:** Kapok spun in split thread around black foam, **Legs:** Turkey biot, **Wings and antennae:** Grizzly hackle tips where the stems become antennae, **Eyes:** Gulff Black UV resin.

Extended-Body Stone Fly—James Lund

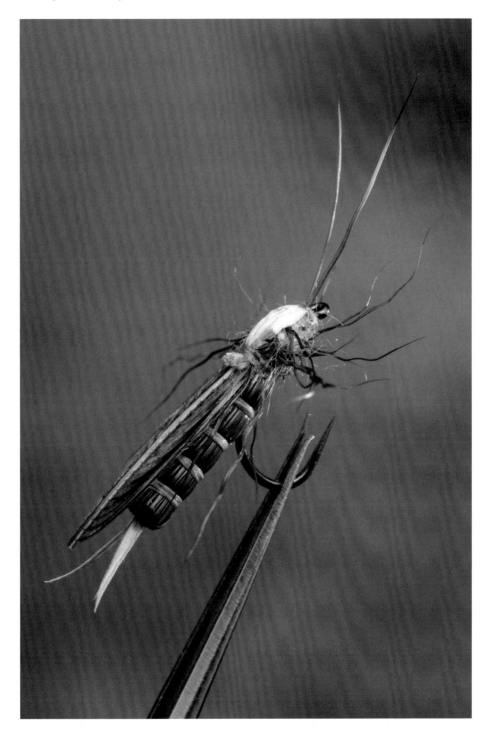

Hook: Hanak 390BL, size 16, **Thread:** UNI 8/0, tan, Veevus GSP 30D, **Body:** Turkey biot, elk hair, **Wing:** Coq de Leon, reversed, **Antennae:** Elk hair, **Thorax/Legs:** Swiss straw, chamois, kapok.

REGINE MAGUHNA, GERMANY

I live with my husband near Düsseldorf in Nordrhein. I retired in 2009 and made my fly-tying hobby into my new profession in 2018. In 2008 I started fishing and passed my fishing exam (a test is required before you can obtain a fishing license). Next, in 2009 I passed the fly-fishing test. Near the end of 2010, I taught myself fly tying, visited trade fairs for inspiration, and attended the EWF trade fair in Fürstenfeldbruck near Munich as a fly tyer from 2016 to 2018.

I slowly dealt with the topic of fly tying and tied all sorts of fly patterns. In 2011, I decided to enter the Open German Championship in fly tying. There, among other things, was the category of realistic flies, which I now also wanted to learn to tie.

There were no mentors who showed me how to tie realistic flies. I was tempted to teach myself, to experiment, to try out materials, and to have my flies evaluated. From year to year, my results became better. And my placements at various championships in fly tying improved. Finally, I got a first place. I was on the right path, and it's always a challenge to try new patterns. When I decide to tie realistic patterns, I let myself be guided by pictures of insects and then decide, spontaneously, what I will tie.

I must confess, however, that I do not consider realistic fly patterns to be fishing lures. They purely show objects unless they are tied up with very little effort. In the future, I believe that realistic fly patterns—even if they are tied as fishing lures and not as show objects—will be purchased by many fly fishermen as a collector's items. I often hear people at shows say the realistics are too good for the fish as baits.

Stone Fly Nymph—Regine Maguhna

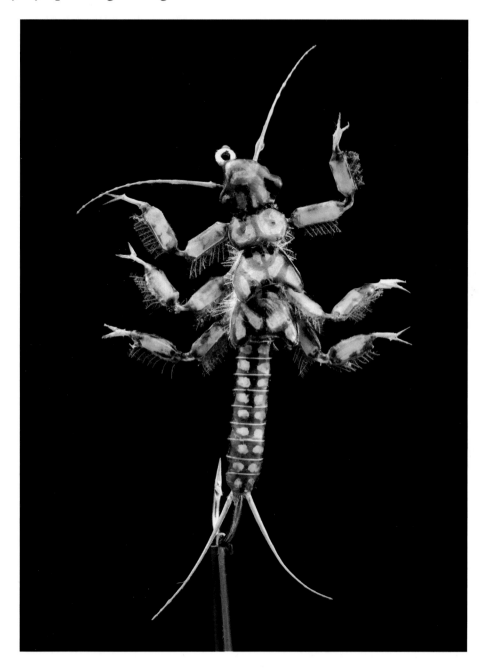

Hook: Sakana Streamerhook, size 4, hook shank from Osprey Streamerhook, size 6, **Thread:** Semperfli Nano Silk white 12/0, **Eyes:** Black bead chain, **Tail:** Quill, coloration: permanent marker ocher, Solarez thin, **Body:** Lead, Body Stretch brown, coloration: nail polish yellow, Solarez thin, **Ribbing:** Gold wire, **Legs:** Japanese Nymph Legs yellow, CDC brown, insulating tape yellow, Solarez thin, **Foot claws:** Biots yellow, Solarez Ultra Thin, coloration: permanent marker brown, **Sensor:** Quill, coloration: permanent marker ocher, Solarez thin, **Divided wings:** DC-Fix brown, coloration: nail polish yellow, Solarez thin, **Thorax hair:** CDC, white.

Cased Caddis Larva—Regine Maguhna

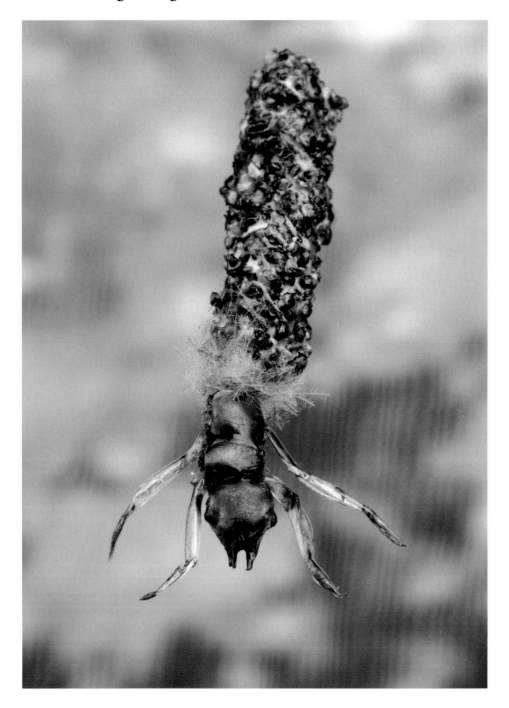

Hook: Osprey Streamer hook size 6, shank from Osprey Streamer hook, size 10, **Thread:** Danville 6/0 brown, **Case:** Decoration sand, wood, Solarez thin, coloration permanent marker brown and black nail polish, white CDC in front of the case, **Pliers:** Quill, coloration: permanent marker black, Solarez thin, **Head:** Polycelon brown, coloration: permanent marker black, **Legs:** Biots yellow, coloration: permanent marker brown, Solarez thin, **Thorax:** Dry fly dubbing olive, **Divided wings:** Latex brown, Solarez thin.

Crane Fly (Daddy Long Legs)—Regine Maguhna

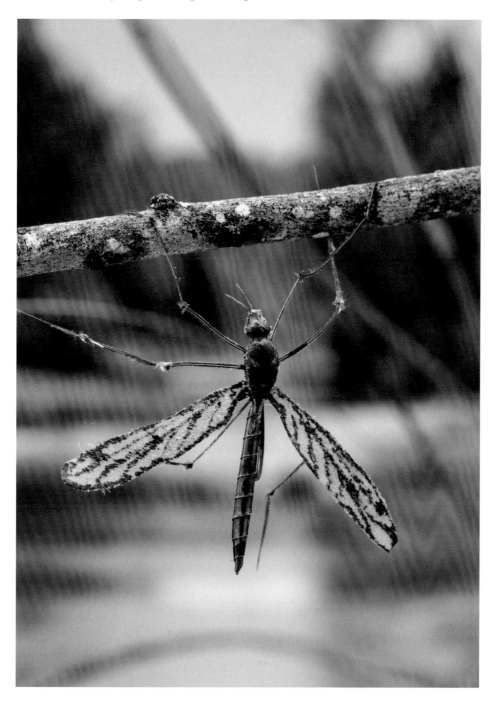

Hook: Partridge Klinkhammer, size 10, **Thread:** Danville 8/0 brown, **Abdomen:** Strip from a clear plastic bag, coloration: permanent marker brown and black, **Legs:** Fibers from the tail from King pheasant wing, glue, **Wings:** Poly II, coloration: permanent marker brown, Solarez, thin, **Sensor:** Pheasant tail fibers, **Divided wings:** Dexion brown, coloration: permanent marker brown and black, Solarez, thin, **Head:** Dexion brown, coloration: permanent marker brown and black, Solarez, thin, **Eyes:** Solarez, thin, coloration: black.

Ladybug *(Marienkäfer)*—Regine Maguhna

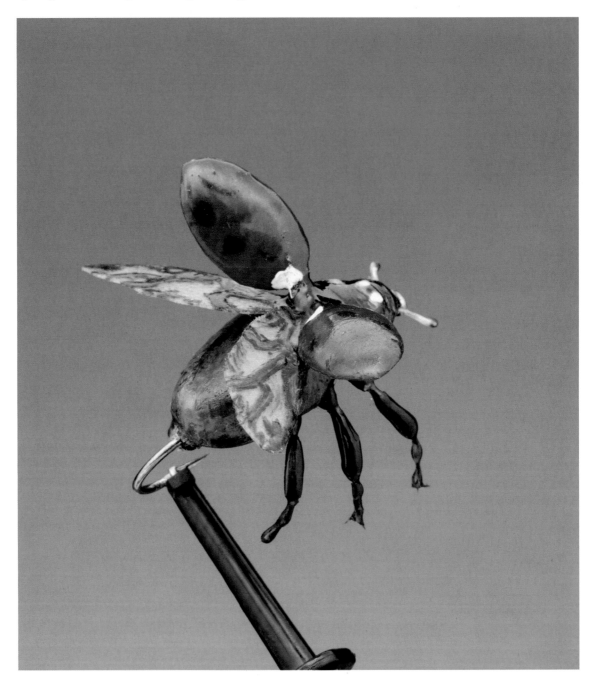

Hook: Osprey Streamer hook, size 6, **Thread:** Ultra Thread, 210 black, **Legs:** Japanese Nymph Legs, insolating tape black, Solarez, thin, **Foot claws:** Biots black, Solarez, thin, **Body and head:** Foam black, body coloration: nail polish orange, permanent marker brown and black, coloration: head nail polish white, permanent marker black, Solarez, thin, **Sensors:** Quill, coloration: permanent marker brown and black, Solarez, thin, **Wings:** Poly II, coloration: permanent marker brown, Solarez thin, **Wing cover:** Artificial fingernail, coloration: permanent marker red and black, nail polish white, Solarez thin.

Stag Beetle (Hirschkäfer)—Regine Maguhna

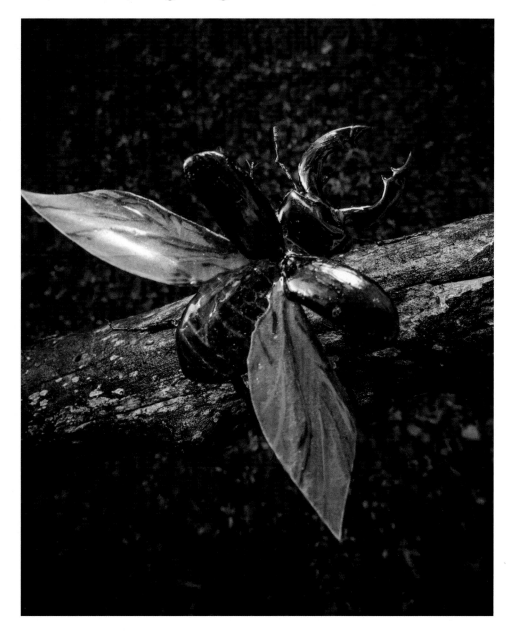

Hook: Mustad Streamer hook 3282, size 4/0, **Thread:** Ultra Thread 210 black, **Legs:** Japanese Nymph Legs, insolating tape black, Solarez thin, **Foot claws:** Biots black, Solarez thin, **Body and head:** Foam yellow, coloration: permanent marker yellow, brown and black, nail polish white, Solarez thin, **Eyes:** Solarez thin, coloration: permanent marker black, **Wings:** Poly II, coloration: permanent marker ocher, brown, Solarez thin, **Wing cover:** Artificial fingernail, coloration: permanent marker brown and black, Solarez thin, **Sensors:** Japanese Nymph Legs and black cock feather, coloration: black, Solarez thin, **Tongue (Labialpalpi):** Foam orange-brown, coloration: permanent marker brown and black, Solarez thin, **Pliers (Maxillarpalpi):** Japanese Nymph Legs, coloration: permanent marker brown, Solarez thin, **Antler:** Mobile film clear, coloration: permanent marker brown and black, Solarez thin.

MIKE MORPHEW, LA GRANGE, TEXAS

I am originally from England and have been tying flies and fishing for trout, salmon, and saltwater fish for over forty years.

I was first drawn to the art of tying as a boy when I watched a guy tying at a show in the UK. I watched him for hours until my father pulled me away. As I was leaving the guy said "come here" and he gave me all his half-empty packs of materials. I was feeling like Christmas morning! I tied my first fly in a pair of needle-nosed pliers held in a woodworking vise. I later found out that the guy was the legendary John Veniard who I later became friends with while starting up a Fly Dressers Guild club.

As an educator in my working life, I like nothing more than teaching the art of dressing a hook. I've spent hours at shows and clubs demonstrating skills for beginners and proficient tyers from setting a dry fly wing to the simple woolly bugger. I still get a thrill from seeing a youngster's face after tying their first fly.

I became interested in tying ultrarealistic patterns about fifteen years ago and have found these flies and bugs to be a huge attraction at shows, both here in Texas and shows I have attended around the States. Although not for fishing, I have found tying these helps me with thread control when tying any other fly from simple trout flies to fully dressed salmon patterns.

I tie the realistic flies and bugs mostly for clients, and these are mounted in box frames or glass domes. Recently at a show I was asked to tie a range of patterns for a museum.

Since moving to Texas, I have had to adopt my tying and fishing for bass and bluegill. I have loved the challenge but still miss my trout, and to that end travel to Oklahoma and Arkansas every year. I have been invited to tie at the IFF International Fairs and feel very honored to be asked.

People always ask me what's the best fish you have caught and it has to be not the biggest but the most rewarding, and that is my fish of a lifetime a 21½-pound brownie on a size 12 fly and a 6-pound tippet. Other achievements that I am proud of was in 2003 while living in the British Virgin Islands I was asked to tie and present Her Royal Highness Princess Anne with a fully dressed salmon fly display. Being awarded the Gold certificate for the FFI tying awards is another achievement.

Mating Damselflies—Mike Morphew

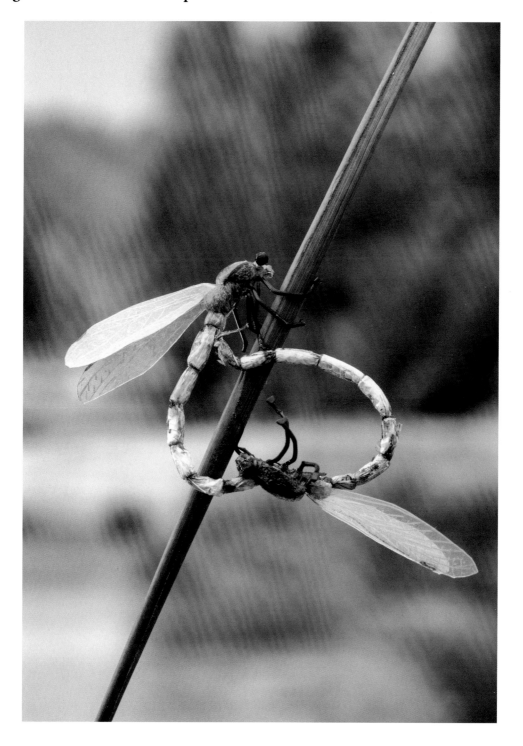

Hook: Veniard grub hook 14, **Thread:** Danville Spiderweb, **Body:** Piano wire, Kingfisher blue Raffine, **Thorax:** Ultrafine chenille and Raffine, **Wings:** Fine acetate sheet with actual photograph of the natural wing printed on, scored with fine needle for veins.

Sulphur Dun—Mike Morphew

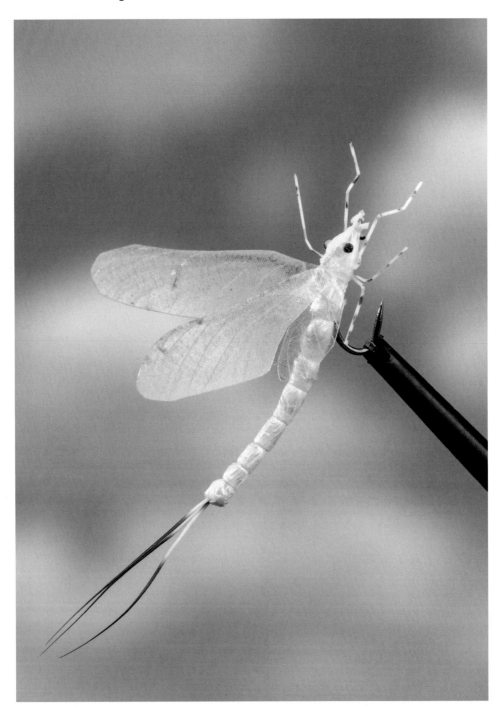

Hook: Tiemco 100, size 12, **Thread:** Danville Spiderweb, **Detached body:** florets wire, 2 mm foam, yellow Raffine cut to make individual body segments, **Tail:** Peccary hair tips, **Legs:** hand brush bristles colored with Copic marker, **Wings:** Fine acetate sheet with actual photograph of the natural wing printed on, scored with fine needle for veins, **Eyes:** 8x nylon burnt and colored.

Stag Beetle—Mike Morphew

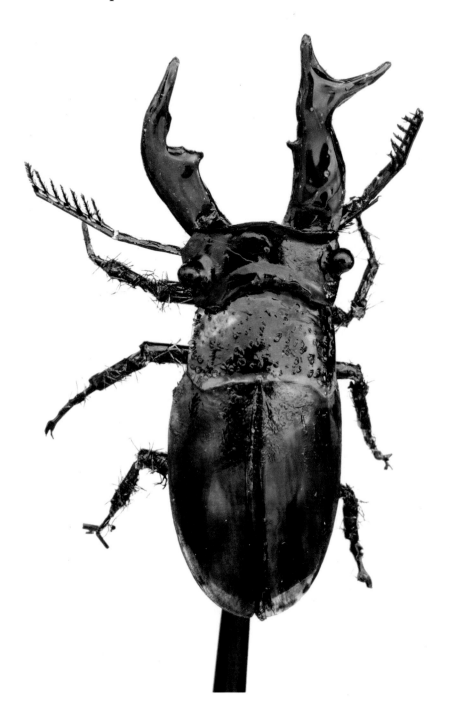

Hook: Tiemco 100, size 8, **Thread:** Danville Spiderweb, colored with brown Copic, **Underbody:** Black foam, **Legs:** Porcupine quill, cut and broom bristle inserted then colored, **Tarsal claws:** Danville monocord, tied in, resin then cut, **Rear shell case (elytra):** False fingernail, split and colored, **Thorax:** Cut fingernail to shape, dotted with hot needle, **Mandible:** Foam cut and shaped, coated with Deer Creek resin, **Antennae:** Peacock sword feather stripped on side, **Eyes:** Small black mono eyes.

ANASTASIOS PAPADOPOULOS, NORWAY

I was born in Greece and moved to Norway at the age of twenty-three. I learned fly tying there and used that mostly for my fishing the coast for seatrout and sea bass. The first years, I was tying mostly simple flies for basic fishing but the more I learned about fly tying, the more I liked to put details on my flies. After some years I came to a point where I spent my evening just to tie one single fly. And, maybe for the next two or three days just to get it as realistic as I could. It became a hobby that was part of an already existing hobby. The goal was not to tie a fly to catch a fish but to tie a fly to look as realistic as possible when compared to the real thing. Still today I will sit for endless hours and tie realistics just to take a break from the "ordinary stuff."

I have had a lot of inspiration from many fly tyers, including Konstantin Karagyozov, Giovanni de Pace, Kern Leo Lund, Bob Popovics, Nacho Heredero, and Steven Farrar. We fly tyers are getting inspired by each other almost every day so it would be unfair not to mention everybody from whom my inspiration comes. But, at the same time, inspiration comes from most of us sharing in social media that gets us inspired from each other. The list is long.

Octopus—Anastasios Papadopoulos

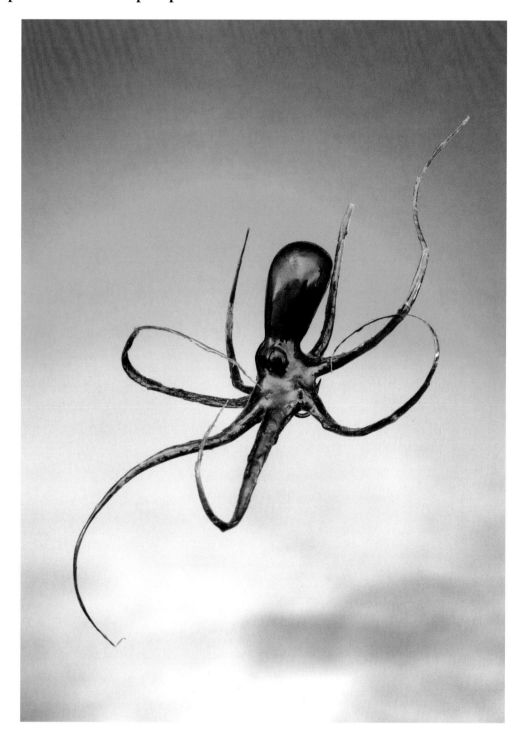

Hook: Mustad 36890 black salmon hook, size 1/0, **Body:** Tan craft fur formed with Solarez Thick UV resin, **Color:** Various brown colors permanent makers sealed with Solarez Thin UV resin, **Eyes:** Black permanent maker sealed with Solarez Thin UV resin.

EP Sea Bream—Anastasios Papadopoulos

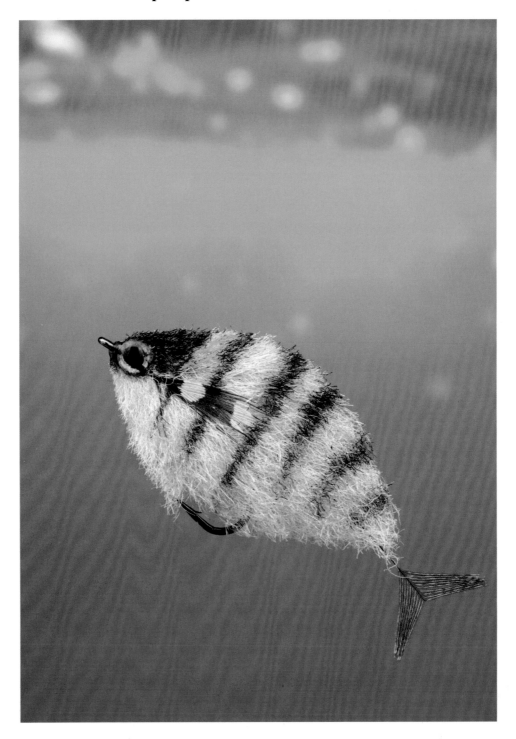

Hook: Ahrex NS 110, #2, **Tail:** Coq de Leon feather cut and shaped as a tail, **Body:** White EP fibers mixed with pearl Angel Hair, **Colors:** Permanent markers, black and yellow, **Eyes:** 3D epoxy eyes 5 mm, **Fins:** Guinea fowl feathers cut to form the fins.

EP Brown Trout—Anastasios Papadopoulos

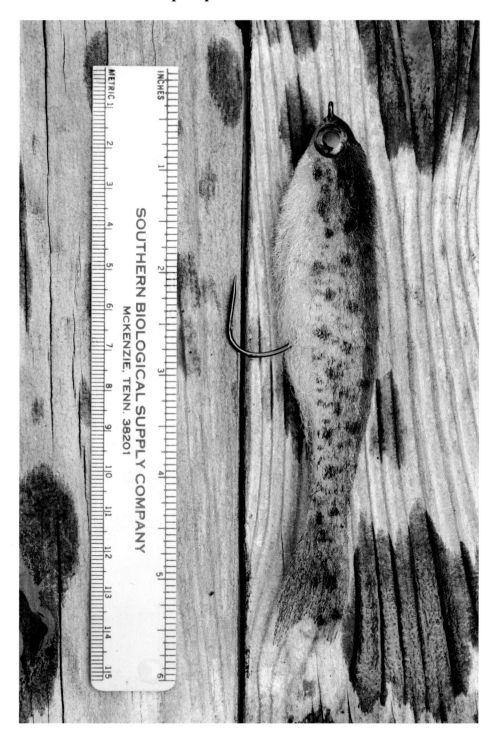

Hook: Ahrex Light Predator barbless, size 6/0, **Tail:** EP fibers tied on with monofilament, **Body:** EP fibers tied on the hook in sections, formed with a scissors and Solarez UV resin to keep the shape, **Dots:** Black permanent marker, **Eyes:** 3D epoxy eyes, 6 mm.

STÉPHANE "STEVO" PERICK, BELGIUM

It is now about only ten years since I started fly fishing and tying my own flies. I have been fishing with other techniques since I was seven years old. From the beginning, tying my own flies was a real passion. Over the years, I have been fortunate to fish in countries other than Belgium, which has led me to meet talented international fishermen and fly tyers who have been generous enough to share their knowledge with me. These meetings only increased my passion for fishing and fly tying. My passion is fishing rivers all over the world to catch brown trout and grayling with dry flies.

For several years I worked with fly-fishing companies such as Deer Creek, Fasna Fly Fishing, and GVS Realistic Fly-Tying System. Discovering new fly-tying materials led me to discover the tying of realistic flies.

My passion for now is to imitate, as much as possible, the insects that I photograph or that I discovered in entomology books.

You will also find me in various fly-fishing shows in Belgium but also in other countries such as the United Kingdom—BFFI. It was at the BFFI that my international friends started calling me "Stevo." When I was contacted to participate in this book, I did not hesitate to accept. I love sharing my passion for fly tying as my friends did with me and I can tell you that in this passion, you learn new techniques, tricks, etc. every day.

Pupa Variant—Stéphane "Stevo" Perick

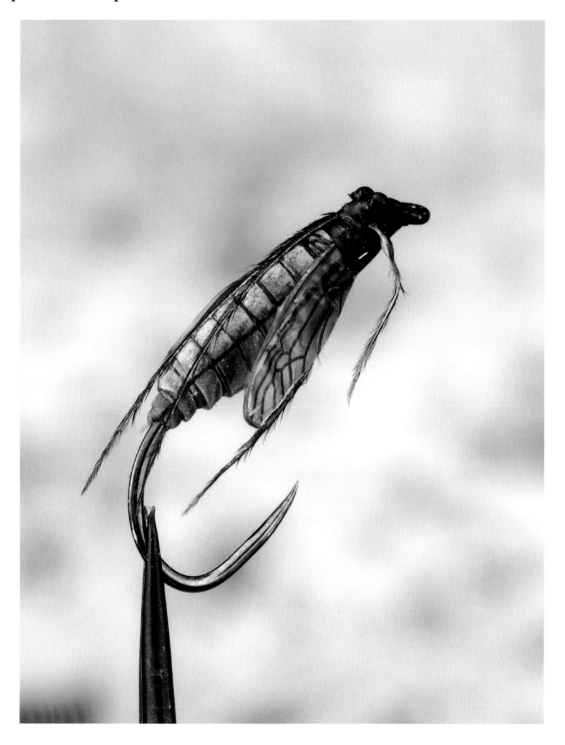

Hook: Fasna F-150 Pupa, size 10, **Thread:** GVS Power Thread Nano Silk White, 50 denier, **Body:** Body Glass, **Thorax:** Fasna Scruffy Dubbing, brown, **Bead:** Fasna copper, 3 mm, **UV resin:** Deer Creek Diamond Fine Flex.

Mayfly Nymph—Stéphane "Stevo" Perick

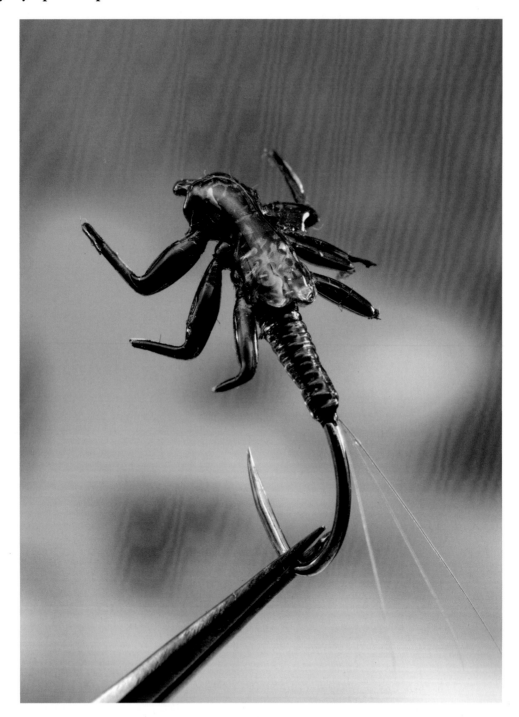

Hook: Fasna F-900 Streamer, size 12, **Thread:** GVS Power Thread Nano Silk White, 50 denier, **Body:** Body Glass, **Thorax:** GVS Realistic Wings for Mayfly Nymph, **Legs:** GVS Realistic NML Legs for Mayfly Nymph, **Tails:** GVS Realistic Tails and Slim Antennas (Microfibets), **Bead:** Fasna Copper, 4X, **UV resin:** Deer Creek Diamond Fine Flex.

Dragonfly Nymph—Stéphane "Stevo" Perick

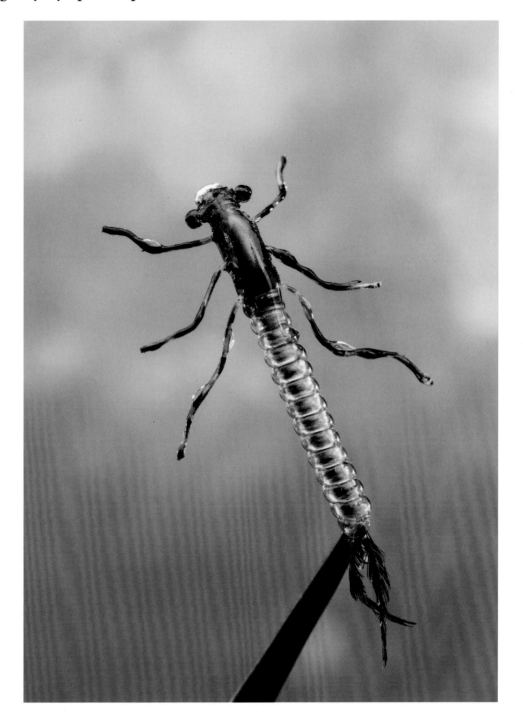

Hook: GVS NH-100 Nymph, size 8, **Thread:** GVS Power Thread Nano Silk White, 50 denier, **Body:** Body Glass, **Thorax:** GVS Realistic Bug Body, covered with UV resin, **Legs:** Homemade colored by pen and covered by UV resin, **Tails:** Peacock, **Eyes:** Homemade with monofilament, **UV resin:** Deer Creek Diamond Fine Flex.

Nymph, Pupa Variant—Stéphane "Stevo" Perick

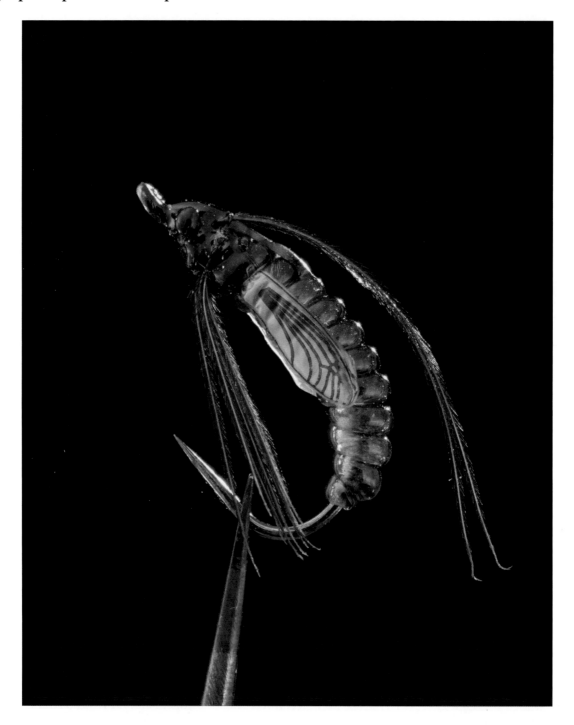

Hook: Fasna F-150 Pupa, size 10, **Thread:** GVS Power Thread Nano Silk White, 50 denier, **Body:** Body Glass, **Thorax:** GVS Realistic Bug Body, covered with UV resin, **Antennae:** Pheasant fibers, **Legs:** Pheasant fibers, **Wings:** GVS Realistic Wings for Terrestrials and Midges, **Eyes:** Homemade with monofilament, **UV resin:** Deer Creek Diamond Fine Flex.

Stone Fly Adult—Stéphane "Stevo" Perick

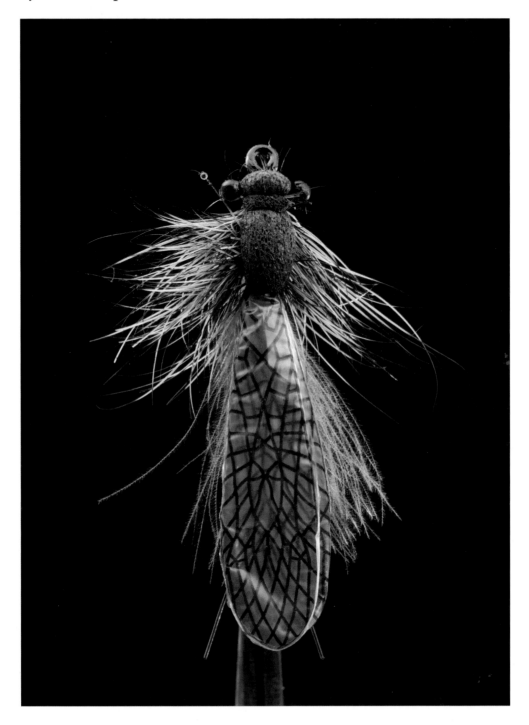

Hook: Fasna F 120 Klinkhammer, size 12, **Thread:** GVS Power Thread Nano Silk White, 50 denier, **Body:** GVS selected Foam for Extended Body of Realistic Flies, 2 mm, **Wings:** GVS Realistic Wings for Adult Stonefly, Underwings: CDC and deer hair, **Thorax:** Pheasant fibers, **Underthorax:** CDC and deer hair, **UV resin:** Deer Creek Diamond Fine Flex.

Stone Fly Nymph—Stéphane "Stevo" Perick

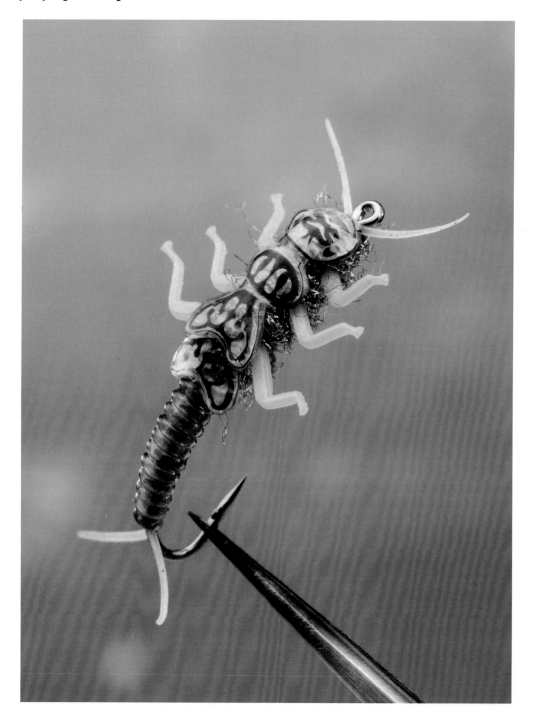

Hook: GVS NH-100 Nymph, size 8, **Thread:** GVS Power Thread Nano Silk white, **Body:** Body Glass, **Legs:** GVS Realistic Legs for Stonelfy Nymphs, Antennae and **Tails:** GVS Realistic Antennas and Tails, **Thorax:** GVS Realistic Wings for Stonefly Nymph, covered with UV resin, **Underthorax:** Fasna Spectra Dubbing, **UV resin:** Deer Creek Diamond Fine Flex.

Mayfly Nymph—Stéphane "Stevo" Perick

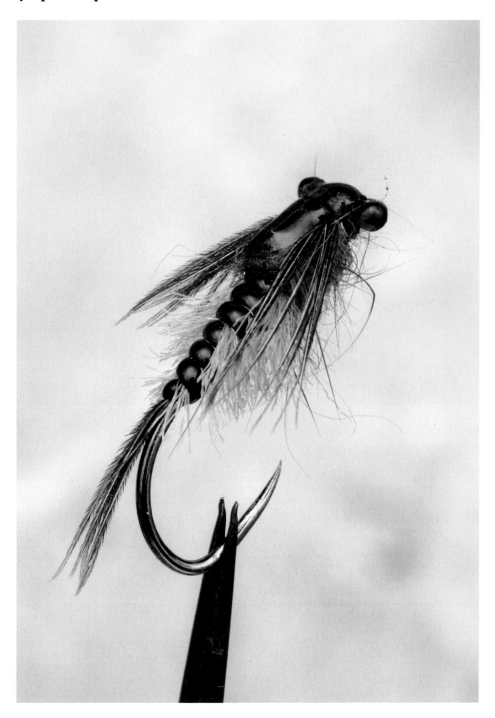

Hook: Fasna F 900 Streamer, size 14, **Thread:** GVS Power Thread Nano Silk White, 50 denier, **Body:** Body Glass with Antron, **Thorax:** GVS Realistic Bug Body, **Underthorax:** Fasna Scruffy Dubbing, **Legs:** Pheasant fibers, **Eyes:** Homemade with monofilament, **Tails:** Pheasant fibers, **UV resin:** Deer Creek Diamond Fine Flex.

Crane Fly—Stéphane "Stevo" Perick

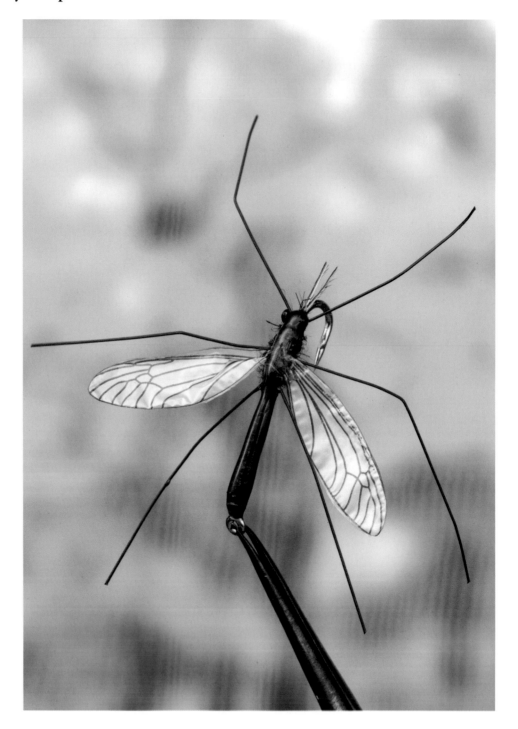

Hook: GVS NH-100 Nymph, size 10, **Thread:** GVS Power Thread Nano Silk paint in brown by marker, **Body:** Thread covered by UV resin, **Thorax:** GVS Realistic Bug Body covered with UV resin, **Case:** Fasna Scruffy Dubbing, **Wings:** GVS Realistic Wings for Terrestrials and Midges, **Legs:** Homemade, **Antennae:** Pheasant fibers, **Eyes:** Homemade with monofilament, **UV resin:** Deer Creek Diamond Fine Flex.

Stone Fly Adult—Stéphane "Stevo" Perick

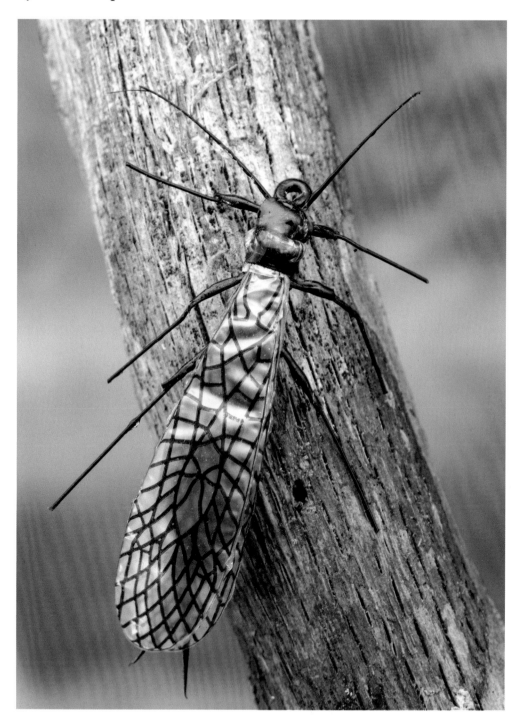

Hook: GVS NH-100 Nymph, size 8, **Thread:** GVS Power Thread Nano Silk White, 50 denier, **Body:** Nymph Skin, Virtual Nymph, **Wings:** GVS Realistic Wings for Adult Stonefly, **Thorax:** Thread, covered with UV resin, **Antennae and legs:** Homemade, **UV resin:** Deer Creek Diamond Fine Flex.

Nymph—Stéphane "Stevo" Perick

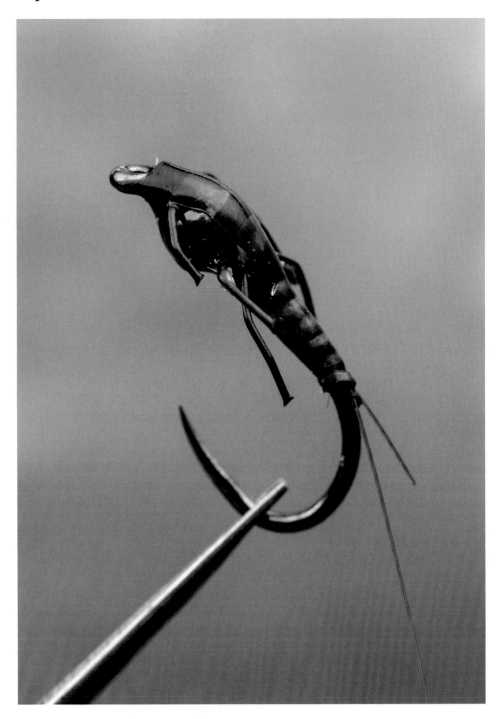

Hook: Fasna F-310 Nymph, size 16, **Thread:** GVS Power Thread Nano Silk paint in black by marker, **Body:** Polish quills and UV resin, **Thorax:** GVS Realistic Bug Body and resin, **Legs:** Homemade, **Tails:** GVS Realistic Tails and Slim Antennae (Microfibets), **Bead:** Fasna Tungsten Bead, 2 mm, **UV resin:** Deer Creek Diamond Fine Flex.

LARS PERSSON, SWEDEN

I work as a carpenter full-time. My favorite hobby is tying flies. I spend almost all my spare time during the long Swedish winter tying flies or learning new techniques. Every evening I often tie at least one new fly. During the spring, summer, and fall I tie less and spend more time by some stream, fishing for trout, trying some of my own flies. I prefer to fish dry flies. I like to spend my free time in nature, drinking coffee and seeing fish rise.

I had been tying flies from time to time since 2014. But, it was in August 2017 that I became really interested after I came across a Facebook group in Sweden about dry flies. After that, it became a big hobby and that was the starting point for me to really learn tying flies.

My realistic tying is not meant to be exactly what bugs look like. I just want to make bug-like flies that look like they are alive. In my experience, flies that look too real don't fish as well as the more buggy-looking ones.

I have been trying to tie realistic for maybe one year or so. I guess I just got involved with realistic tying: it just happened. It was a way to test myself, to see what I was able to do. One of the first patterns I saw was a larva tied by Markus Hoffman. He and Ola Andersson are great inspirations. After that time, I have seen a lot of realistic flies from different persons and find some inspiration in all of them. I think more and more people will try to tie realistic in the future as we get more people tying all the time. But, in the end, a buggy fly will fish better.

Spent Mayfly—Lars Persson

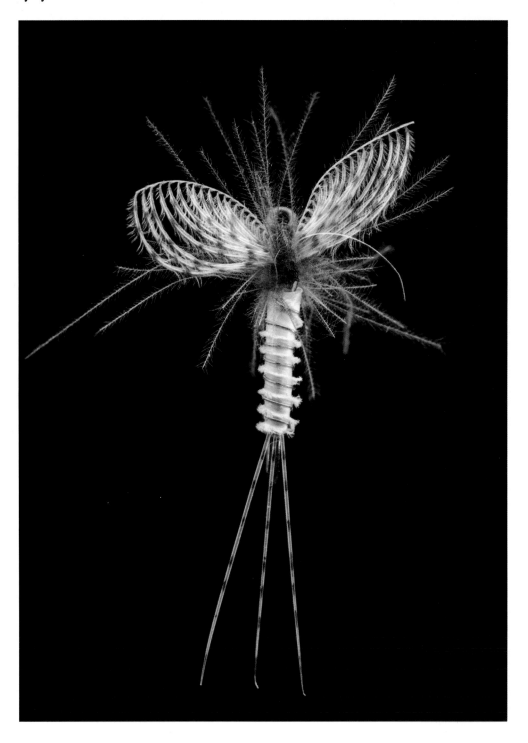

Hook: Firehole 419, size 16, **Thread:** Semperfli Nano Silk 18/0 white, **Tail:** Paintbrush fibers, **Rib:** Sybai wire Gold 0.1 mm, **Body:** Turkey biot caddis green, **Wing:** Mallard natural, **Thorax/hackle:** CDC.

Spent Mayfly—Lars Persson

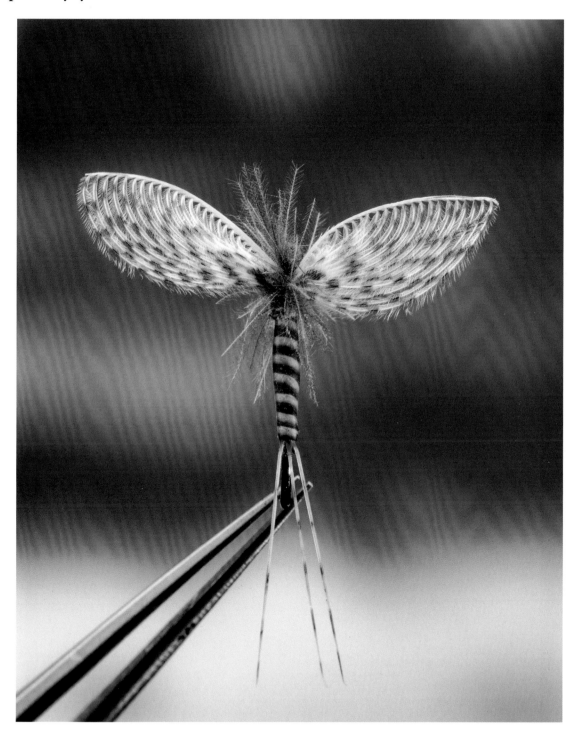

Hook: Firehole 419, size 16, **Thread:** Semperfli Nano Silk 18/0, white, **Tail:** Paintbrush fibers, **Body:** Peacock quill natural and UV resin, **Wing:** Mallard natural, **Thorax/hackle:** CDC.

Mayfly—Lars Persson

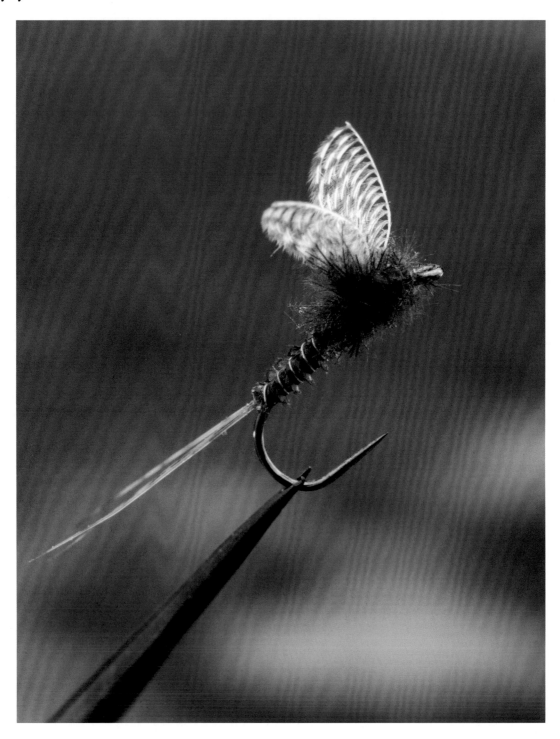

Hook: Hanak 100 bl, size 14, **Thread:** Semperfli Nano Silk 18/0, white, **Tail:** Paintbrush fibers, **Rib:** Sybai wire Gold 0.1 mm, **Body:** Turkey biot black, **Eyes:** Nylon thread 0.40 mm and Gulff Black Magic UV resin, **Wing:** Mallard natural, **Thorax/hackle:** CDC.

Cased Caddis—Lars Persson

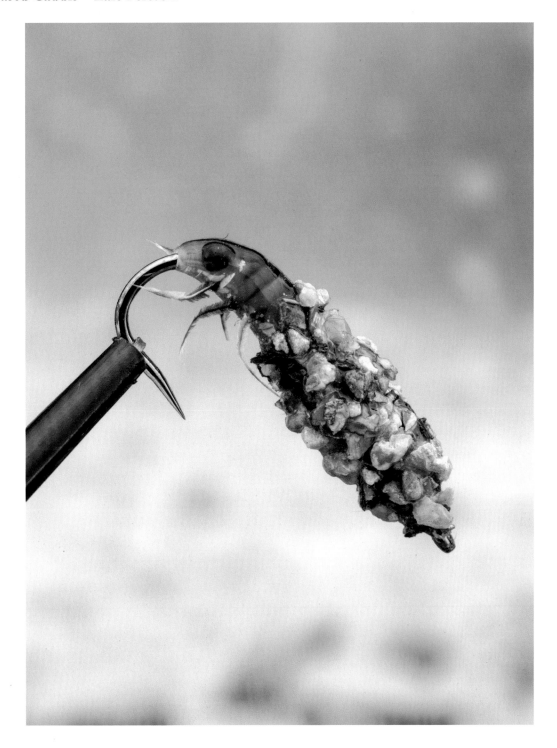

Hook: Hanak 970 bl, size 10, **Thread:** Semperfli Nano Silk 18/0 white, **Body:** Latex and Marc Petitjean split thread, 8/0 cream, **Weight:** Tungsten sheet, **Legs:** Pheasant tail fibers, **Eyes/body:** Gulff Black Magic UV resin, **Case:** Superglue and pepper mix.

Cased Caddis—Lars Persson

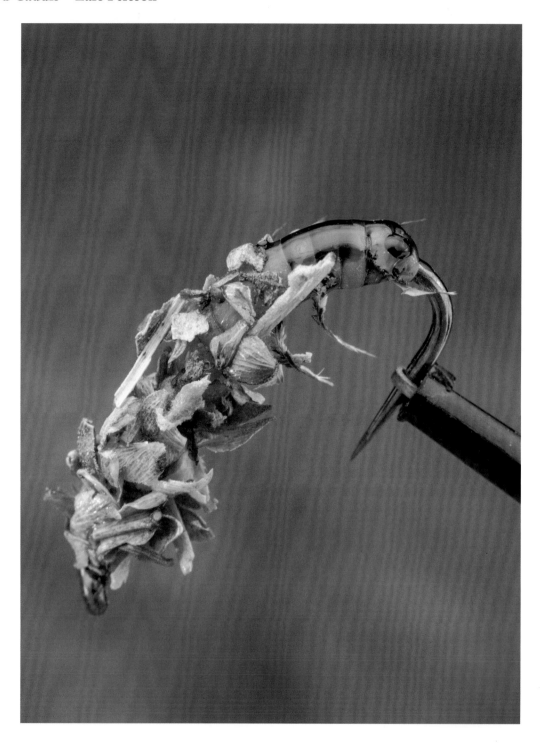

Hook: Hanak 900 bl, size 8, **Thread:** Semperfli Nano Silk 18/0 white, **Body:** Latex and Marc Petitjean split thread 8/0 cream, **Legs:** Pheasant tail fibers, **Eyes/body:** Gulff Black Magic UV resin, **Case:** Oregano and superglue.

Caddis Larva—Lars Persson

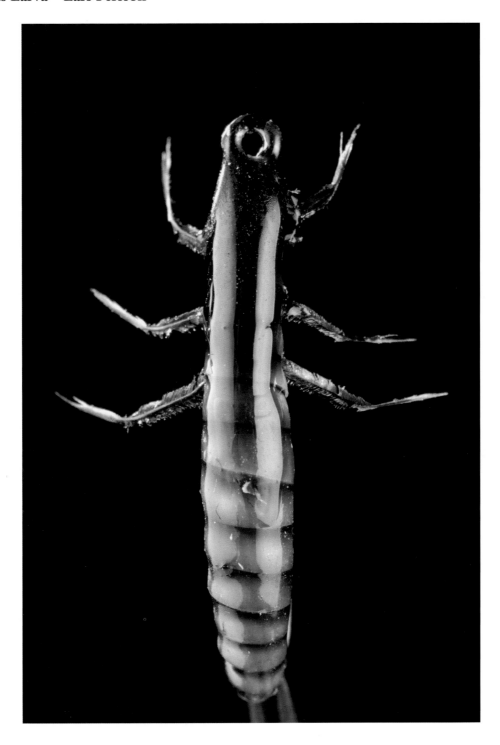

Hook: Firehole 718, size 12, **Thread:** Semperfli Nano Silk, 18/0 white, **Body:** Latex and Marc Petitjean split thread 8/0 cream, **Legs:** Pheasant tail fibers, **Eyes/body:** Gulff Black Magic UV resin, permanent marker.

Caddis Larva—Lars Persson

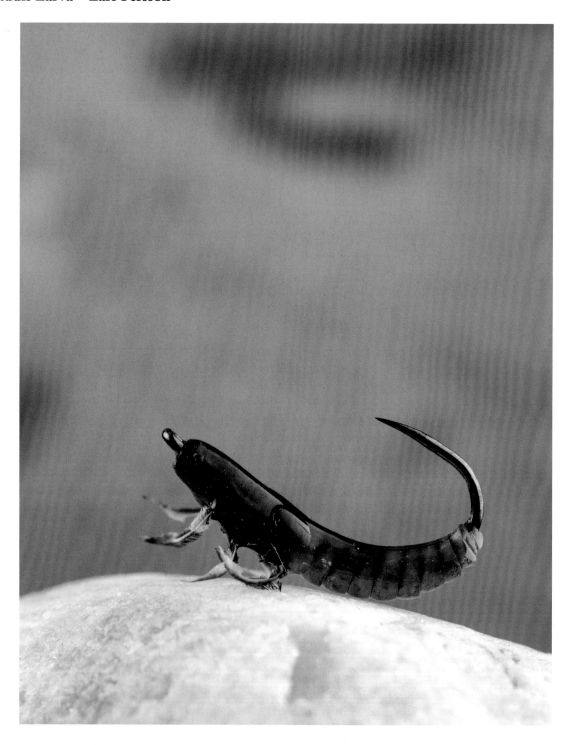

Hook: Firehole 317, size 12, **Thread:** Semperfli Nano Silk, 18/0 white, **Body:** Latex and Marc Petitjean split thread 8/0 cream, **Legs:** Pheasant tail fibers, **Eyes/body:** Gulff Black Magic UV resin.

Caddis Pupa—Lars Persson

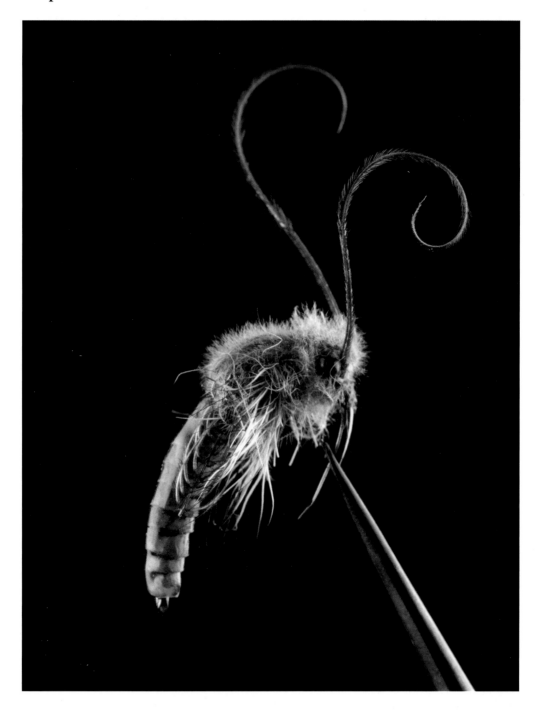

Hook: Dohiku, type P, size 10, **Thread:** Semperfli Nano Silk 18/0 white, **Body:** Latex and Marc Petitjean split thread 8/0 cream, **Eyes:** Nylon thread 0.40 mm, **Eyes/body:** Gulff Black Magic UV resin, permanent marker, varnish body, **Head/cover:** CDC, **Thorax:** Brown SLF dubbing, **Wing case:** Coq de Leon, **Thorax:** Brown SLF dubbing, **Legs:** Moose fibers, **Thorax:** Brown SLF dubbing, **Antennae:** Pheasant tail fibers, **Thorax:** Brown SLF dubbing.

Caddis Pupa—Lars Persson

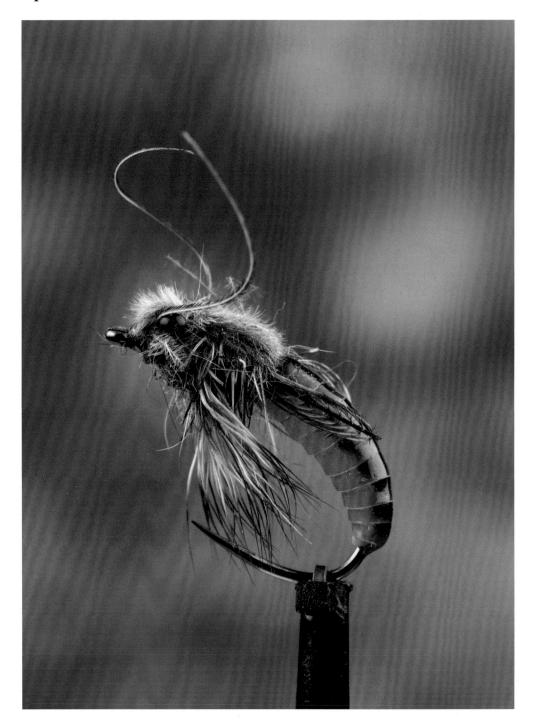

Hook: Dohiku, type P, size 10, **Thread:** Semperfli Nano Silk, 18/0 white, **Body:** Latex and Marc Petitjean split thread 8/0 cream, **Eyes:** Nylon thread 0.40 mm, **Eyes/body:** Gulff Black Magic UV resin, permanent marker, varnish body, **Head/cover:** CDC, **Thorax:** Brown SLF dubbing, **Wing case:** Coq de Leon, **Thorax:** Brown SLF dubbing, **Legs:** Moose fibers, **Antennae:** Pheasant tail fibers, **Thorax:** Brown SLF dubbing.

Caddis—Lars Persson

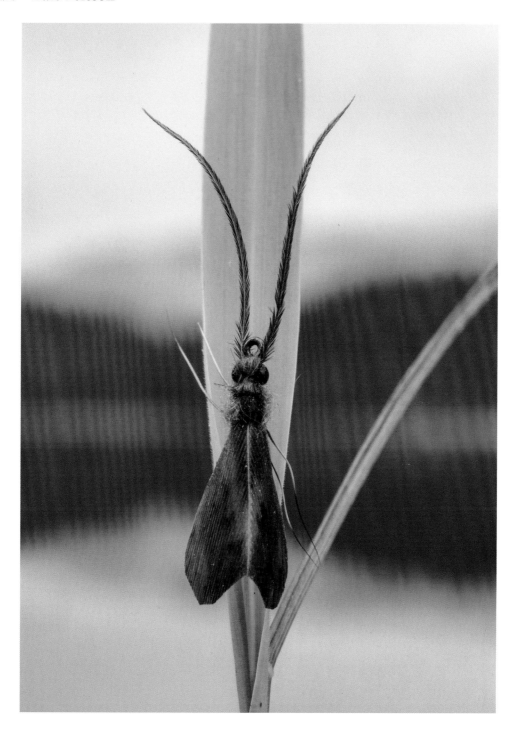

Hook: Firehole 419, size 14, **Thread:** Semperfli Nano Silk 18/0 white, **Body:** CDC, **Eyes:** Nylon thread 0.40 mm, **Wing:** Pheasant feather, **Thorax:** Brown SLF dubbing, **Antennae:** Pheasant tail fibers, **Legs:** Moose fibers, **Head:** Kapok, brown.

KAREN ROYER, OHIO

Karen Royer is an internationally recognized fly tyer and published author with over twenty-three years of experience. Her book, *The Art of Tying Realistic Flies* was published in 2018. She is originally from the Pacific Northwest, but her military family now resides in Clayton, Ohio. Throughout the year she gives presentations at numerous venues across the United States. An artist at heart, Karen specializes in creating and tying her own "Fishable Realistic" patterns. Although she appreciates and admires the plethora of existing patterns available, following someone else's patterns was just not in her nature. Ever the conservationist, she remains passionate about not contributing to the continued pollution of our waters and therefore developed her patterns using only natural materials.

Inspired, mentored and encouraged by the likes of Bob Mead, Jackson Leong, Bill Blackstone, and the late David Martin, she plans on continuing to develop new realistic patterns and completing a second pattern book in the future.

Blue Damsel—Karen Royer

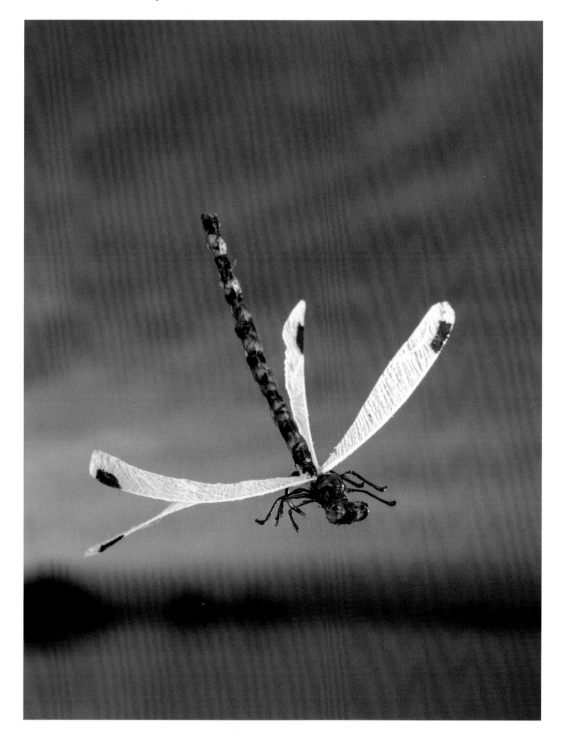

Hook: Partridge of Redditch, Patriot Barbless, Ideal Standard Dry size 14–16 SUD2, **Thread:** Danville, black, size 8/0–10/0, **Extended Body:** Kingfisher blue hackle feather, **Body:** Kingfisher blue marabou, **Wings:** White Cul de Canard, **Legs:** Stripped feather quills, **Eyes:** Waxed blue marabou, **Coating:** UV gel glue.

Stone Fly—Karen Royer

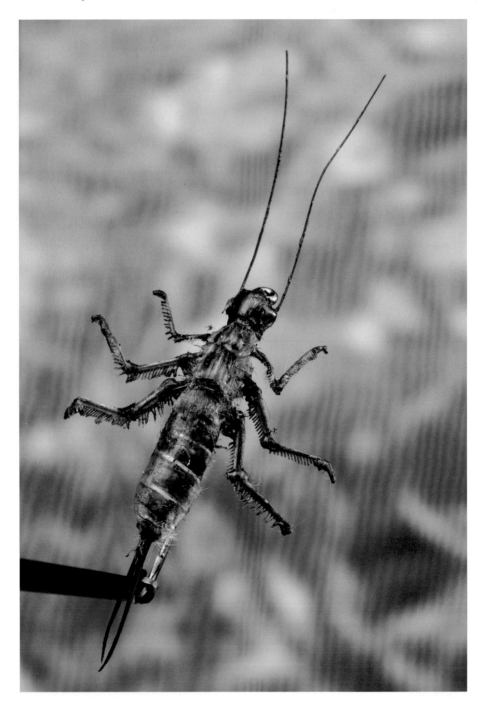

Hook: Partridge of Redditch, Heritage Streamer 5X Long, sizes 6—8, **Thread:** Danville, brown, size 8/0, **Tail:** Goose biot, **Abdomen:** White ostrich herl rib, raffia strip, waxed Nature's Spirit Fine Natural Dubbing, white, **Thorax:** White ostrich herl, tan Nature's Spirit Fine Natural Dubbing, **Overwing:** Dried fish fin, **Legs:** Stripped feather quills, **Head:** Raffia over tan Nature's Spirit Fine Natural Dubbing, **Antennae:** Stripped feather quill, **Coating:** UV gel glue.

IVO SMITS, IRELAND

Originally from Latvia, Ivo moved to Ireland in 2009. He was interested in fishing from an early age. After moving to Ireland, Ivo discovered fly fishing, which was not popular in Latvia at the time. As he developed into a seasoned fly angler, Ivo was always looking to adapt various fly-fishing styles used in different parts of the world to his local rivers and lakes. His attempts to adopt fishing styles used in North America and Canada subsequently led to the need for different flies to be used. The shortage of these flies in local angling outlets, resulted in Ivo's first attempts at fly tying.

Ivo has been involved in the fly-tying art for five years with the main focus on Irish lake flies. Popularity in flies tied by Ivo led him to become a professional fly dresser despite his achievements in education where he holds a master's degree in business studies. Ivo has fully dedicated himself to the fly dressing art.

In addition to supplying anglers with custom flies, Ivo is actively involved with various fundraising activities associated with angling such as youth development sponsorship, Casting For Recovery sponsorship, and sponsorship of angling clubs of which he is involved.

Pink Caddis Pupa—Ivo Smits

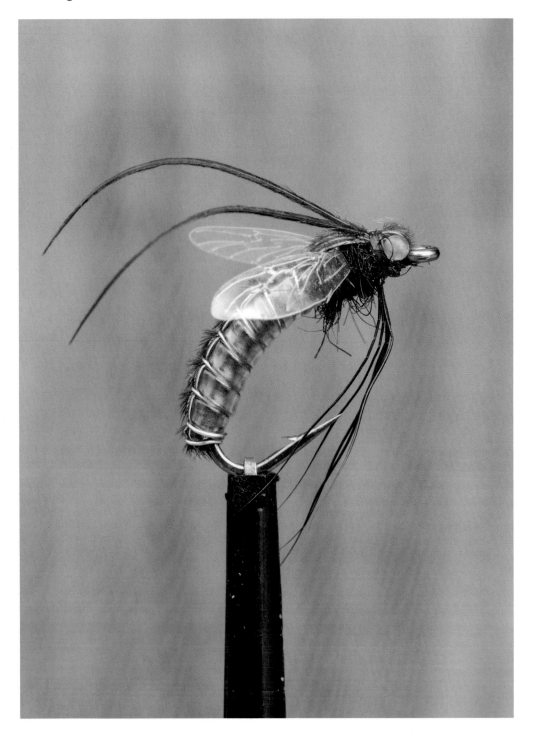

Hook: Partridge Caddis Emerger, size 10, **Thread:** Danville's brown 70 Denier Waxed, **Ribbing:** UTC gold wire, **Main Body:** Stretch tubing, **Thorax:** Brown dubbing, **Back:** Pheasant tail fibers, **Legs:** Dyed black deer hair, **Antennae:** Bronze mallard fibers, **Eyes:** 25-pound monofilament, **Wings:** Joseph Ludkins Reel Wings.

Pale Caddis Pupa—Ivo Smits

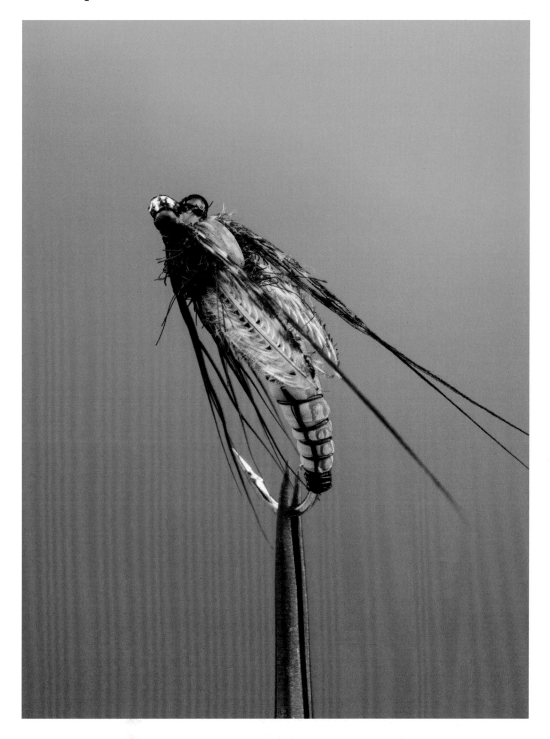

Hook: Partridge Caddis Emerger, size 10, **Thread:** UTC Ultra Thread, black, 70, **Ribbing:** UTC black wire, **Body Wrap:** Latex Nymph Skin, **Thorax:** Brown dubbing, **Wally Wing:** Mallard flank feather, **Legs:** Dyed black deer hair, **Antennae:** Bronze mallard fibers, **Eyes:** 25-pound monofilament line.

Mosquito Fly—Ivo Smits

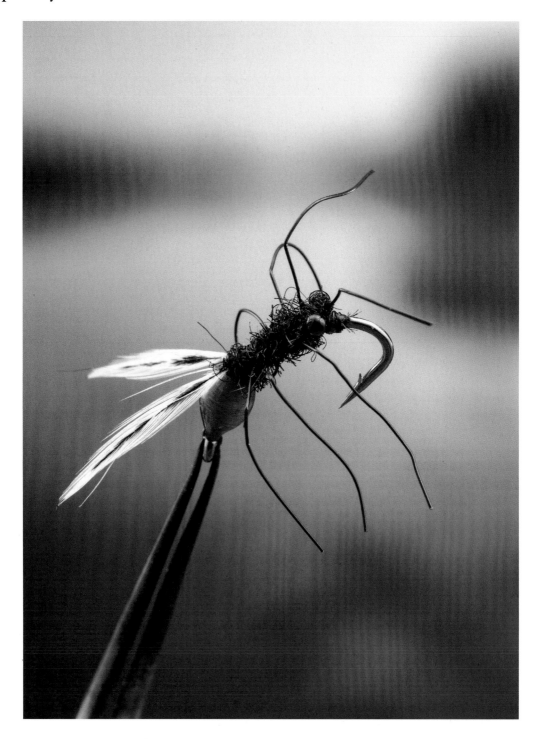

Hook: Partridge Caddis Emerger, size 10, **Thread:** UTC Ultra Thread, black, 70, Main **Body:** UV resin, **Legs:** UTC black wire, **Wings:** Bleached Indian cock feathers, **Thorax:** Black dubbing, **Eyes:** 25-pound monofilament.

Red Ant—Ivo Smits

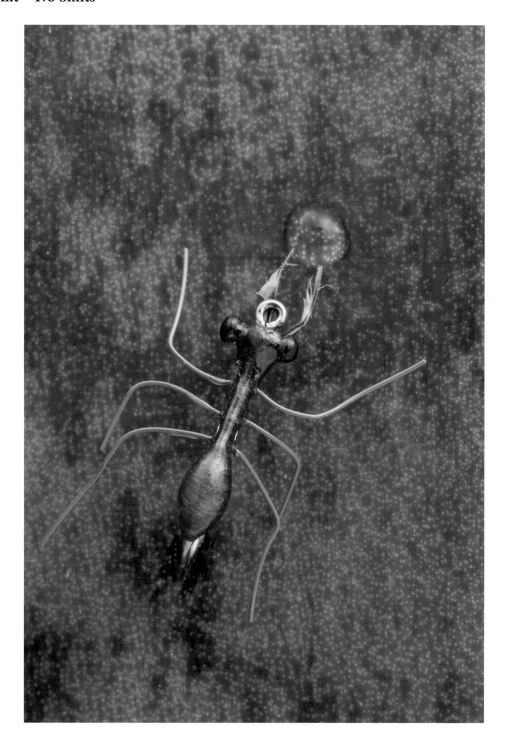

Hook: Partridge Spider, size 12, **Thread:** Danville's brown 70 Denier Waxed, **Main Body:** UV resin, **Legs:** UTC ginger wire, **Mandible:** Pheasant tail fibers, **Eyes:** 25-pound monofilament.

Reversed Stone Fly Nymph—Ivo Smits

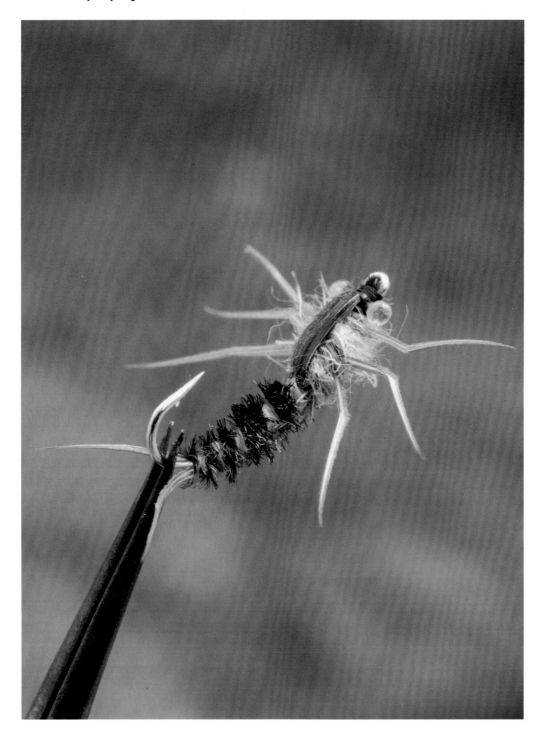

Hook: Partridge Caddis Emerger, size 10, **Thread:** Danville's brown 70 Denier Waxed, **Tails:** Brown goose biots, **Ribbing:** Brown quills, **Main Body:** Peacock herl, **Legs:** Brown goose biots, **Back:** Pheasant tail fibers, **Thorax:** Mature seal fur, **Eyes:** 25-pound monofilament.

Common Black Spider—Ivo Smits

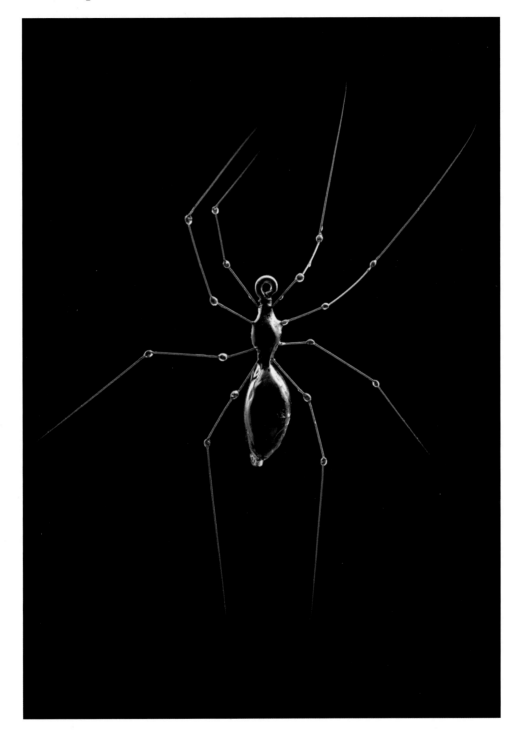

Hook: Partridge Spider, size 12, **Thread:** UTC Ultra Thread, black, 70, **Main Body:** UV resin, **Legs:** Black Microfibets.

Brown Egg-Laying Caddis—Ivo Smits

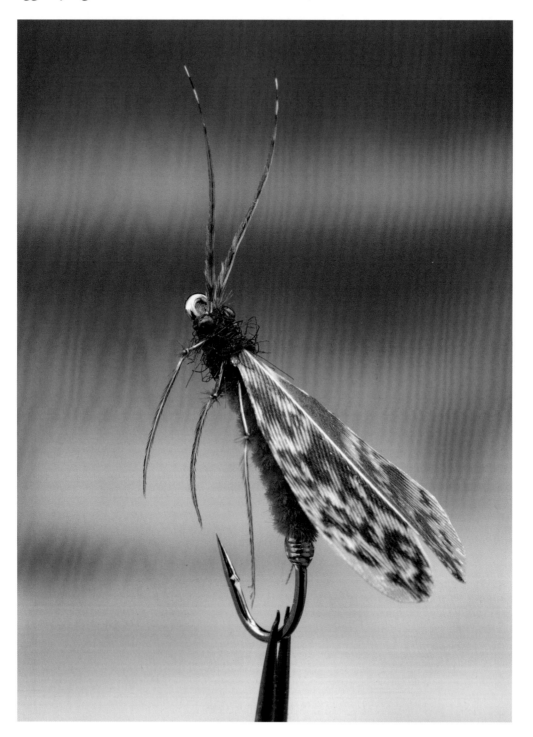

Hook: Partridge Sedge/Caddis, size 10, **Thread:** Danville's brown 70 Denier Waxed, **Egg:** UV resin, **Main Body:** Brown chenille, **Legs:** Pheasant tail fibers, **Thorax:** Brown dubbing, **Antennae:** Bronze mallard fibers, **Eyes:** 25-pound monofilament, **Wing:** Under-taped partridge feather.

Adult Mayfly—Ivo Smits

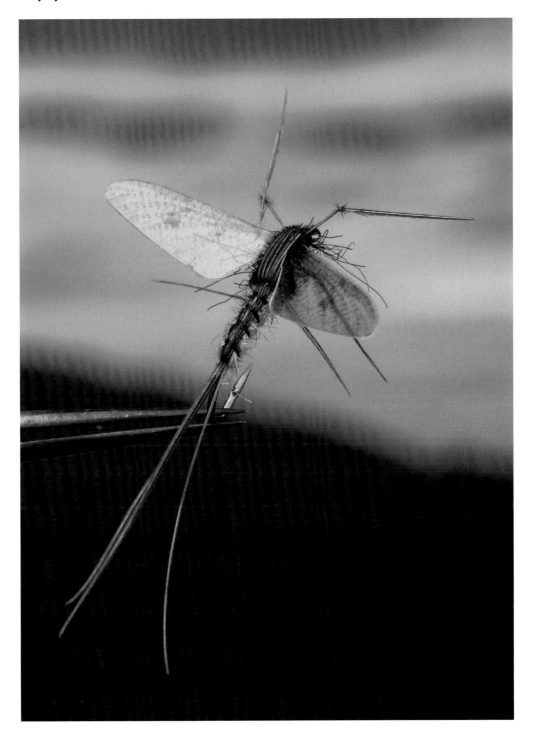

Hook: Partridge Dry Fly Supreme size 10, **Thread:** UTC Ultra Thread, black, 70, **Tails:** Pheasant tail fibers, **Back:** Pheasant tail fibers, **Body:** Yellow dubbing, **Thorax:** Pheasant tail fibers and black dubbing, **Legs:** Pheasant tail fibers, **Wing:** Hemingway Realistic Wings.

Freshwater Shrimp—Ivo Smits

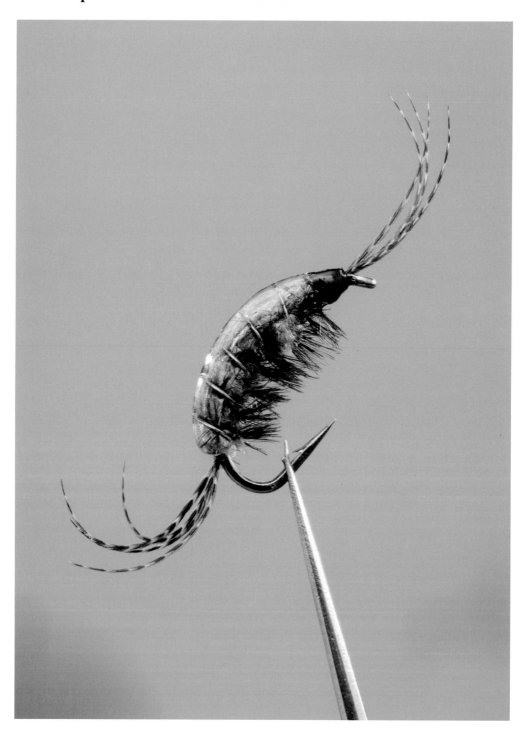

Hook: Partridge Grub/Shrimp size 10, **Thread:** UTC Ultra Thread, black, 70, **Tails:** Bronze mallard fibers, **Ribbing:** UTC gold wire, **Body Skin:** Fino Skin, **Main Body:** Olive dubbing, **Legs:** Brown ostrich herl, **Antennae:** Bronze mallard fibers, **Body Cover:** UV resin.

MOUAMAR TANASH, EDMONTON, ALBERTA, CANADA

I work in the oil and gas industry, and that requires me to travel away from home for a few weeks at a time. I stay in work camp and I usually go fishing after work. In May 2019, I purchased a fly-fishing kit to try something new. I was losing a lot of flies in the process of learning how to cast the fly rod. Because there is no fly shop and limited fly-fishing supplies in the town where I work, I had to wait until my days off to stock up on flies.

In July 2019, I purchased a Superfly Deluxe Fly Tying Kit with materials. I wanted to learn to tie my own flies while I was at work camp. I started tying simple patterns then moved on to salmon flies after watching lots of YouTube videos on how to tie them. It was very hard to gather all the materials I needed for all these beautiful patterns. One day while fishing, I saw a Tar Sand Beetle land on the surface of the water and a big northern pike jumped out of nowhere and swallowed it. That was the moment I decided to match the hatch.

Plecoptera Nymph—Mouamar Tanash

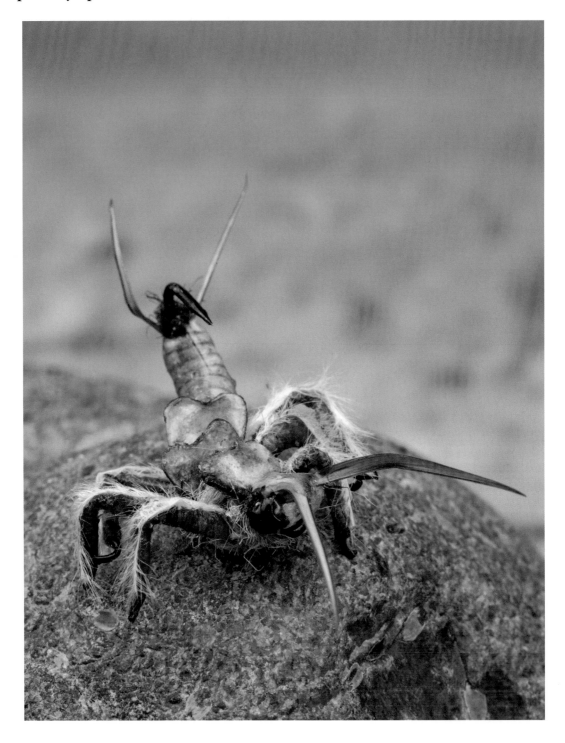

Hook: Hends BL599, size 8, **Thread:** Semperfli 18/0 white colored with Sharpie marker, **Underbody:** Lead wire, **Body:** Swiss Straw, cream, Antron dubbing, clear plastic bag, and Solarez UV resin, **Head:** Craft foam, **Antennae and Tail:** Goose Blots, **Legs:** Coats All-purpose thread, Zap-A-Gap, and Solarez UV resin.

Silk Moth Cocoon Adult—Mouamar Tanash

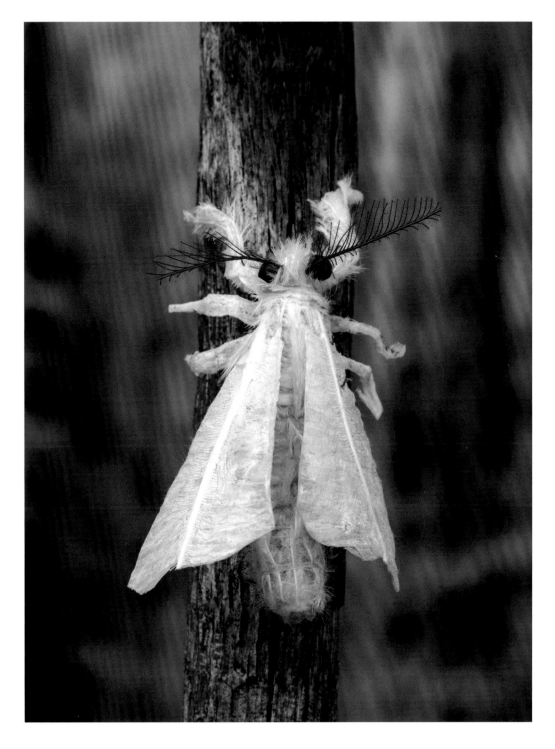

Thread: Semperfli 8/0, **Hook:** Hends BL588, size 8, **Body:** Monofilament, ostrich, yarn, **Head:** Ostrich, **Antennae:** MFC CDC, **Eyes:** Monofilament, **Wings:** Turkey marabou, Solarez Thin UV resin, **Legs:** Ostrich, monofilament, yarn, Zap-A-Gap.

Dragonfly—Mouamar Tanash

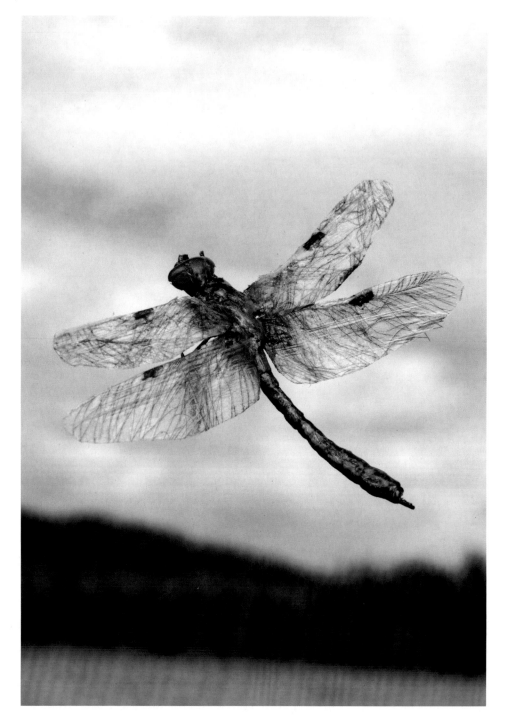

Hook: Size 4 salmon Superfly, **Thread:** Semperfli Nano Silk, 30D, **Body:** Semplerfli chenille and Raffene, **Wings:** Semperfli Raffene, Scotch tape, and black CDC, **Head:** Craft foam, Solarez UV Thin resin and Semperfli Raffene, **Eyes:** Solarez UV thick Resin, Loon Hard Head, red, **Legs:** 4x tippet, Semperfli 8/0 waxed thread and superglue, **Finishing touchups:** Sharpie markers, superglue, Solarez UV resin, **Tail:** Broom bristles.

Grasshopper—Mouamar Tanash

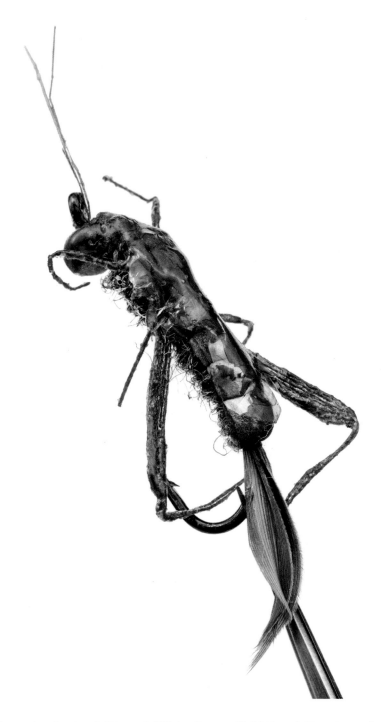

Hook: Superfly Salmon hook, size 4, **Thread:** White Semperfli 18/0 and Sharpie marker, **Antennae:** Coats Thread, Solarez UV resin, and Sharpie marker, **Eyes:** Solarez UV resin, Sharpie markers, **Head:** Craft foam, **Body:** Craft foam, Antron dubbing, Sharpie markers, **Tail:** Turkey feather, **Legs:** Uni Floss, Zap-A-Gap, Solarez UV resin, **Wings:** Clear plastic bag, Sharpie markers, Solarez UV resin.

Female Black Widow Spider—Mouamar Tanash

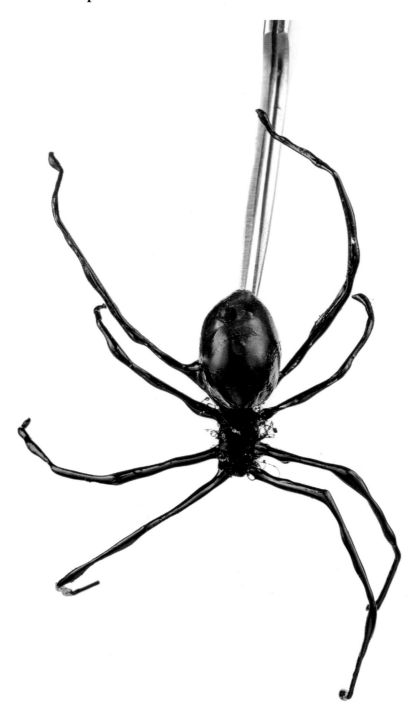

Hook: Mustad 3366-BR Wet Fly, size 10, **Thread:** Black Coats All Purpose T1, **Body:** Craft foam, latex grease gorilla glove, white marker, red Sharpie marker, Solarez UV resin, **Thorax:** Antron dubbing, **Head:** Black craft foam, Solarez UV resin, **Legs:** Broom bristles, thick Solarez UV resin, black nail polish.

Rainbow Grasshopper—Mouamar Tanash

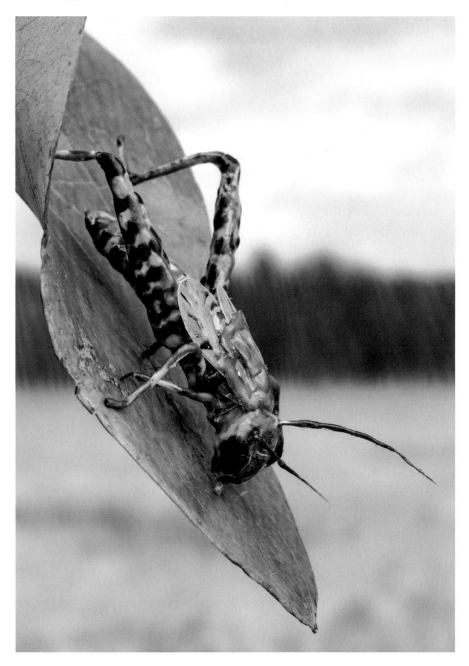

Hook: Superfly salmon hook, size 8, **Thread:** Semperfli 12/0, **Body:** Dollorama polyester yarn, Semperfli Swiss Straw, Solarez UV resin, Anself UV nail polish, monofilament and copper wire, **Back Legs:** Monofilament, Uni 8/0 thread, Anself UV nail polish, **Mid and Front Legs:** Monofilament, Uni Floss, Zap-A-Gap, Anself UV nail polish, **Wings:** Saddle hackle, Anself UV nail polish, **Wing Case:** Semperfli Swiss Straw, Anself UV nail polish, **Eyes:** Thick Solarez UV resin, Anself UV nail polish, **Antennae:** Natural peccary hair, UV Anself UV nail polish, **Head:** Craft foam, Anself UV nail polish, **Mouth:** Monofilament, Anself UV nail polish.

Praying Mantis—Mouamar Tanash

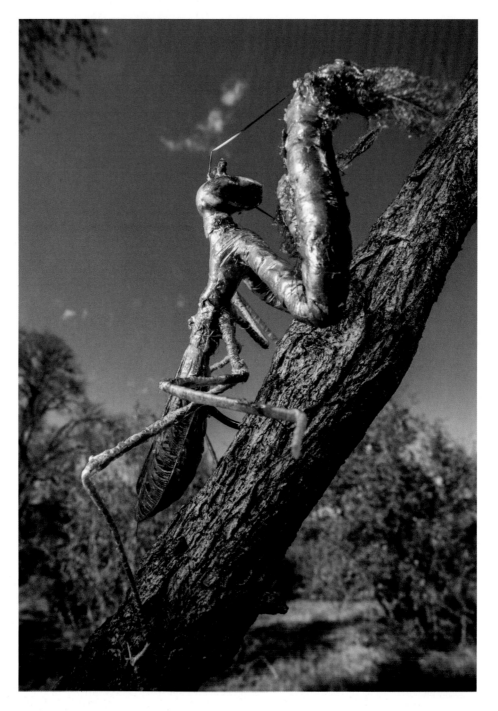

Hook: Cabela's size 1, **Thread:** Uni 8/0, green, **Body:** Monofilament, polyester yarn, Semperfli Swiss Straw, **Back and Mid Legs:** Monofilament, broom bristles, Zap-A-Gap, **Front Legs:** Monofilament, broom bristles, polyester yarn, Semperfli Swiss Straw, MFC CDC feather, **Tail and Antennae:** Natural peccary hair, green Sharpie marker, **Wings:** Hen neck feather, Solarez UV resin, Anself UV Nail polish, **Eyes:** Solarez UV resin, Anself UV Nail polish.

Mayfly—Mouamar Tanash

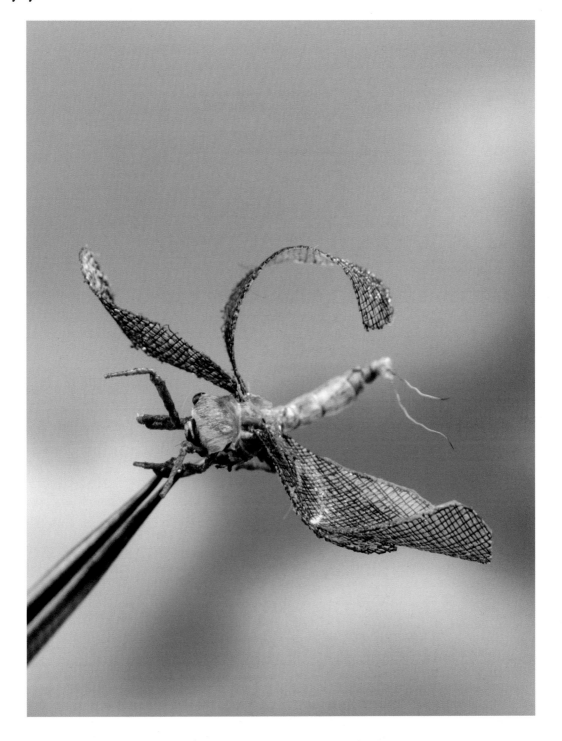

Hook: Size 12, **Body:** Craft foam and raffene, **Abatement:** Raffene, **Legs:** 8/0 threads and Krazy Glue with Sharpie coloring, **Head:** Craft foam, UV resin, **Wings:** Craft mesh, **Tail:** Elk hair, **Eyes:** Burned monofilament.

Aquatic Nymph—Mouamar Tanash

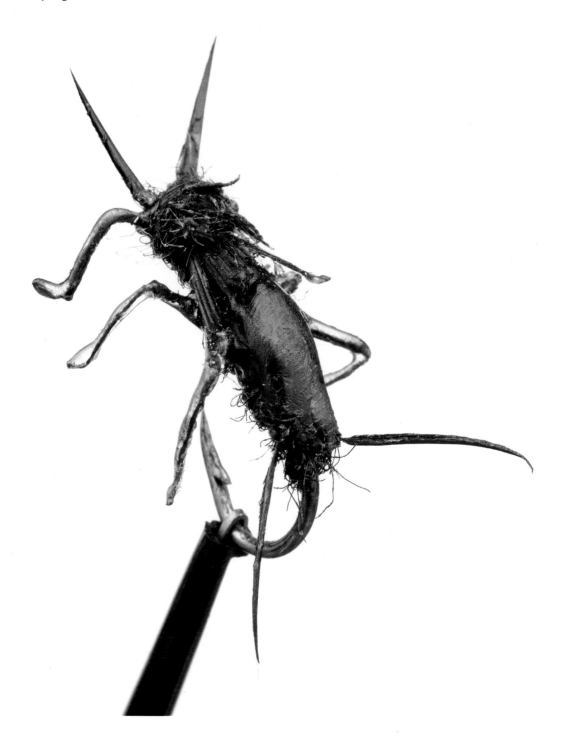

Hook: Size 8, **Body, abatement, and head:** craft foam, UV resin, **Legs:** Thread, brush bristles, Krazy Glue, and UV resin, **Wings:** Guinea feather, Sharpie marker, and UV flex resin, **Antennae and tail:** Goose quill, Sharpie marker, and UV resin.

BRAM VAN HOUTEN, NETHERLANDS

Bram van Houten is still addicted to fishing after more than forty years. By following his passion, he won multiple national competitions after starting with a fixed-line fishing rod. After a few years, he discovered fly fishing, and he started tying his own flies. Bram's mentor at that time was Ben Pont, one of the founding fathers of fly fishing in the Netherlands. Now known for his realistic wings and tying tools, Bram has become one of the most well-known fly tyers in the world.

Bram loves to fly fish in the Ardennes, Belgium. When time permits, he travels to Slovenia or the Czech Republic, known for the good rivers that have a high density of fish. The natural flies in those rivers are his inspiration for the patterns he creates.

It is not easy to find the right materials for a fly. Therefore, Bram started making his own materials. His realistic wings became something that many people wanted to have. Go to dutchflytying.com to find out more about his wings and tools.

Spent Mayfly—Bram van Houten

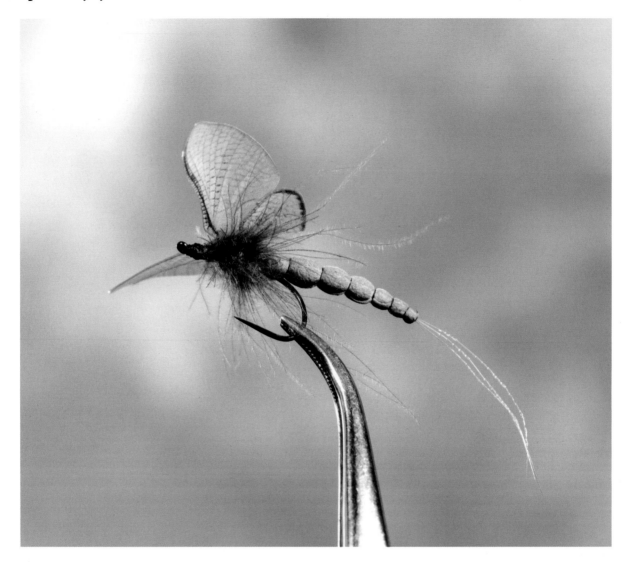

Hook: Muruto C47 BL, #12, **Thread:** Veevus, 16/0, brown, **Tails:** TMC Versatail, **Body:** Foam (Dutch Fly Tying mayfly body), **Thorax:** CDC in a loop, **Wing:** Dutch Fly Tying no. 45 # 20, **Wing Case:** Antron.

Butterfly—Bram van Houten

Hook: Muruto C47BL, #10, **Thread:** UTC 70, **Body:** Foam colored with a marker, **Thorax:** CDC in a loop, **Wing:** Dutch Fly Tying butterfly wing, **Eyes:** Melted nylon, **Antennae:** TMC Versatail.

Mayfly—Bram van Houten

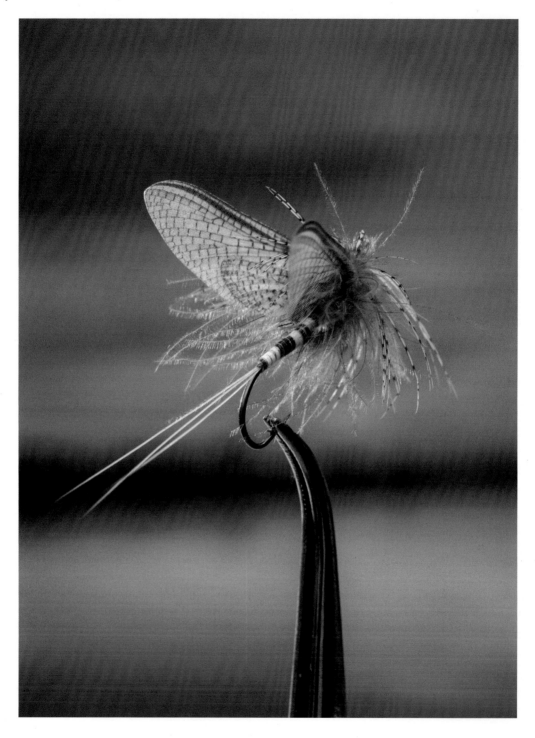

Hook: Daiiichi 1770, #8 or #10, **Thread:** UTC 70, **Tails:** TMC Versatail, **Body:** Magic Quills, **Thorax:** Squirrel dubbing and CDC in a loop, **Wing:** Dutch Fly Tying mayfly wing 37, #20, **Wing Case:** Antron, Front **Hackle:** Partridge.

Spent Caddis Fly—Bram van Houten

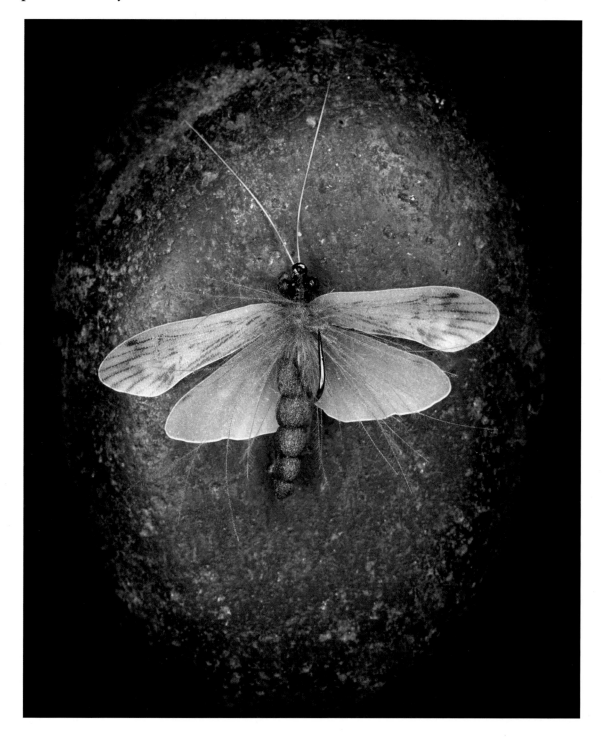

Hook: Muruto C47BL, #14, **Thread:** UTC 70, **Body:** Foam, **Thorax:** CDC in a loop, **Wing:** Dutch Fly Tying caddis wing 25, **Wing Case:** Antron, **Eyes:** Melted nylon, **Antennae:** TMC Versatail.

Moth—Bram van Houten

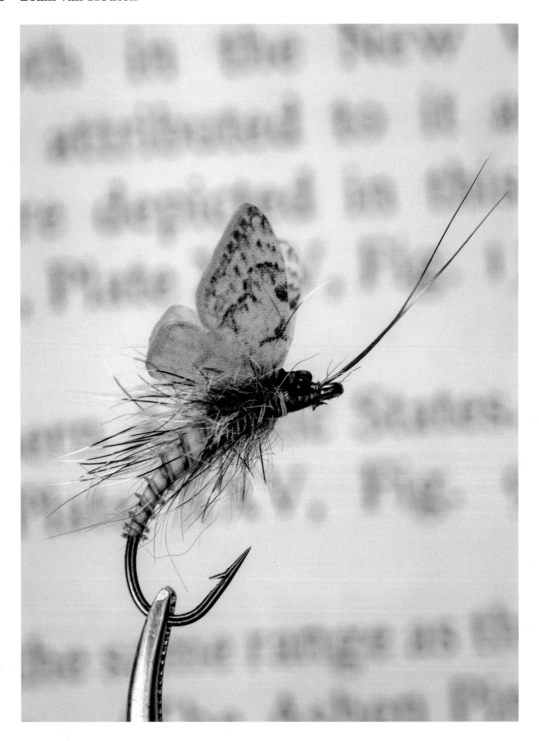

Hook: Muruto C47BL, #14, **Thread:** Veevus 16/0, brown, **Body:** Turkey quill, **Thorax:** Squirrel hair in a loop, **Wing:** Dutch Fly Tying moth wing, **Wing Case:** Antron, **Eyes:** Melted nylon, **Antennae:** Partridge.

Nymph—Bram van Houten

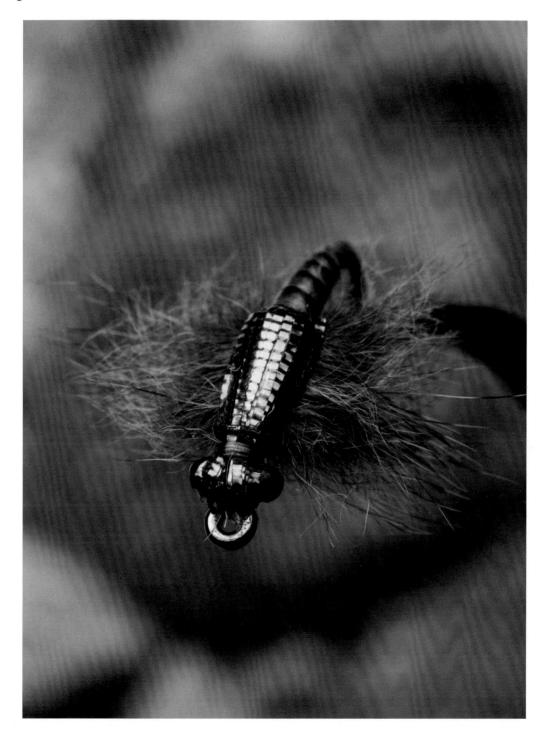

Hook: Demmon DG300BL, #12, **Thread:** Veevus, **Body:** Magic Quills, **Thorax:** Squirrel hair in a loop, **Wing Case:** Gold floss, **Eyes:** Melted nylon.

Damselfly—Bram van Houten

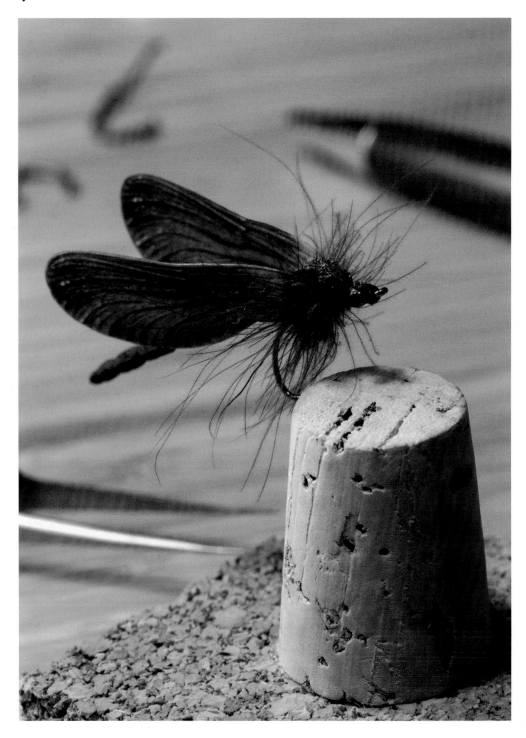

Hook: Muruto C47BL, #10, **Thread:** UTV 70, **Body:** Foam, **Thorax:** CDC in a loop, **Wing:** Dutch Fly Tying wings, **Wing Case:** Foam, **Eyes:** Small glass beads with nylon

Caddis Fly—Bram van Houten

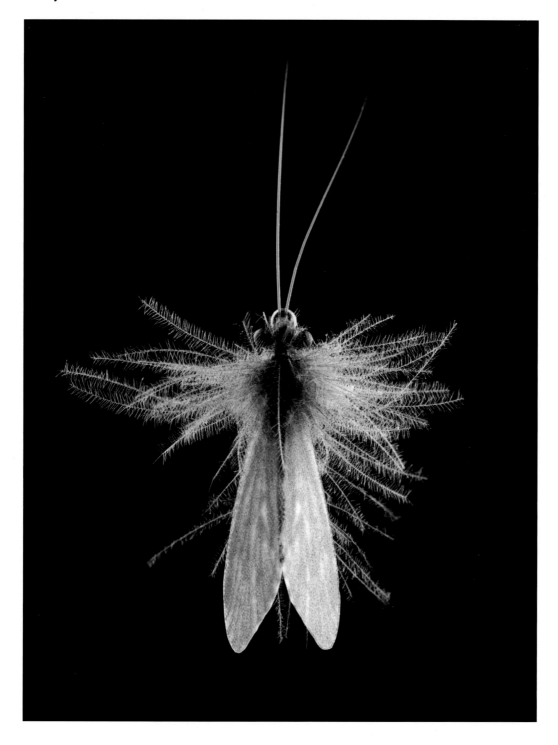

Hook: Muruto C47BL, #14, **Thread:** UTC 70, **Body:** Squirrel dubbing, **Thorax:** CDC in a loop, **Wing:** Dutch Fly Tying caddis fly wings, **Wing Case:** Pheasant, **Eyes:** Melted nylon, **Antennae:** TMC Versatail

Damselfly—Bram van Houten

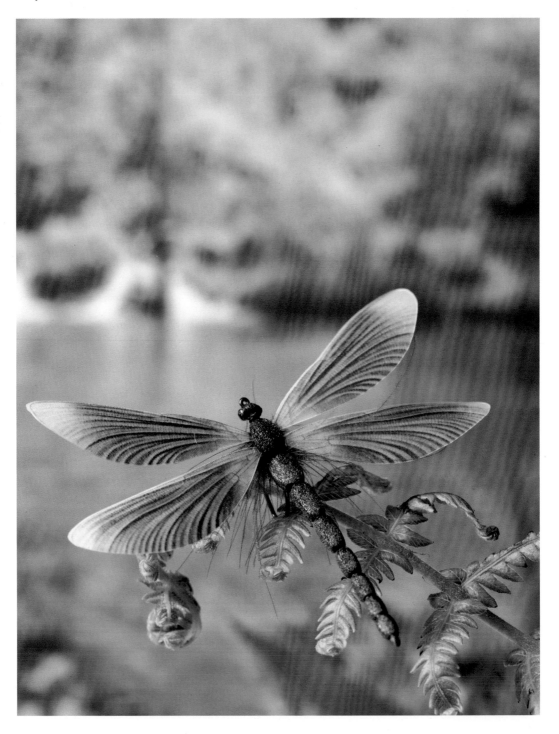

Hook: Muruto C47BL, #10, **Thread:** UTC 70, **Body:** Foam, **Thorax:** CDC in a loop, **Wing:** Dutch Fly Tying wings, **Wing Case:** Foam, **Eyes:** Small glass beads with nylon.

Damselfly—Bram van Houten

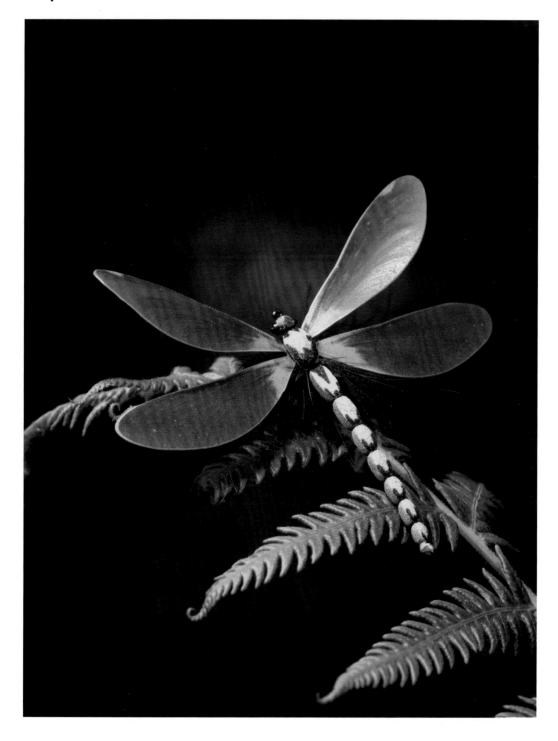

Hook: Muruto C47BL, #10, **Thread:** UTC 70, **Body:** Foam, **Thorax:** CDC in a loop, **Wing:** Dutch Fly Tying dragonfly wings, **Wing Case:** Foam, **Eyes:** Small glass beads with nylon.

Damselfly—Bram van Houten

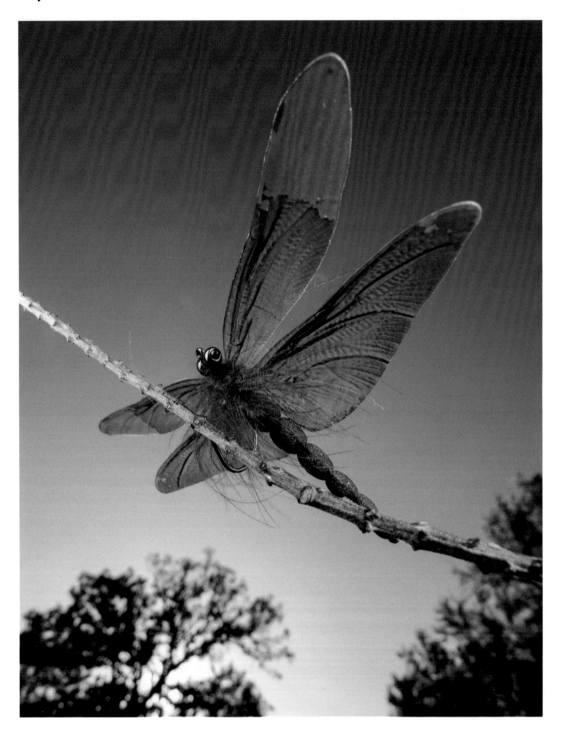

Hook: Muruto C47BL, #10, **Thread:** UTC 70, **Body:** Foam, **Thorax:** CDC in a loop, **Wing:** Dutch Fly Tying wings, **Wing Case:** Foam, **Eyes:** Small glass beads with nylon.

PEDER "WIGGO" WIGDELL, SWEDEN

I have been fly fishing and tying my own flies for over forty years now and I still love it. The first fly I tied was an E12, and I also caught my first trout on that fly. I still have the fly, framed with the picture of my first trout. The last six or seven years I have been tying more and more realistic flies that are not meant to be fished with. I call them Artflies and I usually mount them in a frame, glass jar, or bottle.

As I needed to develop and increase the skill level of my own tying, I started to tie realistic flies. Paul Whillock's book *Flies as Art* became one of my go-to books when I needed inspiration. On Facebook, I found several master tyers on the realistic scene, such as Johan Put, Konstantin Karagyozov, and Fred Hannie.

I love to try new materials, and I also try to use them in my fly tying, creating new and unusual ways to tie a realistic fly. I often use photographs of real insects as inspiration. I try to figure out the best way to use new materials and what materials to use to get as close to the real insect as possible. Both for now and in the future, I am convinced that realistic fly tying is a genre in itself even if it owes a lot to ordinary fly tying.

Mosquito—Peder "Wiggo" Wigdell

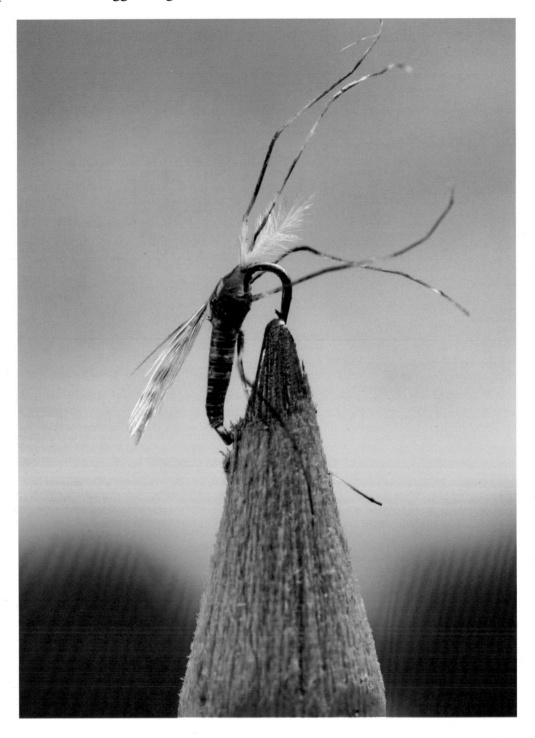

Hook: Akita 501, size 24, **Thread:** FTS Ultra Strong, 20/0, **Body:** Natural peacock quill, covered in Deer Creek Fine Flex, **Thorax:** Tying thread colored with permanent marker, **Wings:** Grizzly hackle, **Legs:** Stripped grizzly dun hen hackles.

Zika—Peder Wigdell

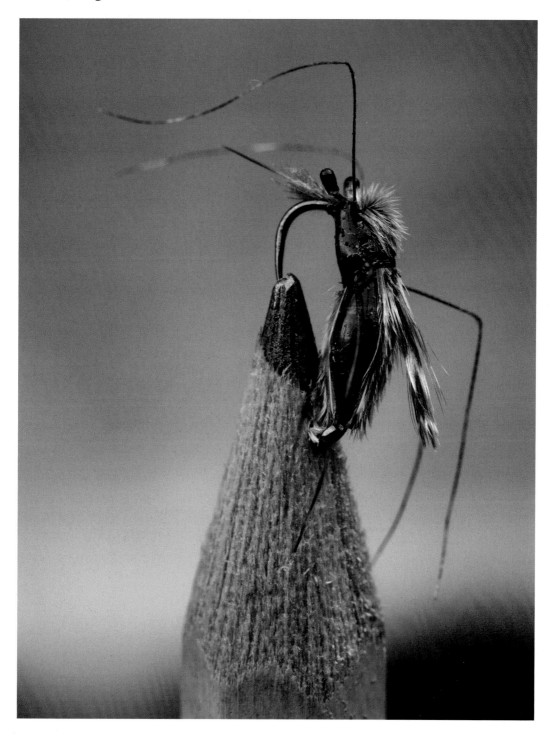

Hook: Maruto DO4, size 18, **Thread:** FTS Ultra Strong 20/0, **Body:** Veevuz red tying thread, covered in Deer Creek Fine Flex, **Back and belly:** three mallard biots, **Wings:** Grizzly hackle, **Thorax:** Tying thread and Capercallie biots, **Legs:** Stripped grizzly dun hen hackles, **Trunk:** Tip of a porcupine guard hair.

Reversed Wally-winged Mayfly—Peder Wigdell

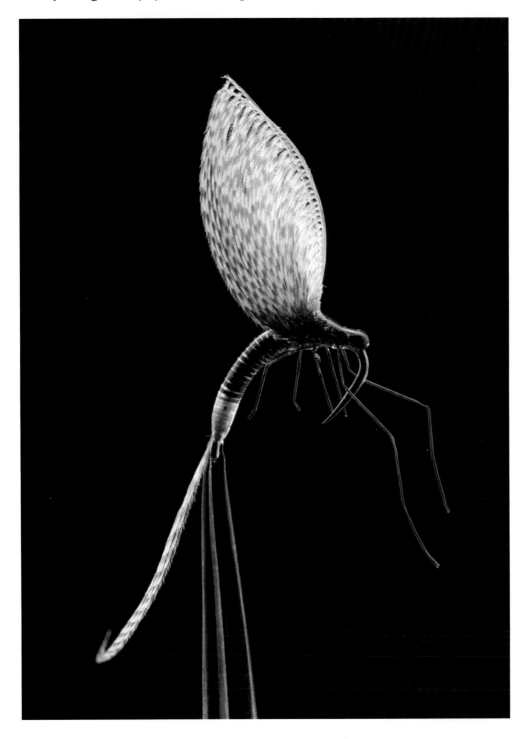

Hook: Firehole 315, size 14, **Thread:** FTS Ultra Strong 20/0, **Tail:** Mallard, **Body:** Peccary covered in Deer Creek Fine Flex, **Thorax:** Tying thread, brown nymph skin; Deer Creek Fine Flex, **Wings:** Mallard Wally-wings, **Eyes:** Black Melt Eyes from FTS, **Legs:** Porcupine guard hair.

Yellow May—Peder Wigdell

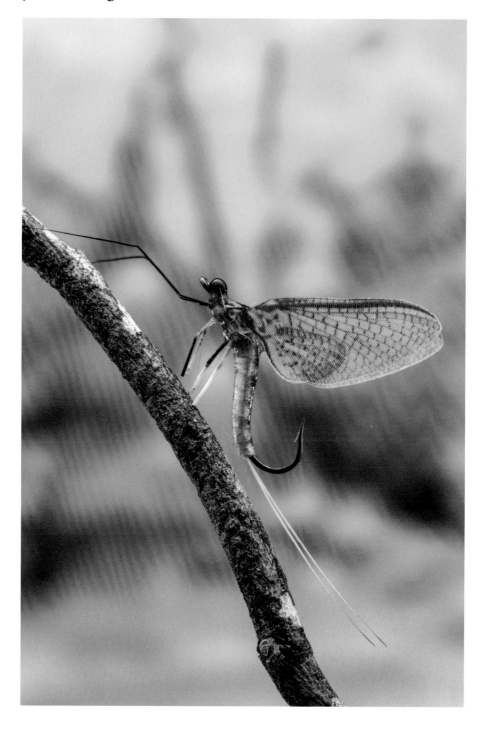

Hook: Mustad Swimming nymph, size 14, **Thread:** FTS Ultra Strong 20/0, **Tail:** Porcupine guard hairs, **Body:** Tying thread, permanent marker, Magic Quill S, Deer Creek Fine Flex, **Thorax:** Tying thread, light yellow nymph skin, Deer Creek Fine Flex, **Wings:** Realistic mayfly wings from Dutch Fly Tying, **Front Legs:** Peccary, **Abdomen Legs:** porcupine guard hairs, **Eyes:** Black Melt eyes from FTS.

Rubbadubb Mayfly—Peder Wigdell

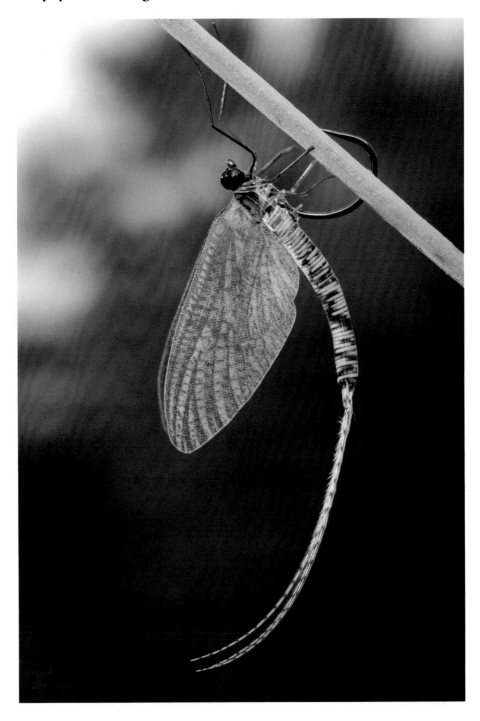

Hook: Hanak 390 BL, size 14, **Thread:** FTS Ultra Strong 20/0, **Tail:** Mallard, **Body:** Tubing wrapped with Centipede Legs Speckled Tan #0, covered in Deer Creek Fine Flex, **Thorax:** Tying thread and Centipede Legs Speckled Tan #0, covered in Deer Creek Fine Flex, **Wings:** Realistic mayfly wings from Dutch Fly Tying, **Eyes:** Black Melt eyes from FTS, **Legs:** Porcupine guard hairs.

HEINZ ZÖLDI, AUSTRIA

This is how it all started for me. One day, when I was a little boy, I decided to make a fishing lure on my own. I wrapped some wool on a hook. And this was the day I started fly tying. I wasn't able to fish with a fly rod at this time, but this wasn't important for me. I loved to make this kind of lure and I tried to get better. At first it was hard. I had no vise, no tools and nobody to train with. But I practiced and gradually became better. Unfortunately, I do not have any flies from this time, and it would be great to look back and see my progress from the start. So, when you start fly tying, keep your first self-tied flies.

In the 1990s I fished in Slovenia many times. These were really nice fishing trips with my father, who is an ethusiastic fly-fisher. During one fishing trip in Slovenia, I think it was in 1991, I learned the basics of fly tying, and was infected with the virus. All the rest was learning by doing and making a lot of mistakes, too.

I started to tie big flies and streamers and during the years they got smaller and better. Today, because of the internet, I think it's easier to learn several techniques, and it's possible to become a great fly tyer in two or three years. One day, I saw a realistic nymph in a magazine and I thought, "I must tie a fly like this!" I started to tie and after a few tries, I made my first realistic-looking fly. I tried a lot but was never satisfied how the flies turned out.

I should note that I am never satisfied with my flies. I always try to improve myself. When I look at a fly I've tied a couple of years ago, I always have to grin a little bit. For me fly tying is a kind of art. We live in a time nearly everyone is called an artist, when he's able to hold a brush or a pencil in his hands. So, I think it's okay to call fly tying an art.

I am member of the Go-Fish Experts, where I develop fly tying tools and tying materials, and I'm part of the Maier&Fazis Speed-Vise Team.

Articulated Damsel Nymph—Heinz Zöldi

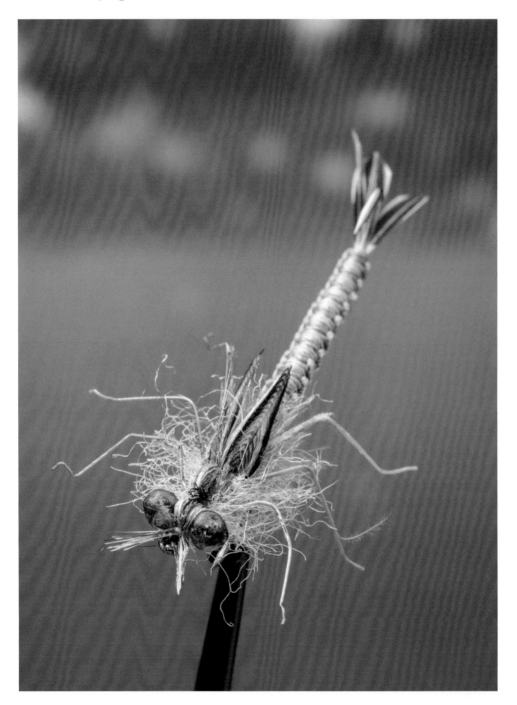

Hooks: Gamakatsu LS-3313F, #4 and MFC 7008, #4, **Thread:** Go-Fish Maximus 30den, white, **Tail:** three jungle cock feathers coated with Go-Fish varnish, **Abdomen:** Woven body with two strands of silk thread, **Thorax:** CDC fibers and dubbing, **Legs:** CDC rachis, **Wing cases:** Jungle cock feather coated with resin, **Head:** Jungle cock feather coated with Go-Fish varnish, **Eyes:** Chain eyes, **Antennae:** Jungle cock fibers coated with Go-Fish varnish.

Danica Mayfly Nymph—Heinz Zöldi

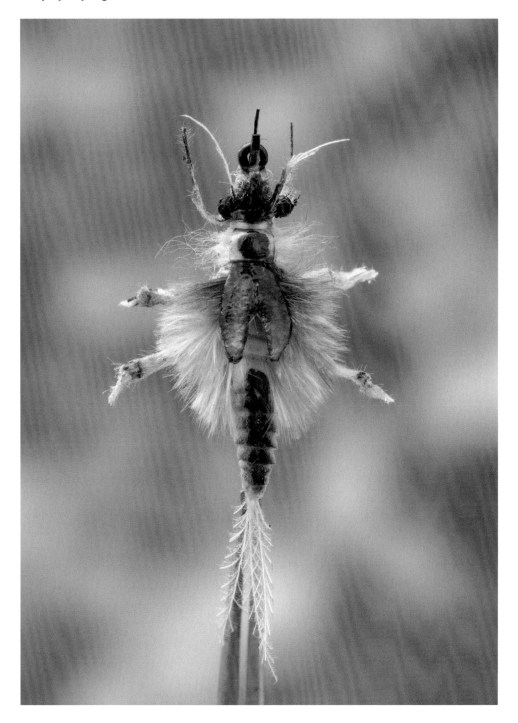

Hook: Daiichi 1770, #12, **Thread:** Go-Fish Maximus 30den, white, **Tail:** three small CDC feathers, **Abdomen:** Go-Fish Latex, **Tracheae:** CDC fibers and ostrich, **Wing Cases:** Go-Fish flex wing, **Legs:** CDC feathers coated with Go-Fish varnish, **Thorax:** Dubbing and Go-Fish flex wing, **Head:** Tying thread and Go-Fish flex wing, **Eyes:** Go-Fish melt eyes, **Antennae:** CDC feathers coated with Go-Fish varnish.

Stars and Stripes Stone Fly—Heinz Zöldi

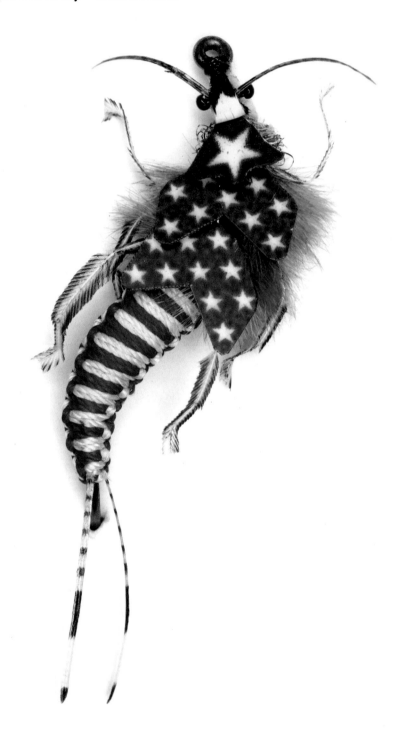

Hook: MFC 7008 #4, bent, **Thread:** Go-Fish Maximus 30den, white, **Tail:** Wood duck fibers coated with Go-Fish varnish, **Body:** Woven body (2 strands silk thread), **Wing Cases:** Self-made foil, **Tracheae:** Ostrich, **Legs:** Jungle cock feathers, **Thorax:** Dubbing, **Head:** Tying Thread, covered with jungle cock, **Eyes:** Go-Fish melt eyes, **Antennae:** Bronze mallard fibers coated with Go-Fish varnish.

INDEX

ABOUT THE AUTHORS

Tony Lolli

Tony Lolli is an author, columnist and fly-fishing guide. His columns have appeared in *Hunting and Fishing News*, *American Angler*, and *On The Water*, among others. He has written several books on fly fishing and tying. The New England Outdoor Writer's Association selected his *Amazing Fishing: Facts and Trivia* as one of the three best books for 2012. He lives in northwest Maryland's Appalachian Mountains.

He has written fly-fishing columns for several outdoor magazines including *The Northwoods Sporting Journal*, *On The Water Magazine*, *New Hampshire/Vermont Outdoor Gazette*, and *The Hunting and Fishing News*. His features appeared in *American Angler*, *The Drake*, *The Pointing Dog Journal*, and *Gun Dog Magazine*.

Lolli's fly-fishing experience began fifty years ago, shortly after his return from Vietnam. An unanticipated sale at the base exchange enticed him into trying fly fishing. He learned something important: fly-fishing equipment does not guarantee trout. He's been a fly-fishing guide for forty years.

Alex Wild

Alex Wild (b. 1973) is an entomologist and science photographer. His research as Curator of the University of Texas insect collection concerns the genesis of insect diversity. His photographic explorations of insect natural history appear in numerous magazines, textbooks, websites, and museum exhibits including: *BBC Wildlife*; *New York Times*; *Washington Post*; *National Geographic*; *New Scientist*; *Natural History*; *Discover*; *USA Today*; *NBC*; *Discovery Channel*; *Ranger Rick*; *Smithsonian*; *Popular Science*; *Scientific American*; *Audubon Nature Institute Insectarium*; *Chicago Field Museum*; *California Academy of Sciences*; *American Museum of Natural History*; *Cleveland Zoo*; *Science*; *Nature*; *Cell*; *Proceedings of the National Academy of Sciences of the United States of America*; *Current Biology*, and many others.

Alex founded the BugShot series of international photography workshops and he teaches entomology courses at The University of Texas at Austin.